London's lost jewels

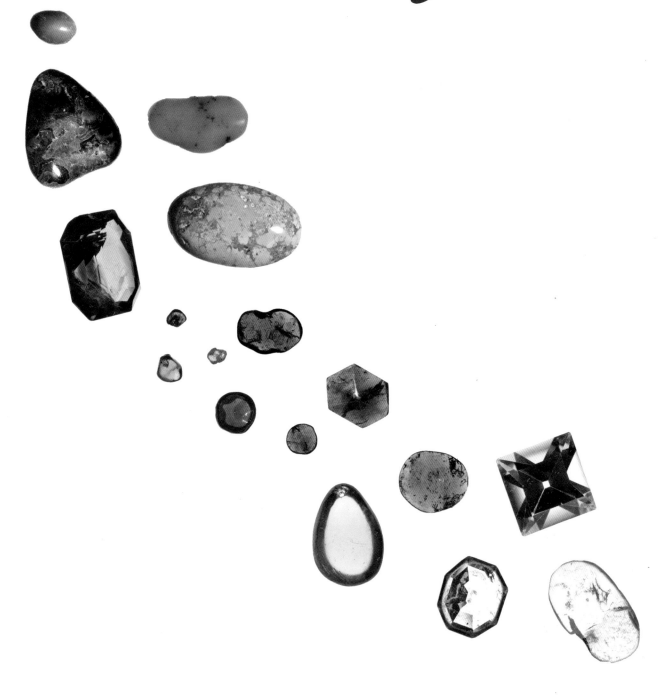

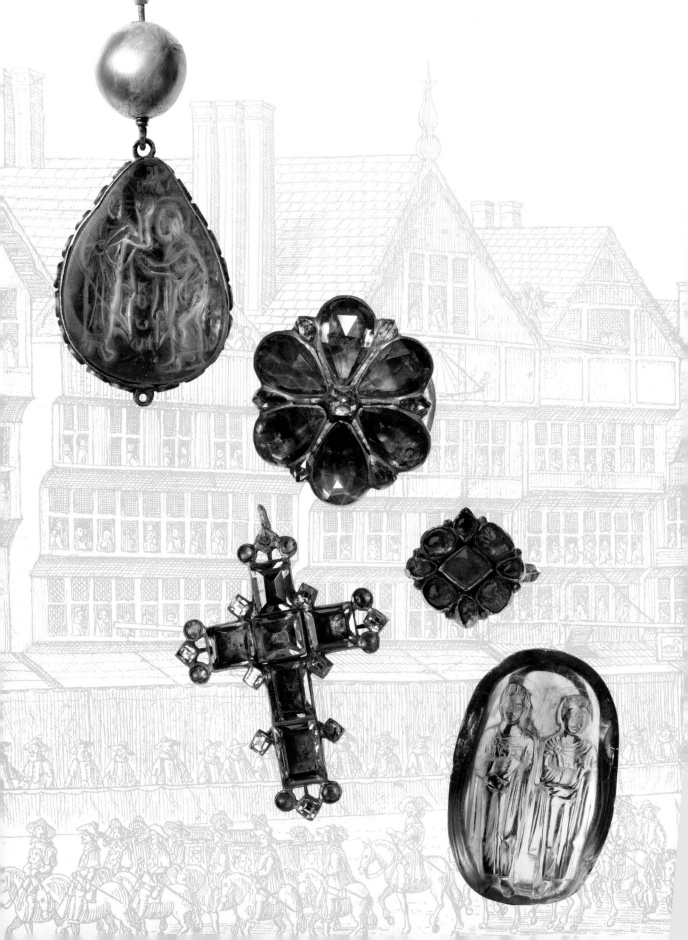

THE CHEAPSIDE HOARD

LONDON'S *Lost* JEWELS

HAZEL FORSYTH

Published on occasion of the exhibition
The Cheapside Hoard: London's Lost Jewels, Museum of London
(11 October 2013–27 April 2014)

First published and reprinted in 2013 by Philip Wilson Publishers
an imprint of I.B. Tauris & Co Ltd
6 Salem Road
London W2 4BU
www.philip-wilson.co.uk

ISBN 978 1 78130 020 6

Distributed in the United States and Canada
exclusively by Palgrave Macmillan
175 Fifth Avenue, New York NY 10010

Designed and typeset in 11 on 16 Monotype Janson
by Lucy Morton at illuminati, Grosmont
Printed and bound by Printer Trento Srl, Italy

Contents

Acknowledgements

FIRST AND FOREMOST, I should like to record my gratitude to the Worshipful Company of Goldsmiths, without whose help this book could not have been written. I also wish to thank the staff of the British Library, the College of Arms, the Guildhall Library, Leicestershire County Council Record Office, the London Metropolitan Archives, the National Archives, the National Archives of Scotland, the Parliamentary Archives, the Royal Society, the Staffordshire Record Office, and the Westminster Diocesan Archives.

Many friends and colleagues in archives, laboratories and museums have offered sage advice and support and I would particularly like to acknowledge Keith Adcock, Derek Adlam, Amir Akhavan, Dr Janet Ambers, Philip Attwood, Marta Baranowska, Francesca Balzan, Gabriella Barbieri, Rosa Barovier, Dr Lynne Bartlett, Dr Justine Bayley, Denis Bellesort, John Benjamin, Eleni Bide, Professor Michèle Bimbenet-Privat, Roderick Booth, Professor Sir John Boardman, Dr Heike Bronk, Dr Duncan Bull, Brian Burfield, Dr Ann-Marie Carey, Christopher Cavey, Dr Beatriz Chadour-Sampson, Steve Collins, Derek Content, Rui Galopim de Carvalho, John Culverhouse, David Davies, Dr Natalia Dementieva, Herman Diederiks, Dr Chris Duffin, Timothy Duke, Dr Richard Edgcumbe, Florence Evans, Monika Frankowska-Makala, Dr Carlotta Gardner, Ben Gaskells, Dr Joachim Gierlichs, Dr Gaston Giuliani, Winifred Glover, Dr Erin Griffey, Mark Grimwade, Dr Kate Harris, Dr Martin Henig, Suzanne Higgott, Alexandra Hutchings, Kathryn Jones, Jackie Keily, Professor Kris

Lane, Dr Hanspeter Lanz, Dr Núria López-Ribalta, Dr Elena Lioubimova, Andrzej Lubienski, Melanie Medniuk, David Merry, Helen Molesworth, Claire Muller, Geoffrey Munn, Dr Juanita Navarro, Dr Jack Ogden, Professor Olga Palagia, Des Pawson, Dr Lucia Pirzio Biroli, Jhinpa Ramon Ronzales, Ron Ringrup, Dr Stefan Röhrs, Jane Sarginson, Margaret Sax, Diana Scarisbrick, Dr Alison Sheridan, Dr Andrew Shortland, Pauline Sidell, Erika Speel, Dr Irena Sterligova, Frithjof Sterrenburg, Susan Stronge, Maria Stuerzebecher, Nino Tagliamonte, Peter Tandy, Joanna Terry, David Thompson, Dr Dora Thornton, Sophia Tobin, Cristina Tonini, Charles Truman, Dr Susan Turner, Marco Verità, Andreu Vilasís, Rozenmarijn Van Der Molen, Jeremy Warren, Kathie Way, Dr Julia Webb, Joanna Whalley, Rick Wolf, Dr Irina Zagorodnjaja, Raakhee Zaman.

My thanks are also due to Sally Brooks who obtained various books and journals at short notice and for her kindness in reading part of an early draft. I owe a particular debt of gratitude to Nigel Israel for his invaluable gemmological expertise, enthusiasm and helpful encouragement, to David Mitchell for generously discussing various issues related to the goldsmiths' trade, and to David Beasley for his kindness in reading through the text and for providing continual support and helpful advice during the course of my research.

Some of my colleagues deserve special mention, and I would like to thank Nikki Braunton and Sean Waterman in the picture library and John Chase, Richard Stroud and Torla Evans for their wonderful photographs of the Cheapside Hoard. Finally I would like to thank the copy-editor, Robin Gable, and designer, Lucy Morton, for their kindness, skill and expertise while this book was going through to press.

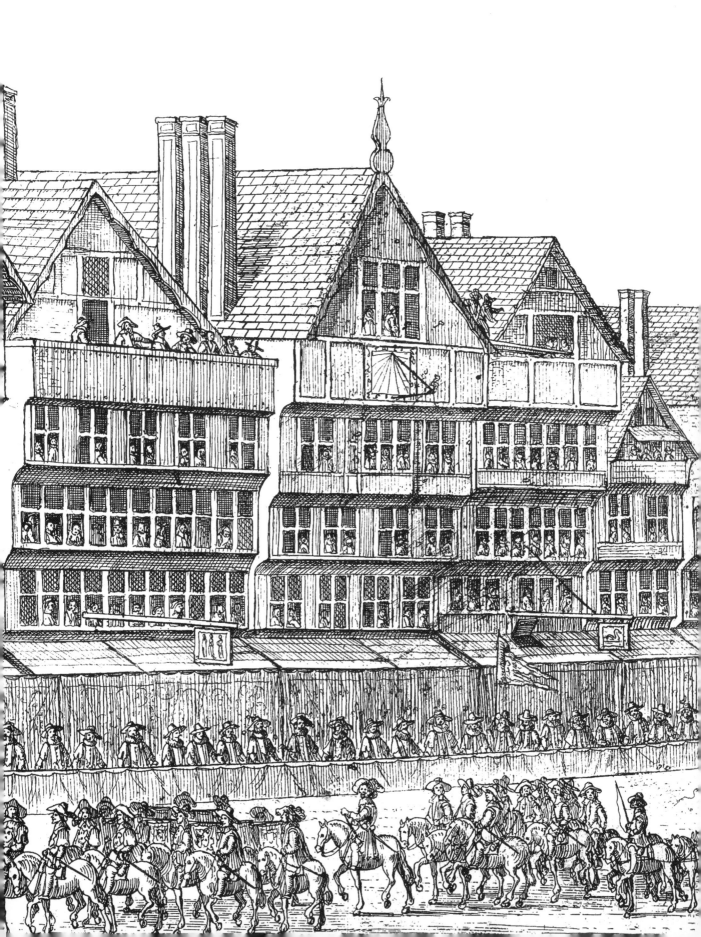

Introduction

A STRANGER to London, or someone familiar only with the modern city, would probably scurry along Cheapside without giving it much thought, except perhaps to note its length and width and the magnificent vista of St Paul's Cathedral, which is now revealed in all its splendour for the first time since the Second World War. Overshadowed by large office developments and lined with shops, modern Cheapside is distinctly unremarkable, and yet for many centuries it served an important function as the principal market and thoroughfare of the City, running in a more or less straight line from St Paul's in the west to Lothbury and the Poultry at its eastern end. And it was in this street in 1912 that workmen made a remarkable discovery, bringing to light for the first time in almost three hundred years a massive hoard of gems and jewels, which is now known and celebrated as the Cheapside Hoard.

From the moment of its discovery the Cheapside Hoard has attracted worldwide interest. It is the most important source of our knowledge of Elizabethan and Jacobean jewellery, and it is the greatest hoard of its type and kind. Such is its rarity and importance that almost every article and book on the Tudor and Stuart period includes some description or reference to the collection. But while the circumstances of the burial and the date of the deposition have given rise to a certain amount of speculation and debate, most writers have concentrated on the finds themselves and hardly any serious work has been done on the early history of the buildings and their occupants. A veil has also been drawn over the murky events surrounding the

opposite Detail from the Coronation procession of Marie de' Medici along Cheapside, 1638.

A18146

remarkable discovery and the subsequent acquisition of the Hoard by the Museum of London.

This book, written to accompany the Museum of London's exhibition *London's Lost Jewels: The Cheapside Hoard* (11 October 2013–27 April 2014) is not a catalogue. Instead it attempts to explore the mysteries surrounding the discovery, and sets out to provide some context to London's gem and jewellery trade in the late sixteenth and early seventeenth centuries – a trade that was both highly organized and necessarily secretive; a trade that offered tempting opportunities for the smuggler, factor, gem dealer, merchant and jeweller. How did gems and jewels arrive in London? Where did they come from? To whom were they sent? It is a highly complex story of hope and despair, tragedy and triumph, intrigue and exploitation. But it is also, fundamentally, a story about the undistinguished and often unnamed mass of miners, gem-cutters, merchants and jewellers upon whose slow toil and incredible skill the foundations and success of the trade were built.

The evidence is largely drawn from unpublished sources of the late sixteenth and early seventeenth centuries, and much of it is published here for the first time.

The terms 'jeweller' and 'goldsmith' were largely interchange-able in the sixteenth and early seventeenth centuries and some-times both terms are applied to the same person in the same document. The term 'goldsmith' occurs far more frequently in contemporary records, even when jewellery was the mainstay of the business. Of course, members of the Goldsmiths' Company were goldsmiths by affiliation whether they were working jewellers, retail jewellers or a mixture of both. The term 'jewel-ler' was often applied to, though not exclusively reserved for, artisans operating outside the Company's control and variously meant a retailer of jewellery, an appraiser, merchant or dealer of jewellery and gemstones, and only sometimes to the craftsmen who actually made the jewels and set the stones. The term 'stone cutter' is used more frequently than 'lapidary' and so unless there is corroborative evidence to the contrary it is not always clear if the cutter in question was a mason or a cutter of gemstones. Only those individuals who were engaged in cutting gemstones are included here. Specific terms like 'setters' and 'mounters' are never used, though it is sometimes clear from the context that the craftsman had a particular skill of this kind. Throughout this book the terms 'goldsmith', 'jeweller', 'stone cutter' and 'lapidary' are variously applied, but in each case the term is either the title selected by the individual concerned or that applied to them by their contemporaries.

A spectacular find

Unquestionably, the most attractive and remarkable feature of the [museum] is the wonderful collection of jewellery of about the first decade of the seventeenth century. The story of this astonishing discovery cannot yet be told in full … and guarded answers [were given] to the many adroitly framed questions of the specially invited company who enjoyed the most private of private views.

Daily Telegraph, 19 March 1914

FOR ALMOST three hundred years a great treasure had lain undisturbed beneath one of London's busiest and most distinguished streets. Then in 1910, Leopold Rosenthal shoe manufacturer, John Bromwich silk agent, Alfred Hobcraft watchmaker, McCaw, Allan & Co., handkerchief manufacturer and other tradesmen received notice that their shops and business premises on the corner of Cheapside and Friday Street were going to be pulled down.[1] The buildings, erected in 1667 to replace those lost in the Great Fire of London a year earlier, were showing signs of age. Floors had started to sag, cracks had begun to appear, and the Worshipful Company of Goldsmiths, who had owned the properties for centuries, were all too aware of their many 'dilapidations, waste and wants of repair'.[2]

When the decision to raze 30–32 Cheapside was finally taken on 29 November 1910, a special agreement was drawn up between the Goldsmiths' Company and the lessees, Messrs J.H. Colls and H. Smith, building contractors and property developers. An unusual clause was inserted into the agreement, and provision was made for any antique treasure that might be uncovered:

previous pages Cheapside c.1890 looking east towards St Mary-le-Bow. Nos 30–32, where the Cheapside Hoard was found, are shaded yellow in the thumbnail above.

Museum of London IN4086

on the 25th March 1912 … the lessees shall at their own expense within three months thereafter in a good and workmanlike manner pull down and remove all existing erections buildings and materials upon the said site. Any such materials shall be the property of the lessees save and except any antiquities and articles or objects of interest or value which shall be preserved by the lessees and handed over to the lessors.[3]

The demolition began on schedule. By mid-June the workmen had started to excavate the cellars, and as they began to break up the floor with their picks they noticed something glinting in the soil. The bricks were flung aside and, no doubt to their astonishment and delight, a tangled heap of jewellery, gems and other precious objects came tumbling forth. They had uncovered what is now known and celebrated as 'the Cheapside Hoard': the stock-in-trade of a seventeenth-century jeweller and the biggest cache of its kind in the world.

A veritable treasure chest of gems and jewels would seem just the sort of 'object of interest' that ought to have been handed over to the landowner, but the Hoard's troubled ownership began from the moment of its discovery, for the workmen, possibly in ignorance, did not hand over their find to the Goldsmiths' Company. Instead, they did what they normally did with any items recovered from London's building sites: they took the jewels to George Fabian Lawrence, better known to London's navvies as 'Stony Jack',

the bloke at Wandsworth who buys old stones and bits of pottery. Got a little shop full of 'em. He's a good sport is 'Stony Jack.' If you dig up an old pot or a coin and take it to him, he'll tell you what it is and buy it off you. And if you take him rubbish, he'll still give you the price of half a pint.[4]

'We've struck a toy shop, I thinks guvnor!'

'Stony Jack' Lawrence (1862–1939) had a multifaceted career as a pawnbroker, dealer, collector of antiquities and sometime employee of both the Guildhall and London museums. But it was in his dealings with the navvies of London that he really

came into his own. Most weeks he could be seen wandering around the building sites conducting 'mysterious transactions behind hoardings' or sitting in one of the City's public houses holding whispered conversations.[5] For, as Lawrence put it when interviewed in 1937,

> I got to know a lot of navvies … [and] I thought what a lot of stuff was being lost because [they] did not know what to look for. I decided to try to teach them … I taught them that every scrap of metal, pottery, glass or leather that has been lying under London may have a story to tell the archaeologist and is worth saving. They were apt pupils, and hardly a Saturday passed without someone bringing me something. I got 15,000 objects out of the soil of London in 15 years for the London Museum alone.[6]

So it was not unnatural that the Cheapside workmen turned to Stony Jack with their pockets, handkerchiefs and hats bulging

George Fabian Lawrence – 'Stony Jack' – in his shop in Wandsworth.

with precious stones and jewels and other items stashed in a sack. According to later newspaper articles, they entered and spilt on the floor 'many great lumps of caked earth – "We've struck a toy shop, I thinks guvnor!" was the comment of one navvy as he indicated various bright streaks in the earth.'[7] Once they had gone, Lawrence set about washing off the soil and, gradually, tangled chains of enamelled gold, cameos, intaglios, carbuncles, assorted gems and hardstones, rings and pendants were revealed in all their brilliant splendour. A day or so later the workmen returned, carrying yet more jewels in knotted handkerchiefs to add to the pile accumulating in Lawrence's shop.

A well-kept secret

There was no question that the Hoard was one of the most important finds ever recovered from London soil. It was also the most thrilling discovery of Lawrence's career, and he was keen to secure the treasure for the London Museum, which had not yet opened to the public. There was a flurry of telephone calls, and on 20 June, at an emergency meeting of the trustees, it was agreed that 'the entire gold treasure recently unearthed' should be removed to the director's flat for inspection. On the same day, Lawrence was made an 'Inspector of Excavations' for the London Museum. That he should receive this position on the very day that trustees met to discuss the treasure may raise a suspicious eyebrow, but, regardless of any self-interest, there is no doubt that Lawrence acted with propriety by drawing the find to the attention of the Museum and not allowing it to slip into private hands.

Once they had seen the treasure, the trustees (Mr Harcourt, later 1st Viscount; Lord Esher and Lord Beauchamp) made up their minds to secure it for the new museum, and Lawrence was instructed

to buy the navvies out. Monies changed hands and over the next few days 'little oddments' from the Hoard came to light. According to later reports, many of the workmen 'disappeared, and were not seen again for months!'[8] Lawrence did his best to secure the bulk of the treasure for the Museum, but it is clear from contemporary records and subsequent events that some items slipped the net. The British Museum bought five pieces from the watch and diamond dealer Percy Webster on 28 June, and in 1926 Lawrence sold an enamelled gold chain, which he had been 'allowed' to keep, to the Victoria & Albert Museum.[9] The following year, two faceted amethysts were given to the London Museum by Lawrence's son,[10] and in 1929 four rings mysteriously 'acquired' by Harman Oates, a former keeper of the London Museum, also ended up in the Victoria & Albert Museum's collection.[11] It is entirely possible that other items remain in private hands.

By the middle of June 1912 the Hoard was delivered to Mr Harcourt's house in Berkeley Square. The King and Queen had a private view and then Harcourt made secret arrangements to have the treasure inspected by the Treasury solicitors on behalf of the Crown. There was no inquest for treasure trove, and, in a surprising ruling, the Treasury granted title to the London Museum.

An Aladdin's cave of jewels

The Hoard was kept a closely guarded secret for two years, until it went on public display for the first time in the new London Museum at Stafford House, near St James's Palace. Sparkling like a veritable 'Aladdin's cave of jewels' in the centre of the Gold and Silver Room, the massed display of almost five hundred jewels and stones was an impressive sight.[12] There were enamelled gold and gem-set chains, earrings in the form of bunches of grapes carved from emeralds and amethysts, brooches, bracelets, rings and pins, unmounted stones, a cameo

Trade card for 'Percy Webster Clockmaker'.
British Museum, Heal, 39,109

opposite
Some of the Cheapside Hoard.

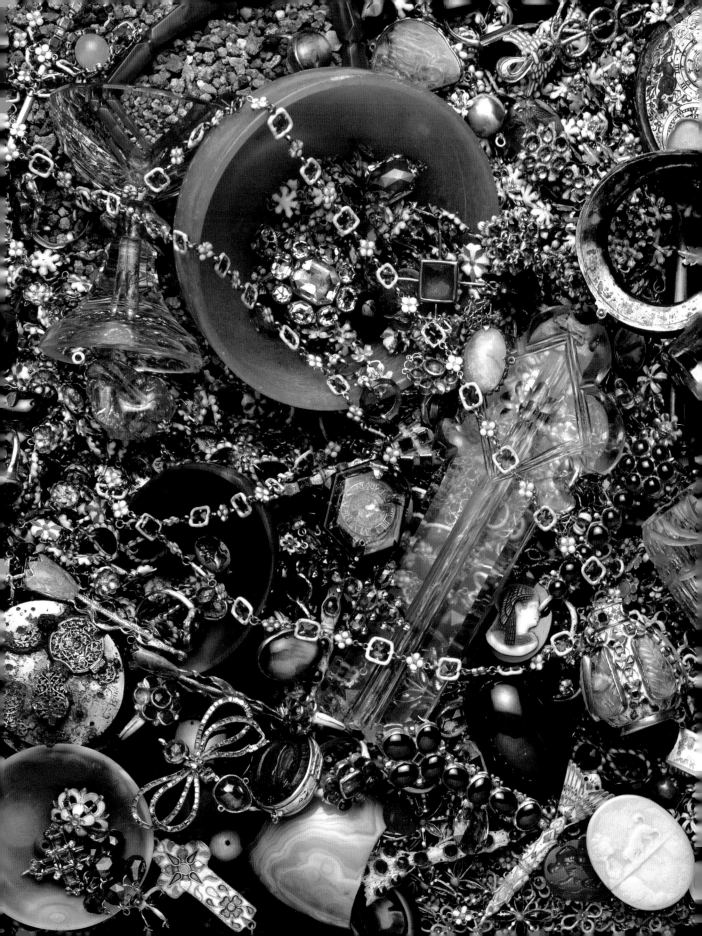

of Elizabeth I, gemstones of classical antiquity, hardstone vessels, and the chief object of admiration – a small watch set in an emerald case (p. 136).

At the official opening on 20 March 1914, the royal party had another opportunity to see the Hoard. They were particularly impressed by the 'wonderful find … [and] Queen Mary, whose knowledge on the subject is extensive, asked many questions, some of which were difficult to answer'.[13] The Museum opened to the public the following day. Crowds flocked to see the jewels and the display caused a sensation. As one newspaper columnist later remarked, 'women are finding the Gold and Silver Room of the London Museum … one of the most interesting rooms in London'.[14]

The press were particularly intrigued by the circumstances of the discovery, and they wanted to know when and why it was buried and by whom. For, as one journalist put it, the 'mystery surrounding the whole thing adds to its romantic interest',[15] and in the media frenzy that followed journalists started to ask searching questions about treasure trove and the details of the find. Most of their questions were met with obdurate silence, although the odd guarded response from the Museum indicated concealment in a building in the City somewhere not far from St Paul's Cathedral and burial in a wooden box. One reporter then suggested that the treasure trove inquest had been hushed up, to which Lawrence loftily replied that 'the authorities thought it best that nothing should be said at the time'.[16]

An unseemly scramble

Perhaps nothing further would have been said, had the Victoria & Albert and British museums not entered the fray. The very existence of the London Museum had already provoked some heated exchanges within antiquarian and museum circles, and the national museums in London, which feared conflict of interest, were particularly concerned. The fact that the Treasury

OLD JEWELRY A FEATURE AT THE LONDON MUSEUM

Remarkable Hoard of Elizabethan or Jacobean Jewels Has Been Added to Collections.

[FROM THE HERALD'S CORRESPONDENT.]
LONDON, Tuesday.—When the London Museum is opened in Stafford House next Monday the surprise will be the cases full of Elizabethan or Jacobean jew...

SECRET JEWEL HOARD.

Romance at Every Turn in London's Treasure House.

The London Museum, which opens in its new home in Stafford House, St. James's, in a few days, will be a notable addition to the public institutions of London.

A "Star" representative who inspected it to-day says that from every point of

ELIZABETHAN JEWELLERY

TREASURE TROVE IN CENTRAL LONDON.

WORKMEN'S SINGULAR DISCOVERY.

The secret of a discovery of treasure trove in the heart of London was revealed yesterday, when in a glass case in the centre of the gold and silver room at Stafford House, the new home of the London Museum, a wonderful collection of Elizabethan or early Jacobean jewellery invited the admiration of beholders.

TREASURE-TROVE IN CITY.

PRICELESS JEWELLERY IN A CELLAR.

A discovery two years ago of priceless treasure in the City of London came to light yesterday, when the objects found, forming a magnificent collection of Elizabethan or early Jacobean jewellery, were exhibited at the new home of the London Museum at Stafford House.

Where the treasure was found is still kept a secret. All that is explained is that some workmen who were excavating an old City cellar, came upon a quantity of jewellery and precious stones in the remains of a

TREASURE IN THE LIGHT

Sparkling Hoard of Jewels Dug Up in the City on Show at Stafford House.

A wonderful hoard of jewels has come into the possession of the trustees of the London Museum.

It has not yet been seen by the public, but when the doors of Stafford House, the new home of the museum, are opened next Monday, the collection is certain to create a sensation.

Two years ago during rebuilding operations in the heart of the City, a wooden casket was dug up beneath the surface of a cellar, and the authorities were notified of the find.

A rich and rare collection of Elizabethan and Jacobean jewels were found inside the casket, and it includes:—

'Secret Revealed: Discovery of Elizabethan Jewellery. London's Buried Treasures – For two years a dozen persons have carefully guarded the secret of the wonderful discovery of treasure trove in the heart of the City. Yesterday the secret was revealed. In a glass case in the centre of the Gold and Silver Room at Stafford House, the new home of the London Museum, a collection of Elizabethan or early Jacobean jewellery, unique in the variety of its designs and priceless from a historic standpoint, invited the admiration of beholders. South Kensington can boast nothing to compare with it.'

Nottingham Guardian, 19 March 1914

had granted the Hoard to a 'rival institution' simply heightened the tension. The British Museum believed that it had first claim to all items of treasure trove, and, since it had already purchased five items from the Hoard, Harcourt felt obliged to hand over a few more pieces to smooth ruffled feathers. Twenty items were transferred in January 1914, and Harcourt was made a trustee of the British Museum the following year.

This left the Victoria & Albert Museum in a somewhat isolated position. They were angry that the Treasury 'generally considered that the British Museum had first claim' to treasure trove. They were even more incensed that the Hoard had slipped through their hands. After all, they argued, without the London Museum, all or part of the collection would have gone to them and would have filled various 'deficiences' in the collection. Was it too late to overturn the ruling? Could they put in a claim? Surely the London Museum could part with duplicates 'without serious detriment' to their displays.[17] Memos and minutes flew back and forth, and finally, in December 1914, the Director of the Victoria & Albert Museum wrote to the Treasury to ask if the objects 'in the London Museum labelled "Presented through the Right Honourable Lewis Harcourt, M.P." … [had] been dealt with as treasure trove and whether the Treasury were in any way concerned in their disposal.' He also said that it would be very desirable for arrangements to be made between the various national museums to 'avoid competition or anything like an unseemly scramble'. The Treasury solicitors replied to say that it was their practice to claim all trove as soon as it was reported and then offer it for sale, first to the British Museum, and then to any other departments or private persons who expressed an interest; the proceeds being paid as a reward to the 'honest finder'. So there could be nothing in the nature of a scramble because there was no bidding process. Furthermore, they added, there was rarely anything worth scrambling about. So far as the Cheapside Hoard was concerned, the objects had found their way to the London

Museum 'by an exceptional route'. The find was first reported to the Treasury by Mr Harcourt after he had purchased it (without realizing that it was trove) for the London Museum, and in the circumstances the first lord of the Treasury decided that it should remain in the London Museum, Harcourt 'being regarded as an honest finder'.[18]

Considerable agitation in the City

While the Treasury were pondering the matter, the matter of treasure trove came up again when the City coroner, Dr Waldo, chanced upon the small case of Hoard jewels in the British Museum. He noticed that this remarkable treasure was labelled 'a recent find from the City' and, realizing that it had not come to his attention, began to make enquiries.

The issue of treasure trove was a serious one. Under ancient charter and a royal grant, the lord mayor, Commonalty and City of London – rather than the Crown itself – had a special franchise for items of treasure trove found within the City of London. According to the law as it stood in 1912, this was defined as 'gold or silver in coin, plate or bullion, found concealed in a house, in the earth, or other private place, the owner being unknown and undiscovered'. The City had no title in a case of treasure trove unless it could be shown, first, that the treasure had been deliberately buried with intention of recovery, and second, that no one else could produce a better claim. The finder of any potential treasure was required to report the find and hand the material over to the proper authorities so that an inquest could be held to determine whether the find was treasure trove or not. If treasure trove was proved, the finder received an *ex gratia* payment equivalent to its full market value.

Thus the Cheapside Hoard, found within the boundaries and jurisdiction of the City of London, had slipped through the net.[19] Dr Waldo duly submitted his report to the Court of Common Council of the City of London, and under direction

The Corporation of the City of London.

TREASURE TROVE.

NOTICE is Hereby Given that the Mayor and Commonalty and Citizens of the City of London are, by ancient Charters, entitled to all Treasure Trove found within the City of London and the Town and Borough of Southwark, and that in the event of any gold or silver coins, gold or silver plate, or gold or silver in an unmanufactured state being found in any house, or in the earth, or in any private place within the aforesaid limits, **the owner of which is unknown,** such articles belong to the Corporation of the City of London, and Notice of the discovery must at once be given to me, the undersigned, Town Clerk of the said City, at the Guildhall, London, E.C.

In the event of any such articles being retained by the finder, or sold or handed over to any other person or Body, or notice of the discovery not being given to me, **the person finding the same will render himself liable to prosecution.**

 JAMES BELL,

GUILDHALL, E.C., *Town Clerk.*
 December, 1915.

Charles Skipper & East, Printers, 49, Great Tower Street. E.C.

Notice of Treasure Trove issued by the Corporation of London in December 1915.

Corporation of London

of the Court the General Purposes Committee was advised that as a preliminary to enforcing legal action an inquest should be held by the coroner to decide 'whether any, and what part' of the find constituted Treasure Trove.

Yet the matter was not so simple. The Hoard had long since been removed from the coroner's jurisdiction, and the precise circumstances of its burial were shrouded in mystery. In correspondence, Harcourt protested ignorance of the City's franchise, arguing that as 'the element of treasure trove in the find was extremely small, consisting only of the gold setting of the jewels and the gold base of some of the enamels … any attempt to separate the two would result in the destruction of the artistic and antiquarian merits of the collection.' In other words, the City's claim extended only to such part of the jewels as consisted of gold or silver and did not include the precious stones and other articles of value made from other materials. Harcourt also said that when he had originally acquired the jewels with the object of presenting them to the nation, he was not so much interested in the locality of the find as in the urgent necessity of preventing their destruction and dispersal. Furthermore, he argued, the evidence as to their place of origin was conflicting and contradictory and did not at the time convey that they had been found in the City. Moreover, he had 'lost any evidence [that he had] originally had as to the locality of the find' and was therefore quite unable to challenge any assertion that it had been found within the City boundaries.[20] Many of the letters and notes in the London Museum archives, however, suggest that Harcourt not only knew that the Hoard had come from the City but had done his utmost to prevent this information leaking out. A few years later, he wrote in a private letter to the curator that 'no new acquisitions should ever be labelled as being found anywhere within the City of London, though a record of their place of origin should … be made in our private catalogue.'[21]

A successful extrication from a rather tight place[22]

In the event, to avoid protracted and costly litigation the issue was amicably resolved. A 'small selection … representative of the collection'[23] comprising 80 pieces was to be given to the City's Guildhall Museum, and the remaining parts, at the London Museum and the British Museum, were to have new labels stating that the collection was the joint gift of 'The Corporation of London and the Rt. Hon. Lewis Harcourt M.P.' The solution, readily agreed to by Harcourt and swiftly acted upon, was greeted with cheers by the Court of Common Council.[24] Steps were taken to put the jewels on display in the Guildhall Museum, but because of the war they were soon afterwards removed to a place of safety from air raids and remained outside London until the end of 1919.

Throughout the whole affair, the crucial question of the Hoard's provenance seems to have been either suppressed or overlooked. Seemingly no records were ever kept to identify the actual building on the site of 30–32 Cheapside, let alone mark the precise location of the Hoard within it, and any rights that the landowners, the Worshipful Company of Goldsmiths, might have had seem to have been entirely ignored. The one point upon which all were agreed was that the Hoard was found underneath a cellar, but what it actually looked like when it was unearthed remains a mystery to this day. Was there one box or several? Were the containers whole or damaged? Was the hole lined in some way or roughly dug? Evidently, the containers held no interest for the navvies, so any information that might have been gleaned to help identify the owner or discover more about the ways in which valuable jewels were stored and packaged in the seventeenth century has been lost.

Nearly sixty years after the thorny issue of ownership caused so much consternation, the Guildhall Museum and London Museum combined to form the Museum of London, and in 1976 the Hoard came back to the City in a new museum five minutes' walk from Cheapside.

The Cheapside Hoard was probably buried in an assortment of bags and boxes. Newspaper accounts of the find describe a wooden box, a casket with trays and drawers, and a leather bucket. Others suggest that the jewels were covered in soil or partly embedded in lumps of earth and most mention the poor condition of the pearls. Whether these fragments of bone and wood came from the surrounding soil, or, in the case of the fish vetebra, from a workman's sardine lunch, is unknown. Some particles of soil remain under the settings the stones and in cracks and fissures in the enamels.

A14068

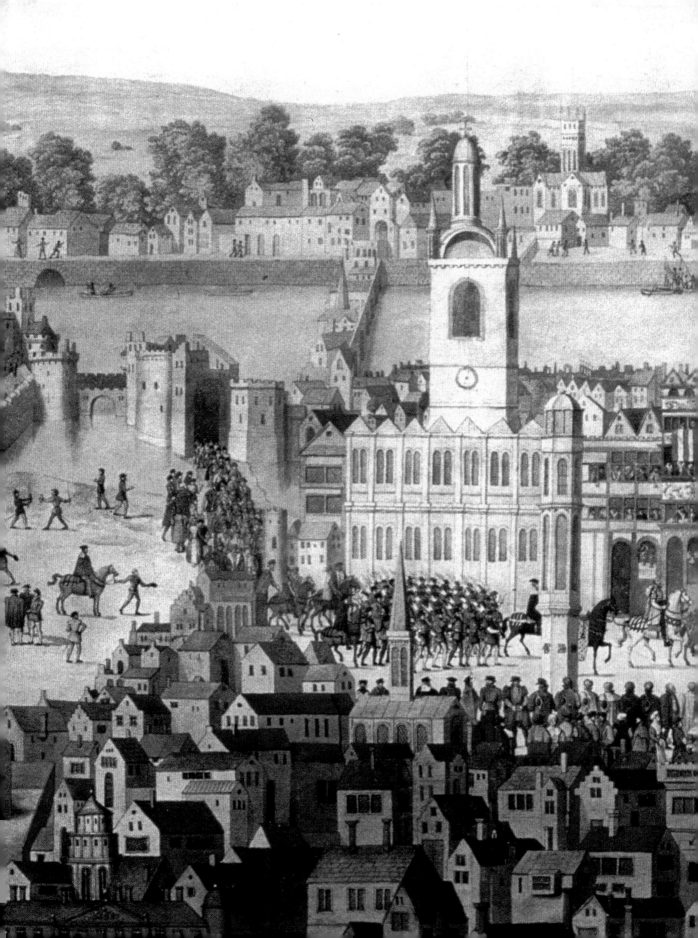

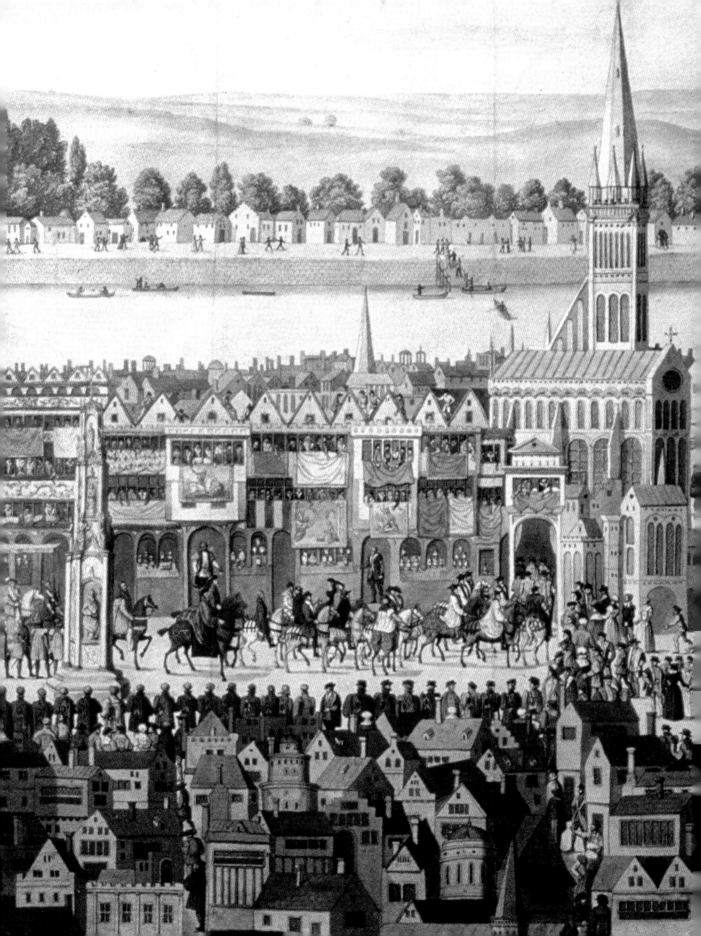

Cheapside

The Goldsmiths shops at London (in divers streets but especially that called Cheape-side) are exceedingly richly furnished continually with gold and silver plate and jewels. The Goldsmiths shops upon the bridges at Florence and Paris have perhaps sometimes been as richly or better furnished … but I may lawfully say, setting all love of my own countrey apart, that I did never see any such daily shew any so sumptuous in any place of the World as in London.

Fynes Moryson, 1617[1]

OF ALL THE STREETS in Tudor and Stuart London, none was more celebrated, none more widely known, than Cheapside, the principal market and thoroughfare of the City. The western branch, called Westcheap, running from St Paul's Cathedral to the Poultry, was not only broader than any other street in the capital but was especially renowned for its elaborate fountains, fair inns, merchants' mansions and luxury shops. From Monday to Saturday, street hawkers plied their wares and market traders sold poultry, milk, honey, vegetables, fruit, herbs and flowers. Water gushed from the fountains and citizens flocked to the shops for spices, haberdashery, ironmongery, millinery and all sorts of leather goods. On both sides of the street the timber-framed and jettied houses of four and five storeys created an impressive spectacle, but the real 'bewtie and glorie of cheapeside'[2] lay at its western end with the shops of the mercers and goldsmiths selling 'all sorts of coloured silks'[3] and 'gold and silver, plate and jewels'.[4] As one sixteenth-century writer put it: 'avarice raiseth Cheape things to the highest price, and in Cheapside makes nothing Cheape be sold.'[5]

previous spread This watercolour by Hieronymous Grimm (1780s) of a now-lost Tudor wall painting shows the coronation procession of Edward VI through Cheapside in 1547.

Society of Antiquaries of London, SOA 2916

Goldsmiths had a presence in Cheapside before the mid-fourteenth century, mostly at the south-west end near St Paul's Cathedral and their Company Hall in Foster Lane. But the business hub, between Old Change in the west and Bread Street in the east, was focused in one unified, timber-framed structure of four storeys, which the antiquarian John Stow described in 1598 as 'the most beautiful frame of fair houses and shops ... in England'. Built for Thomas Wood, a goldsmith, who was sheriff of London in 1491, its 10 houses and 14 shops were given to the Goldsmiths' Company and 'beautified towards the street with the Goldsmiths' arms and the likeness of woodmen, in memory of [Wood's] name, riding on monstrous beasts, cast in lead, richly painted over and gilt'.[6] The block was soon identified as Goldsmith's Row, and the name became so celebrated that it was later associated with the whole line of tenements and shops occupied by goldsmiths on this side of the street.

Carved and painted seventeenth-century sign from a house on the corner of Cheapside and Friday Street.

16337

By the early 1500s, the imposing line of goldsmiths' shops in Cheapside was so striking that one Italian traveller thought they were the 'most remarkable thing in London … in all the shops in Milan, Rome, Venice and Florence put together I do not think there would be found so many of the magnificence that are to be seen [here].[7] A hundred years later, the spectacle remained just as impressive. In 1594 the facades of Thomas Wood's original block were freshly painted and gilded and the numbers of shops occupied by goldsmiths in Goldsmith's Row had grown to 55, each identified with a colourful sign which, one commentator noted, began 'as the world did, with Adam and Eve'.[8]

By the late sixteenth century Westcheap was dominated by manufacturing and retail goldsmiths. A good number set up shop in Foster Lane and in the narrow alleys and streets nearby, but the majority settled on the south side of Cheapside in Goldsmith's Row and the adjoining streets leading towards the river. Goldsmith's Row was quite literally the 'shop window', the visible face of the trade, but behind the street frontage was a less glamorous world of workshops, vaults, counting houses, gilding chambers and storerooms: in effect, a goldsmiths' quarter bounded by St Paul's Churchyard and Old Change in the west, St Matthew's Alley in the south and Friday Street in the east. Over the years, buildings had sprung up to fill every available space, leaving a maze of alleys, narrow passages and yards. Most of the buildings were small and irregular in plan,

This detail from Hieronymous Grimm's 1780s' panorama of the coronation procession of Edward VI through Cheapside shows the shops of the goldsmiths in Goldsmith's Row. The goldsmiths' shops in Cheapside were perfectly placed to attract custom from the citizens, tourists, merchants, traders and dealers who flocked to the area each day.

Society of Antiquaries of London, SOA 2916

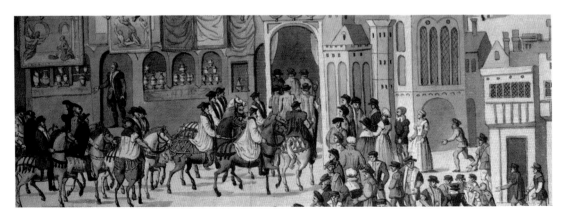

one or two rooms deep and two to three storeys high with garrets. Some were ranged around an open or partially covered court with one or more passages leading directly into the street. Others were accessed via a backyard or alley, and a few of the smaller premises had entries at first-floor level from a gallery or adjoining building.

Property disputes

The Goldsmiths' Company tried to keep an eye on business by concentrating as many goldsmiths as possible in a small area. They held the freehold for most of the houses and shops in Goldsmith's Row and each lease included a restrictive covenant which effectively barred the lessee from letting or sub-letting to any apart from a 'mere goldsmith'.[9] The Company tried to ensure that their properties were fit for habitation, but the lessors were responsible for general upkeep and day-to-day repairs. Problems sometimes occurred when a tenant stayed on after the expiration of the term of the lease and when leases for the same plot or property were shared. Further complications arose when two properties were knocked into one. In June 1610 Mr Martin was furious when his neighbour, Mr Williams, pulled down a partition which had stood between them for 18 years.[10] The Company was obliged to intervene to settle the dispute.

Sometimes relations between the tenants were so strained that the Company were forced to take drastic action. On 3 April 1600 they were faced with a particularly difficult situation when several goldsmiths in Cheapside complained about their neighbour George Langdale, who had set up a furnace in his cellar which 'he doth verie dangerouslie mainteyne and work'. It transpired that Langdale had tunnelled through his privie walls to vent the smoke into the street so that noxious fumes wafted through adjoining properties to his neighbours' 'great disquiet of mind'. This contraption and the relative inaccessibility of

the cellar posed a major fire risk which 'threatened thereby all the inhabitants of goldsmiths Row', but when Langdale was challenged about the upkeep of his furnace and the tunnels through his privie (toilet) walls he 'very obstinately [made] divers frivolous and idle observations'. He made matters worse by asking the Company wardens point blank whether his house was fit for a goldsmith to live in – 'Yea or No?' He then claimed that the Company had forced him to 'inhabit a house not fit to put a furnace in' and demanded that they should either find him somewhere better for his furnace or 'themselves stand to the danger of it'. As far as the Company was concerned, Langdale was entirely to blame and when he refused to remove the furnace he was sent to prison.[11] Another incident seven years later caused distress when John Hawes took advantage of his neighbour Edward Wheeler's absence in the country to break down the wall between them. He extended his own property by a few inches but, worse still, exposed parts of Wheeler's study 'wherein [were] divers writings' and other personal papers. Company officers inspected the damage and Hawes had to pay Wheeler 20*s* in reparation.[12]

Owners and occupiers

Although the estate records for Goldsmith's Row seldom describe anything above the ground-floor level, they do show that most of the houses and shops were split into smaller units, subdivided vertically and horizontally and occupied by more than one household or family. Cellars commonly under-spanned adjoining buildings and yards were often shared. Some residents owned or rented more than one property and the relationship between the leaseholders and freeholders was extremely complex. In 1651, for instance, the house known as the 'Halfmoon', held by Gervase Andrewes and his tenant, was sandwiched between the shop called the 'Flower de Luce' on the west (also owned by Andrewes) and another house at the

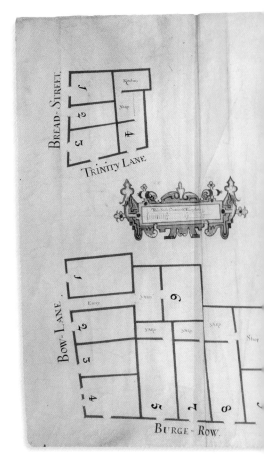

above John Ward's survey of 1692, showing the Goldsmiths' Company's property in Cheapside.

below Detail from the Goldsmiths' Company 'Rent' Book, 1610.

Worshipful Company of Goldsmiths

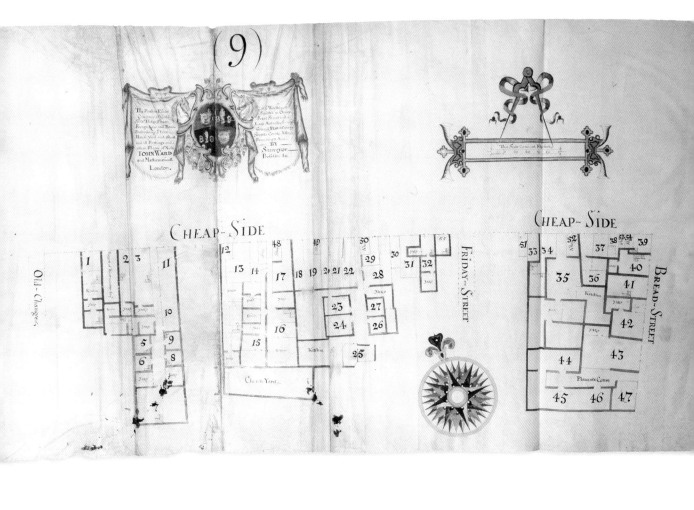

(9)

CHEAP-SIDE

CHEAP-SIDE

OLD-CHANGE

FRIDAY-STREET

BREAD-STREET

Church Yard

Cheapeside

mencement	Terme	Expiration	ffyne	Rent per annū	Present occupier	Donor
yeares from	Mihias 1632	Surrender of Taylors leaff	ffine included in Lot 80 for the ffine of this Shop		John Tayler	John Carbonell
y day 1593	ppℓ	Lady day 1618	ppℓ	hio mᵈ		
ømbℓ 1613	xxℓ	Midsomer 1634	xxℓ	idem reddit	william Taylor	

St Mathewes alley

o 1645	24 yeares	Mihias 1669	ℓ	53º 4ᵈ 3ᵒᵘᵗ		
somer 1606	ppℓy	Midsomer 1627	Tenn pound	hio mᵈ	John Selloes	Proper lande

sign of the Old Fox & Goose on the east (leased by Latham but belonging to another freeholder), and this shop 'lyeth under parte of the second shop of the tenement of Gervase Andrewes and under parte of the second shop of Raphe Latham'.[13]

One of the most helpful sources for Goldsmiths' Company properties in Cheapside is a leather-bound Rent Book dating to 1610.[14] This supplies the names of the tenants, a summary statement of their holdings, the date and duration of the lease, the amount of rent payable, the names of the current occupiers and, finally, the names of the donors and benefactors of the listed properties. For Cheapside, 84 principal tenants and 79 occupiers are recorded. A number held leases for more than one house or shop and, because leases frequently changed hands, there was an ever-changing pattern of occupancy. The lease terms were usually set at 21 or 30 years, though occasionally longer terms were granted. George Dalton was able to secure two neighbouring tenements, two shops and a stall for seventy years.

The Rent Book shows that many of the properties in Cheapside and Friday Street were held by the same family over a number of years. Walter Chauncey passed on the lease of his house and shops in Cheapside and Saint Matthew's Court with six tenements in Petty France to his brother and nephews,[15] and Gervase Andrewes bequeathed the indenture of his lease for his tenement and appurtenances in Goldsmith's Row to his son John, but left other family properties, including a newly built tenement in Hyde Park, to his wife.[16] But while some families stayed put, many goldsmiths moved up or down the street expanding or contracting their property holdings according to their means and business requirements.

Records show that some of the goldsmiths in Cheapside occupied or part-occupied the properties they rented, while others kept their working and dwelling houses separate. John Mabbe the elder (d. 1587) lived in Old Fish Street in the City, but had properties at the sign of the Leg and the sign of the

Cup in Goldsmith's Row.[17] He also owned the Tabard Inn in Southwark with six adjoining tenements, and acquired other properties from a fellow goldsmith in Totteridge in Hertfordshire. Goldsmiths were sometimes obliged to terminate their lease if there was no one able or willing to continue the family business, and in 1621 William Bereblock found that he had to sell the lease for his 'dwelling house and shop with their appurtenances situate together in Westcheape' so that monies could go to his son James and other children.[18]

Shops and workshops

The 1610 Rent Book provides scant information about property type beyond a simple name description. The term 'shop' is used 24 times, the word tenement on 57 occasions and there is just one entry for a shop with a counting house, cellar and yard. Sometimes it is clear that the tenements included a shop, but as this level of detail is generally lacking it is very difficult to know how many shops there were at any one time and who occupied them.

Fortunately, other sources provide clues about the appearance and internal spaces of the Goldsmiths' Cheapside properties. Of the four known pictorial views of sixteenth- and seventeenth-century Cheapside, the earliest and best is a watercolour of the Coronation procession of Edward VI in 1547. This image, dating to the eighteenth century but actually derived from a now lost sixteenth-century wall painting, offers a panoramic view of the south side of Cheapside. Even allowing for a certain amount of artistic licence the spectacle is impressive. Half-timbered gabled buildings of three to five storeys are decked out with colourful tapestries and painted banners with biblical and mythological scenes.[19] The shop windows, no doubt specially arranged for the occasion, are crammed with dazzling displays of plate. Goldsmiths stand proudly in their shop entries and hundreds of spectators, some propped

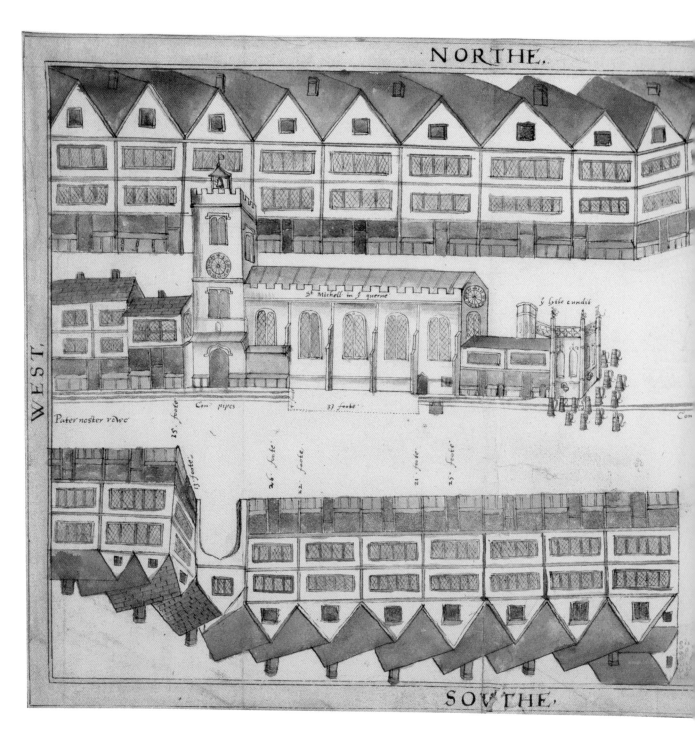

WEST.

SOVTHE.

St Michell in S querne

S lytle cundit

Pater noster rewe

Con pipes

15 foote

33 foote

13 foote

26 foote

22 foote

21 foote

23 foote

Con

Ralph Treswell's survey of the west
end of Cheapside, showing the
church of St Michael-le-Querne with
neighbouring shops and houses, 1585.

British Museum Print Room, no. 1880,1113.3516

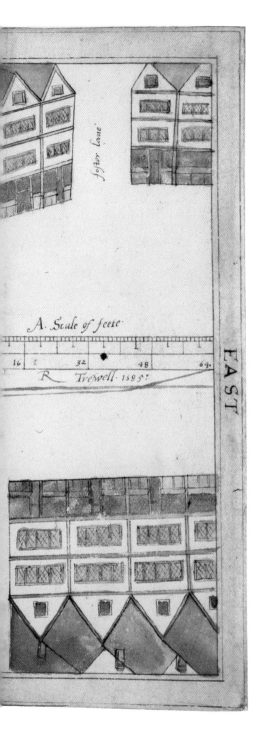

against a bolster or cushion, gaze through the open windows of the upper storeys. Faces peek out of the tiny garret windows, and several young men (perhaps apprentices) have climbed out onto the roof. Some facades are embellished with parapets and ornamental friezes but none of the distinctive, carved and painted signboards is shown.

The second image, a pictorial survey of properties at the far west end of Cheapside in 1585, is much more schematic.[20] It shows the parish church of St Michael-le-Querne, an island in the middle of the street, with the Little Conduit at its eastern end surrounded by large water cans. Foster Lane on the north side and Old Change on the south side, barely five or six feet wide, are both named. The buildings along Cheapside itself are depicted in a formulaic fashion, each three storeys high, with shops fronting the street and a single entry between two windows. The buildings vary little in width and most seem to have some sort of board or stall beneath the shop windows. Stalls or stallboards were a common addition to London shop fronts. Most were hinged or suspended from ringbolts and chains so they could be lowered to provide additional display space during the day and at night, levered up to cover the window like a security shutter. Stallboards also took the form of a trestle-type table with folding or detachable legs that could be dismantled for overnight storage, and some even had a lockable box underneath to house display equipment, awnings and protective covers for inclement weather and other articles of that sort. How many of the Goldsmith's Row shops were fitted with stalls is unknown, and there is just one reference to a tenement with two shops and a stall in the 1610 Rent Book.[21] The Cheapside shop rentals averaged between £2 and £5 per annum and it is possible that some goldsmiths rented a 'lock up and leave' stallboard even if they did not hold the lease of the shop itself. Evidence for the use of stalls outside goldsmiths' shops in this period is slight, though one account in 1631 describes the stall of the goldsmith Nicholas Pope in Fleet

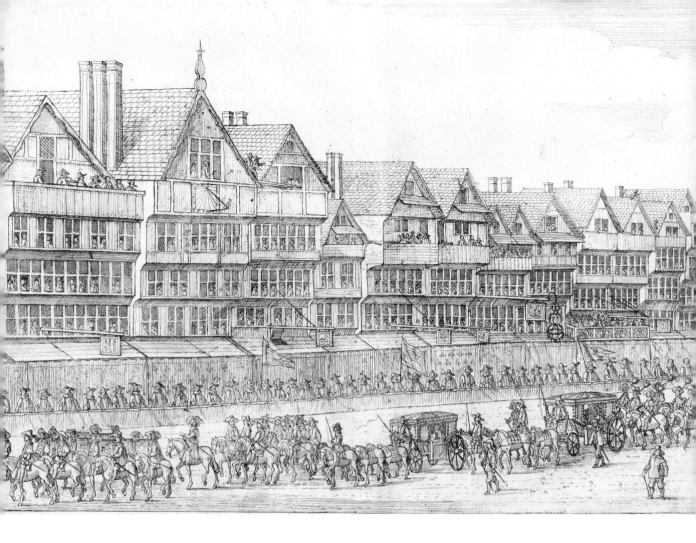

Bridge, Holborn, which attracted unwelcome attention from a shifty-looking customer who began to fiddle with a 'cheyne of pearles' (see p. 114).[22]

The last known depiction of Cheapside before the Great Fire of 1666 is a French engraving of the procession of Marie de' Medici in 1638.[23] The great width of the street is apparent, but the image also provides the clearest indication of the physical structure of the buildings with their brick and timber framing and glazed casements on the first and upper storeys.

Next to nothing is known about the shop facades in Gold-smith's Row (they are not shown in the 1638 engraving). Were they open or partly glazed? Were they protected by hinged or

The procession of Marie de' Medici along Cheapside in 1638.
Museum of London A18146

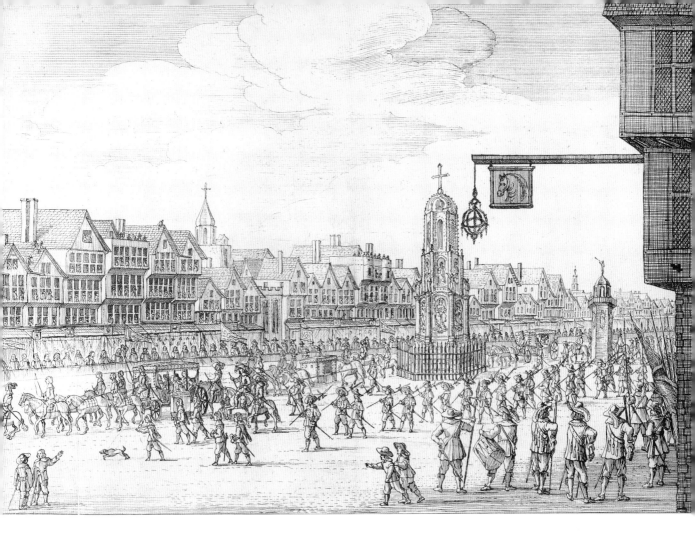

sliding shutters? Glazed windows are mentioned on just three occasions in the Rent Books between 1601 and 1631 when Thomas Langton and John Strong, who shared a lease, paid 3s 4d per annum for 'light', and Gaius Newman, next door but one, paid 12d per annum. Whether these were shop windows is uncertain. Good light and access to light were necessary for many trades and crafts, but for goldsmiths, jewellers and lapidaries it was essential. The need for good light was highlighted in 1556, when the chamberlain of the City of London was commanded to place lattices before the shop windows of foreign workers that opened on to public highways.[24] Although this measure was designed to restrict the trade of 'alien craftsmen' and stop

passers-by from venturing into their shops and placing orders, it met with limited success because the craftsmen needed good light to work. Ten years later, following another spate of complaints against immigrant workers, the authorities tried again, and this time to avoid trouble the chamberlain was ordered 'in a quiet manner' to ensure that 'all the foreigners and strangers born [were] to shut up their shop windows that they commonly keep open … with lattices before the same'.[25] In 1571, the Broad Street goldsmith Adrian Brokepotte, a native of Antwerp, obtained a special licence to 'open his shop windows and to work therein' provided that the openings were obscured by a lattice.[26] The City eventually relaxed its rulings and in 1587 foreign workers were told that their windows and doors had to be constructed in such a way to enable them to see clearly while 'people passing by may not see them at work and so as their wares and merchandises … give no open show'.[27] The window embrasures must have been divided: the upper half or third glazed and the lower section open, but covered with wooden shutters or latticework.

The shops in Goldsmith's Row were accessed directly from the street or via a small lobby or passage. Most were rectangular, long and narrow, 6–9 feet wide and sometimes as much as 24–35 feet long, with a single window fronting the street or alley. The very long shops were formed by knocking through party walls or removing partitions separating the front and back ground-floor rooms. The jeweller Roland Beresford had a narrow plot of this kind, 29′ 4″ in length and a mere 4′ 6″ wide, on the corner of Foster Lane and Cheapside.[28] Some shops were roughly square, 10–12 feet or so, with an entry midway between two windows or from a covered passage to the side. Others were L-shaped with a narrow street frontage that widened out at the back into a double room stretching across the entire width of the property and sometimes behind the back walls of neighbouring tenements on either side. The goldsmith Elston Wallis had an L-shaped plot just over 34 feet deep, with

an 8-foot-wide shop in the narrow section fronting Cheapside.[29] A few of the shops in Goldsmith's Row were wider along the street than they were deep, but this was only possible when an adjoining shop or house became available and the party wall on the ground floor was removed or knocked through. Hardly any of the shops were of uniform breadth or length because of irregularities in the timber framing, the placement of chimneys, furnaces, entries and stairs, and constant refurbishments and alterations made by the leaseholders.

Neighbourly disputes over rights of access, blocked light, leaking gutters and other property issues were common. Most were amicably resolved, but sometimes a quarrel escalated into a full-blown row and the Goldsmiths' Company was forced to intervene. In 1568 John Mabbe fell out with his neighbour William Denham over access to a little backyard behind Mr Denham's house and shop. Since neither was prepared to come to terms, the matter was referred to the Company. At a court meeting in November it was agreed that William Denham should have a bolt on his side of the door, while John Mabbe, upon giving adequate notice, 'should have free ingress egress and regress by and through the same door into St Matthew's Alley'.[30]

Fixtures and fittings

Detailed descriptions of household goods and stock-in-trade rarely extend to the fittings and tools in a shop or workshop. Phrases like 'working tooles as were belonging to a gold-smith: files, anvils, sheares, plyers, raspes and such like' or 'a pair of small bellows with other working tools for a small working goldsmith' are the rule.[31] The stock inventory for John Winterton's workshop in St Giles Cripplegate is slightly more detailed, with a parcel of silver and plate valued at £98 10*s*, one forging anvil, five other anvils, three forging hammers and other hammers, one screw plate, six iron stakes, two small ingots,

below left Touch needles or bars of known purity, alloyed with copper and silver, were used to assess the purity of gold alloys in the 'touchstone test'. There were 24 needles in each set, corresponding with the 24 carat fineness of gold. The needles showed the colour range of gold alloys available and the colour differences helped the assayer select the appropriate needle to match the colour of the sample. In the test, the gold article is rubbed on a black Lydian stone to produce a thin streak. Another streak is made alongside with a touch needle. The two marks are compared for a colour match – the origin of the phrase 'coming up to scratch'. The marks are then washed with a dilute solution of acid to dissolve the alloying metals. As gold resists all but the strongest acids, the carat purity can be assessed by comparing the two marks, which gave rise to the phrase 'the acid test'.

Worshipful Company of Goldsmiths

below right This early-seventeenth-century drawing of a jeweller's lens by François Pelgrim of Antwerp is included in an album of jewellery designs attributed to the Dutch merchant jeweller and London resident Arnold Lulls. According to the inscription, the paired-lens magnifier could be fixed to a beam and raised or lowered to the right focal length by means of a pulley and counterweight. Whether this sort of lens was actually used by London jewellers and lapidaries is unknown.

Victoria & Albert Museum, D.6 (24) – 1896

opposite Portrait of a Man with Ring and Touchstone, 1617, by Werner Jacobsz van den Valckert. According to the seventeenth-century cleric Thomas Fuller, 'Men have a touchstone to try gold, but gold is the touchstone whereby to try man.'

Rijksmuseum, Amsterdam, oil on panel, SK-A-3920

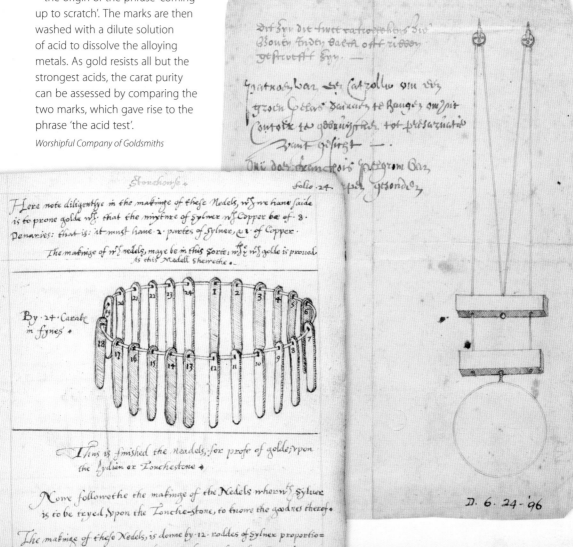

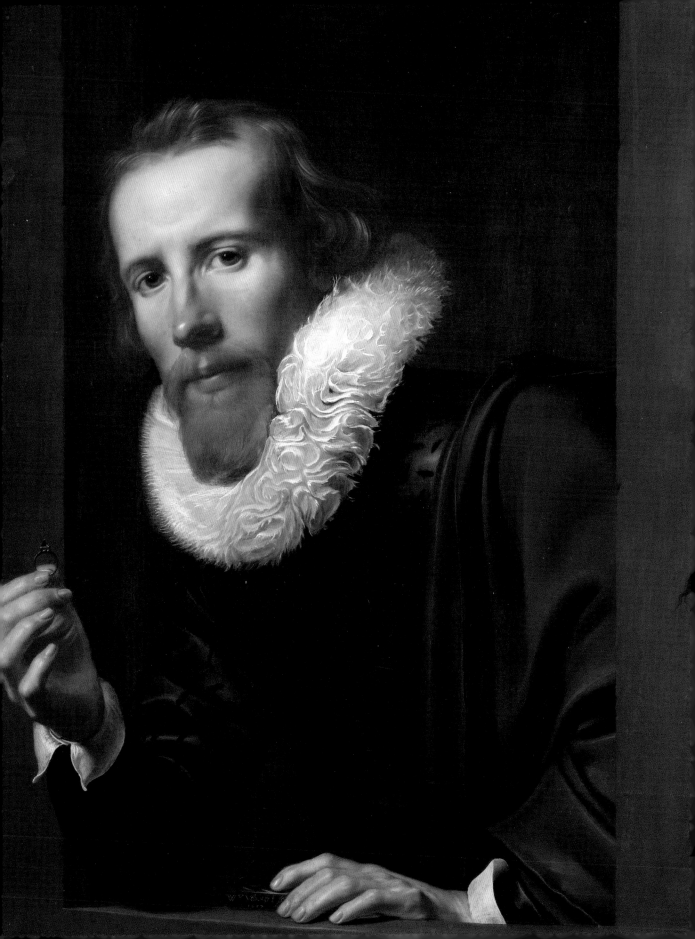

two pairs of casting tongs, one pair of organ bellows, shears, weights and scales and 'other working tools'.[32] Presumably, appraisers found the task of listing every scribe, blade, punch and hammer too onerous. Valuations are seldom supplied, and when they are given the tools are generally lumped together and a rounded figure of a few shillings or a couple of pounds tends to be given for the job lot. It is doubtful if the capital outlay in acquiring tools was high since most would have been handed down from generation to generation and from master to apprentice, but even if the intrinsic value of these items was slight the value to the craftsman was immense, and over a lifetime jewellers and goldsmiths must have amassed a large range of tools, which would have been adapted and customized to suit their own needs.

Packaging materials and display containers are rarely described in detail, and references to the types of specialist equipment used by enamellers, setters, mounters and gem-cutters are largely lacking. Even the inventory of the prominent Cheapside jeweller Nicholas Herrick, who apparently committed suicide by throwing himself from his garret window, contains very little information about the contents of his workshop – 'Item, certain saddle trees and other tymber vallewed at *6s 8d*' – and the only item of equipment in his shop is a 'ringe with needles' (presumably touch needles; see p. 34) valued at £4 10s. Presumably, Herrick, being 'of perfecte memorie ... but sicke in Bodie', had already ceased practical work and had passed on his valuable tools and equipment to friends and family before he drafted his will in 1592.[33]

Inventories seldom mention lathes, workbenches and draw benches because these items were probably regarded as fixtures rather than removable fittings. There is an oblique reference to a mill in papers relating to the theft of a large diamond and other stones from the Portuguese prize vessel *Madre de Dios* in 1596. Some of the stones were smuggled to London and after an intensive search these were traced to Hannibal Gamon's house

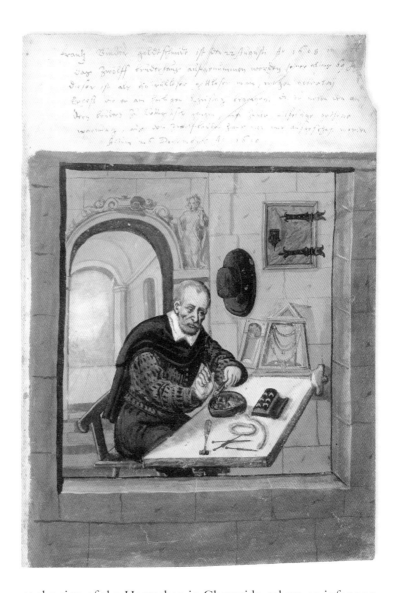

Goldsmith in the *Landauer Habsbuch* by Franz Binder, 1608.

Stadtbibliothek Nürnberg, Amb. 279.2. fo. 76 recto (Landauer 1)

at the sign of the Horseshoe in Cheapside, where an informer reported that they were being cut 'in a study on the second floor of his house'. A trap was set to waylay the Dutch cutter, who 'may be apprehended in the morning as he cometh from his house to work, and so may be accompanied by some fit person to the place where it remaineth'. The cutter was to be charged with 'cutting a ruby or carbuncle of great price', and the agent tasked with trying to locate the diamond said that he did not think it would be 'ready for the mill as soon as it was thought'.[34]

Mills are also mentioned in relation to a dispute between the Cheapside jeweller Humphrey Beddingfield and William

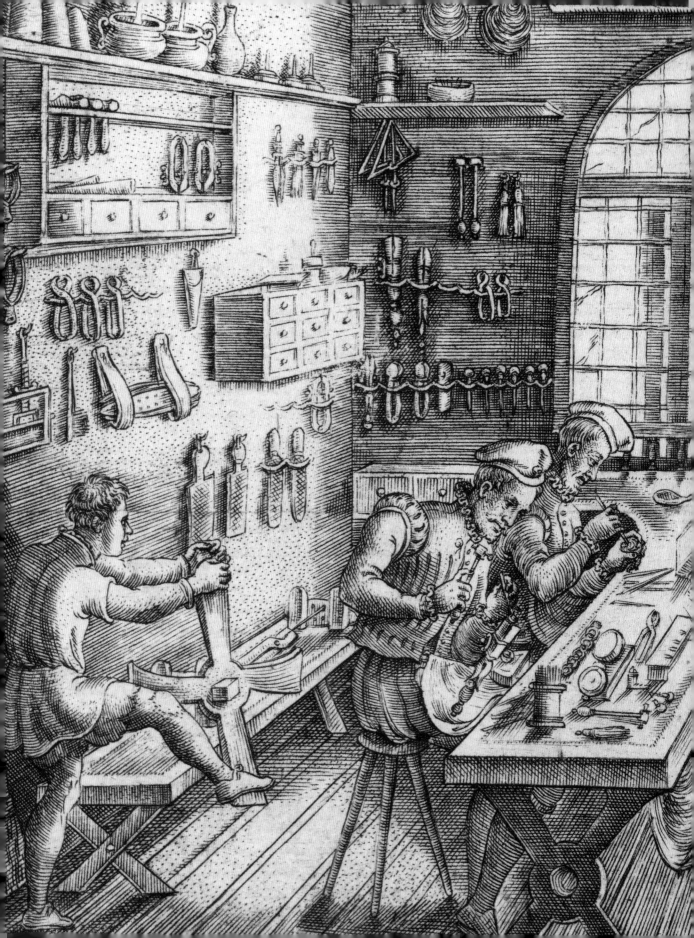

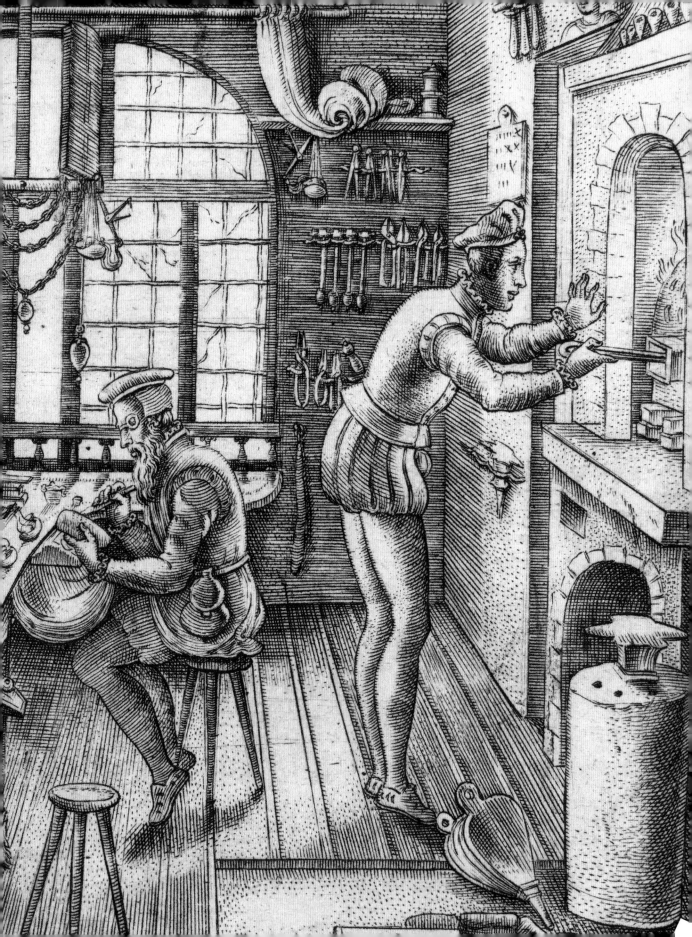

de Flyes, a diamond polisher, whose goods were listed in a brief schedule in March 1633. De Flyes was clearly living in a rather simple fashion with very little in the way of furnishings, just his bed and bedding, one trunk, 22 pictures (which suggests that he might have been dealing in paintings at the same time), thirteen diamonds and 'two working mills to pullishe dyamonds'.[35]

Although there are no contemporary views showing the inside of London goldsmith jewellers' shops, their basic layout was probably similar, if not identical, to illustrated examples from Continental Europe. These show some sort of counter placed near or directly below the window, with assorted bags and display boxes for jewels. Loose gems nestle in drawstring bags and some are set in wax-filled boxes. Rings are sometimes fastened to paper or threaded on to rolls of parchment. Chains, bracelets and pendants hang from a horizontal bar across the window, and other jewels, some in the process of manufacture, are scattered across the workbench. Jewellers either serve their customers through an open window, or are intently focused on their work.

To a large extent the function and layout of a shop or workroom was influenced by its size and position in the building. Some of the Goldsmith's Row shops were so tiny that the window took up the entire street frontage. Others were just wide enough to accommodate a window and a door, but were so narrow that virtually all of the usable space was taken up with the entry passage, and these were sometimes described as 'little shops' to distinguish them from the main or 'great shop' behind. If a shop was really small, customers were served through the window or across a counter strategically placed to form a barrier between the public and private space. The amount of stock on show was probably limited to a few boxes and display cabinets, with the rest stashed safely away under the counter or stored elsewhere on the premises. It is possible that the smallest shops were used by manufacturing jewellers and goldsmiths, who undertook most of their work in backroom

previous spread Engraving showing the interior of a jeweller's workshop by Étienne Delaune, 1576.

British Museum, PD 1951–11–20.5

workshops, leaving the front window as a small display area to entice customers inside.

As far as possible shops were fitted out to suit the needs of the business, whether that was retail or craft focused, or a mixture of both. Some jewellers made work on the premises while others manufactured off-site in various locations around the City. Thomas Sympson, in Cheapside, seems to have employed a team of specialists: stone cutters, enamellers, setters and mounters, but undertook most of the assembly work himself (see p. 68). The shops of manufacturing jewellers invariably doubled as a workroom, and accounts suggest that the functional distinction between a shop and workshop was often blurred. In all likelihood, simple repairs or alterations were done in the shop while the technically challenging tasks and those requiring tighter security took place in a back room or upper-floor workshop, away from prying eyes. How much space was used for retailing is uncertain but it is probable that some of the shops were fitted out as a kind of showroom for more than one retailer.

Some of the best evidence for jewellers' shops and workshops lies outside Goldsmith's Row. One unnamed jeweller in Hornchurch in Essex had a substantial and well-furnished property, with a clock and harpsicord, looking glasses, pictures, tapestries and carpets. The two parlours and bedrooms were filled with all sorts of chests, two deal trunks and various cupboards, and the workhouse, next to the buttery and kitchen, contained a 'paire of bellowes for an organ, two irons and a hoope, two paire of tongs one Ingott or Anvill and hammer with other utensils', which was valued at £1 10s. The shop had a counter with a flock bed and bedding for the apprentice, with two presses (cupboards), a chair, an iron chest, scales and weights, one old table and 'some working tools' valued at £5. The stock-in-trade included over a hundred rings, dozens of bracelets, chains, crosses and pendants set with all sorts of precious stones; over a thousand cut and polished and rough diamonds packed and

protected in seventeen wax-filled boxes; a number of rubies and other coloured stones; three parcels of pearls in three boxes; eleven 'stones in a paper'; strings of pearls and parcels of gold and enamel rings.[36]

The 1639 inventory of the shop and house occupied by the French jeweller Ezekiel Maior in the precinct of Blackfriars is even more informative.[37] Maior's property included a cellar with six wooden tubs and 'certaine old lumber', and his well-equipped kitchen contained gridirons, dripping pans, brass kettles and pots, skillets and spits, fire tongs, shovels, a warming pan, brass mortar, bellows and 'smale brasse thinges'. The kitchen furniture comprised a round table with three wooden chairs, a cupboard with assorted plates and saucers, thirty large and small pewter dishes, a ewer and basin, a couple of flagon pots, two dozen porringers and seven pewter candlesticks. There was a small yard with a lead cistern behind the kitchen. The hall, probably on the first floor, had a fireplace with andirons, shovels, tongs and a pair of bellows, and was comfortably furnished with a wicker chair, six joint stools, a table, cushions, a court cupboard, candle sconces and nine pictures. Behind or possibly above were two chambers, one better furnished than the other, with feather beds, tapestry coverlets and various chairs and stools. The larger room had a fireplace and a window with curtains. The garret room, possibly occupied by Maior's journeyman or apprentices, contained three more beds, three wooden chests and an 'old chest'.

The contents of the shop, valued at just 20 shillings, are summarily described as 'all the tooles in the same belonging to a jewellers trade', but fortunately rather more information is given about the 'Compting' or Counting House, a room usually found at the back of a shop or workshop on the ground floor. These rooms often doubled up as a private workshop-cum-office: a discrete space where a valuable jewel or precious stone could be appraised and a space for clients to view a wider and more

from top: A14275, A14354, A14339, A14341, A14343

select range of stock. Ezekiel Maior's counting house contained a cabinet with 'some enamel and some working tooles' and various books and ledgers. There was a box filled with eight diamonds and other small stones, several loose jewels, mostly pearl- and gem-set pendants and a string of pearls. Possibly on a table, though this is not specified, were three 'glasses' or display cabinets. The largest was filled with 'certaine jewells and other stones' valued at 50*s*. The middle-sized glass contained 'certaine pearles and cornelian rings' worth £5, and the smallest held various chains, cornelian and amber beads and a small box with a gemstone, also valued at 50*s*. In addition, the counting house contained 101 ounces of plate valued at 4*s* 10*d* per ounce, with six pairs of sheets, napkins and other linen and nine pairs of bellows. The whole estate was appraised at £133 4*s*.

The word 'compter' was also used to denote a lockable plate or jewel cupboard, of the sort owned by the jeweller Elias Gason, which had three sets of drawers, three pairs of balances and a pile of iron and gold weights. Gason also had one 'greate glasse' holding plain gold and enamelled rings of various weights and qualities, all sorts of small silver trinkets (not specified), six gold 'ropework jewels', twenty-four gem-set rings, six pairs of earrings, thirty gilt rings, six gilt bodkins and 'severall sorte of loose stones'. Another glass held pieces of coral, turquoise, a 'fowle jewell', four agate beads, some spoons and other small things. There is no evidence of a workshop or tools and so it is possible that Gason was a retail jeweller or had a workshop elsewhere. The household contents suggest a modest-sized property, probably with a kitchen directly behind the shop and a parlour with a bedroom on the floor above. Gason had several books and his bedroom was furnished with a large cypress wood chest, a large box with drawers, a cabinet and several small boxes.[38]

Records suggest that many goldsmiths used their cellars and garrets for storage or workrooms. Cellars were particularly useful as they were commonly lined with stone or brick and

therefore provided some measure of protection against fire. They were relatively secure spaces and were conveniently sited along, or close to, the street frontage, with internal access via a short flight of stairs or trapdoor. A few were set further back underneath a yard or a separate range of buildings behind. Some goldsmiths had more than one cellar, or a single large cellar that underspanned the entire ground floor. It was also common for cellars to run underneath adjoining properties. In 1608 the Cheapside goldsmith Hannibal Gamon[39] was dismayed to find that his neighbour had breached his cellar wall and had removed a considerable quantity of soil from under his house. The Company wardens and carpenter were summoned to inspect the damage, and they came to the conclusion that, although Mr Gyllam had increased the size of his cellar without permission, the work had progressed too far to reinstate the original wall. After a certain amount of debate, the Company said the structure could remain on the understanding that Mr Gamon was given enough money and timber to make any necessary repairs.[40]

The garret or attic rooms provided extra storage space and many doubled up as bedrooms for apprentices. A number of the Goldsmith's Row leaseholders converted their garrets into 'cock-lofts' or gilding chambers and Company accounts suggest that they were placed on the south side where they had access to the best light with larger windows that opened out on to a flat or low-pitched roof. Additional space was sometimes gained by recessing the attic at the back of the property to provide a roof-top walk, and several of the Goldsmith's Row properties had access to flat lead-covered roof spaces. Although the lofty position of these working areas had distinct advantages, the weight on the roof trusses and floor joists was considerable, and Richard Hanberrie at the sign of the Maidenhead in Cheapside was forced to dismantle the gilding house in his attic because its weight was causing structural problems.[41]

30–32 Cheapside

Although the exact find spot of the Cheapside Hoard is unknown, it was evidently buried underneath the floor of a cellar on the site of 30–32 Cheapside. The cellar survived the devastation of the Great Fire and the post-fire rebuilding in 1667 and the Hoard remained hidden until the buildings were pulled down, and the floor was finally broken up, by the workmen in 1912. Newspaper accounts in 1914 suggest that the cellar was set 16 feet below the street, and it is interesting that recent archaeological excavations in the vicinity have uncovered the footings and remains of other similar brick-lined structures at the same depth. Sadly there is no archaeological evidence for the buildings on the site of 30–32 Cheapside because the post-1912 building had extensive basements.

Fortunately, plans of pre- and post-fire tenements have survived in the Goldsmith Company archives, and these show that the buildings covered a substantial plot of approximately 2,485 square feet (230 m²). Precise correlation between the pre- and post-fire tenements, however, has proved difficult. Until the eighteenth century, few buildings were numbered so properties were mostly identified by a distinctive name or sign, often combined with some sort of reference to the location. When the goldsmith John Ledham's property was described in an inventory in June 1581, for instance, he was recorded at 'the signe of the cluster of grapes in foster lane in London next and unto cheapesyde and … next unto the signe of the rose'.[42] Some signs, rather like a modern-day logo or brand, came to be associated with an individual or business. Others were adopted because they had personal significance – the Lombard Street goldsmith Job Bolton, for example, had a painted sign depicting a Bolt and Tun. But signs were not always a reliable or straightforward guide to ownership since many were swapped or used by several occupants over long periods.

Unfortunately, the particular signs used for the Cheapside

Hoard tenements are unknown, although the neighbouring property to the east was called the Wheatsheaf. This means that the Hoard properties can only be distinguished from their neighbours by careful reading of leases and title-deeds, and noting down the names of the leaseholders and tenants. The multifarious tenures are so complex, however, that it is difficult to get even a basic idea of the size, shape and arrangement of the buildings, let alone who lived in them. What at first seems to be a straightforward leasehold agreement with a single tenant, suddenly changes when the interior is modified, if the lease is shared among several tenants, or if adjoining properties are merged. Where there was but one shop there are suddenly two, and vice versa. What was once an entry passage for one property becomes part of a room for another. Partition walls went up and down. Cellars were enlarged and contracted. The situation becomes even more complicated when a goldsmith dies and his widow re-marries, keeping the original lease under her own or her former husband's name. For instance, one of the buildings on the Hoard plot was leased by Joan Wheeler, the widow of William Wheeler, a prominent goldsmith. Shortly after William's death, Joan married John Bonner who had a workshop elsewhere in the City. Joan continued to hold the leases for properties rented by William and sublet the building that she shared with Bonner to Francis White and Richard Taylor.

The best evidence for the pre-fire buildings dates to 1652. Nothing much is known about the plot to the west (later number 30), except that it comprised a house with a shop. Fortunately rather more is known about the premises to the east, and by piecing together information from rent books, title-deeds and other documents, it seems that there were three buildings on this plot, aligned north to south and separated by two large yards paved with Purbeck stone.

The five-storey property, fronting Cheapside, had a 'divided shop' with a combined street frontage of 15′ 3″ tapering to 11′ 3″ and a depth of just over 14′. Part of the shop was set over a cellar

Diagram showing tenements on the site of 30–32 Cheapside, redrawn from a lease of 1652.

CHEAPSIDE

no. 30 nos 31/32

SHOP

HOUSE

15′ 3″

14′ 3″

PASSAGEWAY

CELLAR

9′ 6″

'DIVIDED'
SHOP AND
HOUSE

11′ 3″

YARD

22′

7′

13′

CELLAR,
SHOP,
HOUSE

22′

FRIDAY STREET

TWO ARCHED
VAULTS

7′

CHAMBER
OVER SHOP

YARD

7′

'DIVIDED'
WORKSHOP
AND HOUSE

ST MATTHEW'S ALLEY

and part ran underneath the adjoining tenement to the west. One of the shops, about the size of a modern tobacconist's kiosk, had a street frontage of 6′ 6″. A staircase in the southeast corner lead to a hall and closet on the first floor, and these rooms were set partly above the eastern part of the shop and partly above another shop set a little further back. The next floor had a kitchen and chamber, and there were two more chambers above. The fifth-storey garret held two more chambers with a sort of mezzanine, incorporating a cockloft or gilding house. As very little light would have reached the lower storeys, the workshop was placed at the top of the building on the south side to gain maximum daylight throughout the year.

The next building to the south was much smaller, comprising four rooms with a parlour and kitchen on the ground floor, and two chambers and two closets on the second. One closet jutted out over the front yard and the other jutted out over the back yard to the south. Behind this lay another yard and another three-storey building which in turn backed on to St Matthew's Alley. This had a 'divided workshop' on the ground floor, a chamber above and chamber in the third storey with a 'skye light' and a 'flat frame of lead' – a flat lead-covered roof or parapet. Over the back of a shop in Friday Street lay another second-floor chamber, which was accessed by its own staircase from the back yard.

Underneath this entire plot lay five cellars. Along the Cheapside frontage and lying underneath the shops was a large cellar 20′ 4″ north to south, and 8′ or so wide. Another larger, measuring 13′ east to west and 22′ north to south, underspanned the first yard and the middle building. There were two brick-lined arched vaults below the second yard and there was yet another under the southernmost building, though no dimensions or details are supplied. The Cheapside Hoard could have been buried under any one of these cellars by any of the tenants or under-tenants living or staying in the properties during the first half of the seventeenth century.

Trading places

> It is a thing that every man's eye meets with as he passeth up
> and down, that the Goldsmith's Row, in Cheapside, which was
> ever held a great ornament to the Citye, should now grow up
> intermixed in a broken fashion with shops of meaner trades,
> which is yet worse than if it had been with houses of habitation
> only.
>
> Privy Council, 1622[1]

UNTIL the early seventeenth century most of the inhabit-
ants of Goldsmith's Row were goldsmiths or had some
connection with the trade, but during the reign of James I
the make-up of Goldsmith's Row began to change. More and
more space was given over to retail outlets of various kinds,
and goldsmiths' properties were increasingly leased or sublet
to others. The trade began to expand and disperse, and many
goldsmiths set up 'remote' businesses beyond the confines of
Cheapside to avoid the high rents and improve their business
opportunities. A few relocated to Lombard Street, the second
most important centre of the trade; some moved across the
river to Southwark, but many moved west to Holborn, Fleet
Street and the Strand to be nearer the court at Whitehall and
the wealthy patrons and customers whose mansions lined the
route from the City to Westminster.

These changes created a number of problems. There was
a legal issue because a fourteenth-century statute, which was
still in force, decreed that 'none which claim to be of the
mystery of goldsmiths should keep shop save in Cheapside
to the end that wen [one] might see that their wares be good
and covenable [suitable]'.[2] There was a social issue because

following spread The London Metropolis,
by Braun & Hogenberg, Cologne,
1574 edn. This bird's-eye view shows
the twin-sister cities of London and
Westminster, with Southwark, a
distinct urban centre in its own right,
on the south bank of the Thames.
With a population of some 200,000
by the end of the sixteenth century,
London was the largest and wealthiest
city in the country.

29.147/1

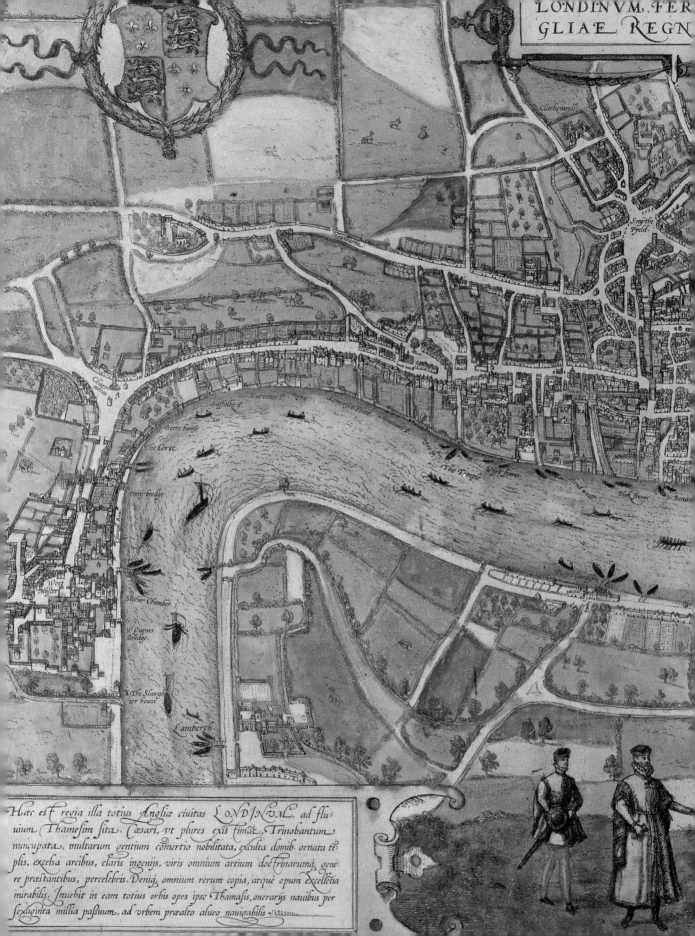

Clarkenwell

Smythe
Fyeld

Holburne

Suffolke P. Duresme P. Somerset Place

Beere house

The Temple Why Freres

The Corte

trent bredge Blak Freres

Lamberth Mars

West
Mynster

Sterrar Chamber

Y Quenes
Bredge.

X The Slaugh
ter howse

Lamberth

Hæc est Regia illa totius Angliæ ciuitas LONDINVM, ad flu=
uium Thamesim sita. Cæsari, vt plures existimāt, Trinobantum
nuncupata, multarum gentium cōmertio nobilitata, exculta domib. ornata tē=
plis, excelsa arcibus, claris ingenijs, viris omnium artium doctrinarumq, gene=
re præstantibus, percelebris. Deniq, omnium rerum copia, atque opum excellētia
mirabilis. Inuehit in eam totius orbis opes ipse Thamasis, onerarijs nauibus per
sexaginta millia passuum, ad vrbem præalto alueo nauigabilis.

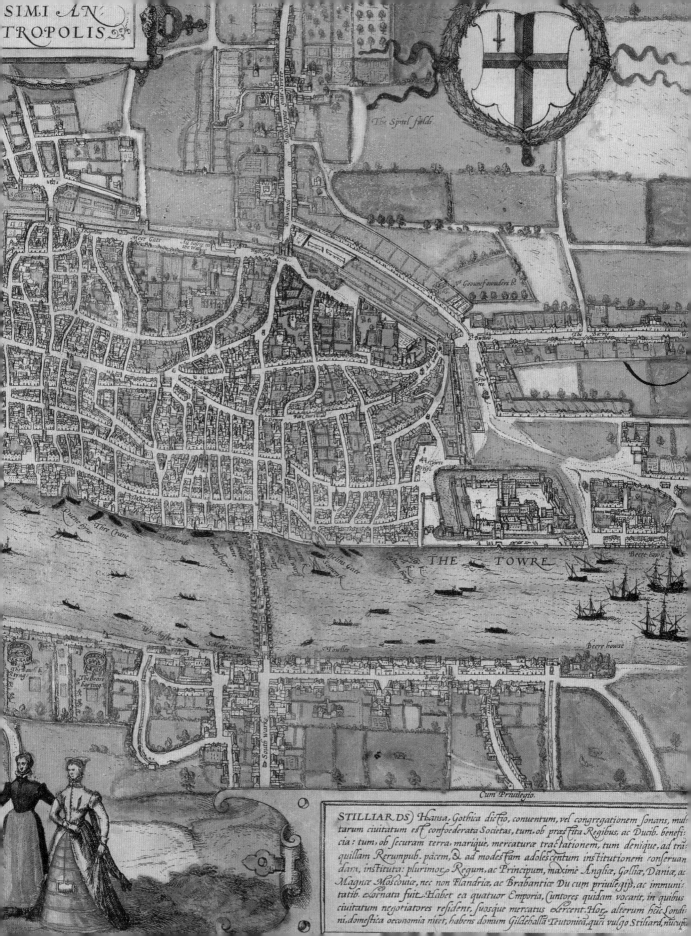

SIMI AN-
TROPOLIS

The Spitel fields

The Spritel fields

ye Goumesowuders P.

The Barre

S. Batton

Moor Gate

ye house in
the Wall

Moor
fee

ye Towne
Ditch

THE TOWRE

Beere howse

Beere howse

South warke

The Bowl
tying

The Beare
bayting

S. Mary overs

S. Towler

Battle bridg

Cum Privilegio.

STILLIAR DS) Hansa, Gothica dictio, conuentum, vel congregationem sonans, mul-
tarum ciuitatum est confoederata Societas, tum, ob prestita Regibus, ac Ducib. benefi-
cia: tum, ob securam terra, marique, mercaturæ tractationem, tum denique, ad tran-
quillam Rerumpub. pacem, & ad modestam adolescentum institutionem conseruan-
dam, instituta: plurimor. Regum, ac Principum, maxime Angliæ, Golliæ, Daniæ, ac
Magnæ Moscouiæ, nec non Flandriæ, ac Brabantiæ Du cum priuilegijs, ac immuni-
tatib. exornata fuit. Habet ea quatuor Emporia, Cuntores quidam vocant, in quibus
ciuitatum negotiatores resident, suosque mercatus exercent Hor, alterum hîc Londi-
ni, domestica oeconomia nitet, habens domum Gildehallâ Teutonicâ, quâ vulgo Stilyard, nucupa

the fine houses in Goldsmith's Row started to show signs of neglect and Cheapside began to lose its appeal as a high-class shopping destination. And, perhaps most serious of all, there was a trade issue because the movement of goldsmiths away from Cheapside seriously weakened the Company's control over its members and provided opportunities for 'strangers' (immigrants) and 'foreigners' (inhabitants who did not have citizenship), as well as those 'inexperienced and unskilful in [the] misterie', to gain a competitive edge.[3]

James I was so concerned that the beauty and lustre of Cheapside had been tarnished that he asked the Goldsmiths to 'consider … some fit course for insuring that the shops in Goldsmith's Row shall be inhabited by goldsmiths only'. Yet there was little improvement. Land values rose and rents continued to increase. The goldsmiths who had already moved away from Cheapside were not keen to return and many of the new occupants of Goldsmith's Row were happily settled and wished to stay put. By 1623 so many milliners, perfumers, haberdashers, stationers and apothecaries had crept in to sully the appearance and uniformity of the Row that there were complaints that the street was 'intermixed in a broken fashion with shops of mean trades, which is yet worse than if it had been with houses of habitation only'.[4]

The situation was so serious that the Privy Council and lord mayor added their weight to the campaign; yet, despite their efforts, the number of goldsmiths in Cheapside continued to decline. A long list of names of 'such persons as were thought fitt' to take houses and shops in Cheapside was drawn up by the Company and this was eventually whittled down to twelve goldsmiths, who were asked to move to Goldsmith's Row. A few days later the twelve were summoned to attend the lord mayor and Court of Alderman. William Wheeler agreed to move but most, like Nicholas Pope in Fleet Street and Edward Green in the parish of St John Zachary, refused to budge.[5]

Portrait of John Lonnyson, Anglo-Netherlandish school, oil on panel, 1565. Lonnyson, the son of an immigrant goldsmith from Brabant in the Spanish Netherlands, received the freedom of the Goldsmiths' Company in 1551. He obtained the leases of two shops in Cheapside in 1552, but in 1568 he moved to new premises at the sign of the Acorn, further down the street.

Worshipful Company of Goldsmiths

Drastic action was needed, and in 1624 the Goldsmiths' Company brought their grievances to Parliament. Two petitions were submitted to highlight the problem of the shops in Goldsmith's Row as well as the sale of gold and silver, jewels, pearls and precious stones, by merchants and others lacking the necessary experience and expertise. After some debate, the bills were passed to the House of Lords, and over a hundred members of the Company swarmed into the Painted Chamber to hear the reading. There was a terrific hubbub and their lordships, 'finding fault that so many gathered there', refused to discuss the matter further until the Company limited their number to just 6–12 representatives who could plead their case.

It was a difficult situation because the Crown had one agenda and the Company another. The Crown's primary concern was to return Cheapside to its 'former state and lustre', but the goldsmiths who had settled elsewhere were no longer prepared to pay a premium to live and work in Cheapside. They had legitimate concerns. They argued that they had been forced to settle in 'other streets, lanes and places in and about the City and suburbs' because there was simply no room in Cheapside, and now they had put down roots elsewhere another move would result in their 'utter undoing'. Besides, there could be no quick solution to the problem, because the present tenants of Goldsmith's Row who were not goldsmiths needed six months' notice to vacate the properties.[6]

The Company was anxious to retain and extend its control over the trade, but it was also sensitive to the concerns of its members. How could the matter be resolved? Clearly some action was called for and after a period of stalemate the Privy Council introduced measures to evict those of 'mean trade' and imprison those who refused to leave. Unfortunately this policy simply exacerbated the problem and before long the leaseholders found themselves without tenants or rental income. As the Goldsmiths' Company woefully reported, the 'highe row of Cheappe [was] exceedingly decayed and many of the howses and shoppes there were shut up'.[7]

Although there was another attempt to encourage goldsmiths back to Cheapside in 1634, it soon became clear that the orders from the Privy Council were neither workable nor sustainable, and eventually market forces and the need for space won out. The process of change was difficult for freeholders and tenants alike and the Company records are littered with their protests and grievances. In 1635, for example, Godfrey Reeve (a member of the Company but actually working as a haberdasher) had obeyed the order and 'removed himself' from the house and shop on the corner of Cheapside and Friday Street to the great 'vexation' of his landlord, Walter Chauncey, goldsmith,

who now had to pay the annual rent of £36 to the Goldsmiths' Company himself. Chauncey was particularly hard hit, because he leased several properties in the Row and had other property holdings in the City and was naturally furious that he 'now holdeth a house and shop shut up' without any prospect of finding another goldsmith to take it on. As a result, he refused to accept the key from Godfrey Reeve until he received at least part of the annual rent due to him.[8] Reeve was naturally upset that he had to pay rent for property that he was no longer able to occupy, and had to find somewhere else to practise his trade. Chauncey was not the only one with troubles. In May 1638, the executors of Mr Somers's estate could not find a goldsmith to take on his house in Goldsmith's Row so they asked the Company to withdraw the restrictive clause that the house should be occupied by a goldsmith only. Instead, they proposed that the new occupant of the house would 'so provide for the state and beauty of Goldsmith's Row that the shop, and the back part thereof, shall not during the said term be let or converted to any other use whatsoever, but only for a goldsmith's shop'. Their request was granted.[9]

The Goldsmiths' Company was so anxious to keep goldsmiths in Cheapside that they even considered limiting entry to the livery (a higher position in the Company) to shop-keeping and working goldsmiths who were prepared to relocate to Goldsmith's Row. They also extended the lease terms from the usual 21 years to 38, 70 and sometimes even 99 years.[10] Just before the outbreak of the Civil War in 1640, however, fifteen shops were still occupied by 'mean trades' or empty, and when the Great Fire swept away the entire street in 1666 the Cheapside shops were no longer a glittering jewel in the City's crown.

The extent to which the Hoard properties were occupied by working goldsmiths and those of 'mean trade' is unclear. From 1590 to 1666 there were at least 18 principal tenants. Many were members of well-established goldsmithing dynasties such as the Gossons, Wheelers, Taylors and Sympsons, who tended to hold

leases for long terms. Others, mostly undertenants, stayed for a year or so before moving on, and there were probably many more who took up residence for a short period, or worked away in a back room, leaving no trace in the records. From the limited evidence available, it seems that the brothers Francis and John Sympson, William Wheeler, his widow Joan and her new husband John Bonner, variously occupied the house and shop on the site of 30 Cheapside. Francis and John Sympson were royal jewellers of some repute. William Wheeler was a retail and possibly also a manufacturing jeweller, specializing in rings, and the leases suggest that he had moved to Cheapside in 1622/23.[11] After William's death, Joan Wheeler was the principal leaseholder from 1630 until the Great Fire and for much of this time the house and shop were sublet to the goldsmith Francis White.[12] Bonner evidently kept his own shop in the Poultry after his marriage to Joan, because between 1640 and 1660 various rings, hatbands and buckles were removed from this location for assay.[13]

The 'divided shops' and the three houses on the site of 31–32 Cheapside also had a succession of tenants, including the father and son Gaius and Gabriel Newman, James Gosson, Andrew Parker, Roger Foster, Thomas Covell, Thomas Hodges, William Taylor, John Davenport, Christopher Rogers and possibly also Thomas Sympson and John Mabbe the younger.[14] Gaius Newman seems to have occupied the property from 1596, when he took out a 21-year lease; the property passed to his son Gabriel after his death in 1614.[15] Evidence for Gaius's work is extremely slight, though one record in 1578 suggests that he was buying topaz for jewels from George Towers (Toers).[16] Gabriel Newman had extensive property holdings in Redcross Street, Addle Street and Jewin Gardens, and the records suggest that he was a merchant goldsmith who spent much of his time overseas.[17] Roger Foster was certainly a tenant by 1613 and he renewed his lease in 1618 for a further term of 21 years,[18] and took over another lease from Thomas Covell in 1620. In 1622 he sublet

the back part of his house but kept the use of the shop.[19] Foster was also working as a jeweller, and in 1615 he was engaged in a dispute with one Dennys (possibly Dennys Fulkye), a French goldsmith and diamond cutter.[20]

William Taylor, who had been apprenticed to the royal jeweller Sir William Herrick (d. 1652), occupied his shop in Cheapside from 1613.[21] Thomas Sympson was working in Cheapside by 1608 (see p. 68); it is possible that he was the same Thomas Sympson who had immigrant goldsmiths working for him in the 1590s.[22] Thomas Covell was apprenticed to John Mabbe in 1569, and in 1573 he was involved in a dispute with John

Portrait of Sir William Herrick (1557–1653), British school, oil on panel, 1594.

Leicester Arts and Museums Service, LF48.1926.0.0

Lonnyson (p. 53) and James Banckes over a water sapphire. The stone was appraised by one Vincent, a stone cutter in Foster Lane, in the presence of expert witnesses supplied by Covell and Banckes.[23] In December 1578, Covell was fined 6 pence for trading after the five o'clock curfew and 'having candell light afore & on the syde of his deske'. He had an apprentice in 1579 and he held the lease of his shop in Cheapside from 1599 to 1620.[24]

Very little is known about Andrew Parker, who received his freedom of the Goldsmiths' Company in 1623;[25] James Gosson, a goldsmith by patrimony in 1628; Thomas Hodges, who was free in 1633; or John Davenport, a goldsmith from 1649.[26] One entry relating to James Gosson in the lease books for 1651 suggests that he might have been an absentee tenant, since he was then living in Cambridge and had not been able to renew his lease, 'being very sicke'.

Most if not all of the occupants of these properties were goldsmith jewellers, but as yet no concrete evidence has emerged to identify any of them as either the owner or depositor of the Hoard.

Deceitful work

> [T]he design by the King and Parliament was, that all the Shop-keeping Goldsmiths in London … should be confined to the High-Street (otherwise called Cheapside) … that their living so publickly together might be a means to prevent the deceits in their Trade, which their living in obscure Turnings, and By-Lanes and Streets would increase and promote.[27]

One reason why the Goldsmiths' Company was so worried about the geographic spread of the trade across London was the practical difficulty of keeping track of its members and regulating their work, and as the old bonds of custom and community began to fray it became harder to maintain quality control and monitor unlicensed activity. Fortunately, the Company still had a few weapons in its armoury against poor workmanship and fraud, one of the most important of which was the right to assay

gold

All of the gold in the Cheapside Hoard has been scientifically analysed by the Goldsmiths' Company Assay Office. The tests, using the non-destructive technique of X-ray fluorescence spectroscopy, identify elements on the surface of the jewellery. Each element emits X-rays of different wavelengths and the computer software converts the results into spectra for the principal alloys, gold, silver and copper, and any other trace elements present.

The machine was calibrated so that it matched the precise gold standards of the touch needles held by the Assay Office. The tests were undertaken for four main reasons: first, to see if the gold alloys matched the official standard set by Act of Parliament in 1576, at 22 carats; second, to see if the gold alloys were homogenous across the Hoard; third, to find out if certain alloys had been used for particular jewels; and finally to ascertain if there was a correspondence between the design of the piece and its metallurgy. Would it prove possible to match certain jewels to particular workshops or production centres? Could more be found out about manufacturing processes?

Research is ongoing, but some items appear to be stylistically and compositionally similar, and, notwithstanding statutory and Company regulations, it seems that most of the Hoard was made from 19.2 carat gold, equating to the standard known as the Paris Touch.

Clockwise from top: A14010, A14095, A14093

(test) precious metals to see whether they met the required standard laid down by statute in 1576 'that no goldsmiths should work, sell or exchange, any plate or ware of gold less in fineness than twenty-two carats, and that he use no … [enamel] or stuffing more than is necessary for finishing the same'.[28] The legislation also prohibited the setting of false stones in gold, the setting of real stones in base metals, any kind of 'secret' work, buying articles through the trade without knowing who the seller was and, finally, fixing the price at which the work could be sold.

The right to assay was combined with special 'powers of search' which entitled senior officers and others appointed by the Company to enter any house, shop, cellar, warehouse, shed and boat both in London and throughout the entire realm. They could also seize and destroy all false, substandard and counterfeit work, and punish transgressors by imprisonment or fines. The 'right to search' was supposed to help protect and regulate the trade, but the challenges faced by the searchers were immense. There was so much subterfuge and clandestine activity, and there were too many people to monitor, too many secret places and too many jewellers and goldsmiths who were prepared to flout the rules. The role of the searcher was often disagreeable and unrewarding, but references to searches in the Company accounts, which largely concern poor quality workmanship and the use of substandard metals, provide fascinating information about trade practices and the types of articles made and sold.

If an item of substandard or defective work was uncovered during a search, it was confiscated and taken to Goldsmiths' Hall for assay. On 24 July 1606, Richard Taylor received a summons to appear before the Court of the Goldsmiths' Company because his work had been found to be 'formed very fowle and coarse'. When Taylor arrived, a 'great quantity of small gold and silver wares' were broken in front of him, and a brief list of the items was recorded in the Company Minute

bodkins

Hairpins, or bodkins as they were generally known, were much in vogue in northern Europe in the late sixteenth and early seventeenth centuries. According to the London clergyman William Harrison in 1577, bodkins were 'first devised and used in Italy by Curtezans and from thence brought into France and there received of the best sort for gallant ornaments, & from thence they came into England'.[29] Anne of Denmark, wife of James I, had a huge number, mostly set with rubies and diamonds, and one remarkable jewel with the head in the form of a fly 'with a spring like clock wheels' to make it vibrate.[30] Plain and jewelled bodkins made suitable love tokens, and some were stamped with initials or the simple phrase 'forget-me-not'. Used like a big needle to 'crest the hairs'[31] they were also worn behind the ear in combination with a diadem-style hairpiece. In the Low Countries the position of the bodkin behind the left or right ear was used to denote marital status.

Londoners were particularly fond of hair ornaments, and in 1583, Philip Stubbes bemoaned the fashion in *The Anatomie of Abuses*, claiming that women strove to outdo each other with 'curled, frisled and crisped [hair] laid out in wreaths and borders from one ear to another … hanged with bugles, gewgawes and trinkets besides'.[32]

There are three bodkins in the Cheapside Hoard. One, set with diamonds and a pale-pink foiled spinel (A14164) at a right angle to the plane of the shank, was evidently designed to be embedded in a thick coil of hair. The others (A14123 and A14124), both in the form of shepherd's crooks, are set with turquoise, rubies and diamonds. The irregular shapes of the rubies and diamonds have been disguised by highly skilled setting. One of the diamonds has shattered and the rubies have been foiled. Both pins have attached loops on the reverse and a further loop at the tip of the hook for a pendant pearl (now lost). The shepherd's crook design reflects contemporary interest in arcadian pursuits and echoes the pastoral themes in much contemporary poetry. Elizabeth I had 66 jewelled bodkins, including one of gold in the form of a harrow set with 'sparkes of Diamondes and one small pearle pendaunte'. The pastoral theme remained popular into the seventeenth century: Anne of Denmark's jewels included a chair of gold, 'having a Rustick personage with a baskett in the lappe' garnished with a small diamond, four rock rubies and several small pearls.[33] In 1622 the Goldsmiths' Company assayed a 'gilt crooked bodkin', though whether this was actually fashioned in the form of a crook or was simply bent out of shape is uncertain.[34] A less ambiguous entry occurs in the records for 12 August 1642, when the Company assayed 'bodkins in the form of shepherds' hooks [which] were found to be coarse' (below standard) and broken.[35]

left to right: A14123; A14124 and A14164

Book. There were seal rings, plain hoop rings, silver-gilt rings, 'all sorts of enamel rings' (one with a death's head), jewels in the 'form of lovers knots', beads, enamelled gold buttons, a chain of coral and other chains (not specified), bodkins (pins), a pair of candle snuffers, silver forks and thimbles. The list is telling because similar items are included in the Cheapside Hoard. The document is even more tantalizing because Richard Taylor had a shop two doors to the west of 30 Cheapside, and he was closely related to, and might have lived for a time with, William Taylor, who took a lease on 31/32 Cheapside.

seal rings

The two seal rings in the Cheapside Hoard are both set with antique Roman gems dating to the first century AD. One is engraved with a plucked and trussed chicken flanked by a fish and knife – signifying prosperity and the pleasures of the table or perhaps a pictogram/rebus of the owner's name. The other gem depicts

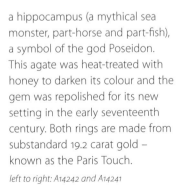

a hippocampus (a mythical sea monster, part-horse and part-fish), a symbol of the god Poseidon. This agate was heat-treated with honey to darken its colour and the gem was repolished for its new setting in the early seventeenth century. Both rings are made from substandard 19.2 carat gold – known as the Paris Touch.

left to right: A14242 and A14241

Richard Taylor's shoddy work was deemed 'very fowle … dangerous in example and scandulous to the Compayne in generall and more particularlie to the honest custome of such of the Companyne as are dwellers and shoppe keepers in Cheapside'. So serious was his offence that he was locked up in the local prison, known as the Wood Street Compter, for a few days, and upon his release was bound not to 'cause to be made nor putt to sale any more such deceitful stuffe'. Evidently Taylor did mend his ways, because he took out another lease for a shop and tenement in Cheapside in 1630 for a term of 20 years.[36]

While many of the cases that came before the Court of the Goldsmiths' Company demonstrated flagrant abuse, goldsmiths were sometimes reprimanded for an innocent or careless mistake, as Nicholas Pope, a goldsmith dealing in jewellery, discovered to his cost. On 8 May 1634, he was found to have 23 enamel rings in his shop, which were removed for assay. A few days later Pope was summoned to the Hall and was told that the rings were 3 carats and 3 grains less than standard, so they were destroyed. To avoid a fine, Pope pleaded innocence, arguing that he had bought them in good faith from another jeweller called John Bonneville. As a result, the wardens decided to give him the benefit of the doubt since he had already suffered a major loss, and they made arrangements to interview Bonneville the following week.[37]

The wardens occasionally received a tip-off that something was wrong which required an instant response. In 1613, they received notice that in some places in Cheapside 'there was to be found muche ill plate deceitfully madde'. So on Friday, 9 January, between 9 and 10 a.m., the wardens arrived in Goldsmith's Row to begin their search. They swooped into premises occupied by Richard Wilton and Matthew King, from whom they got 'some parcelles of plate for assay and a copper chain gilt'. Then they hurried on to the house of William Ward a few doors down the Row, but by this time they had lost the advantage of surprise and Ward's servant said that his master

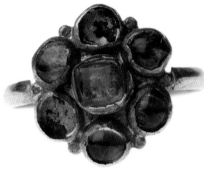

In 1677, the author of *A Touch-stone for Gold and Silver Wares, or A Manual for Goldsmiths*, argued that no one should be persuaded that the official gold standard was too soft to be serviceable. Those who claim otherwise, he argued, were quite deluded because it was entirely possible to make 'gold rings of all sorts, with stones and without … and all Jewels whatsoever' as all honest and 'ingenious Artists or Workers of these Works … will avouch'. Moreover, he asserts, the collets of rings (the thin bands that encircle and secure the stone)

rings set with gems

have to be made of 22 carat gold otherwise they 'will not close, but spring from the Stones and there endanger their falling out'.[38] Many of the Hoard rings have missing stones and analysis of the collets show that they are all two or three carats below the standard. Most of the pendants, however, which still have their stones in place, have collets of 22 carat gold.

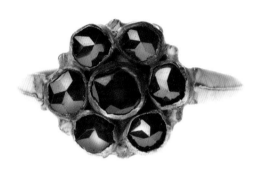

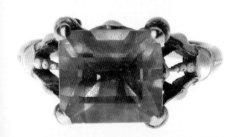

'There are now, and more than a good meanie [goldsmiths]. They are for (for the most part) very rich and wealthye, or else they turne the fairest side outwards … They have their shops and stalls fraught and bedecked with chaines, rings, golde, silver and what not wonderfully richly. They will make you any monster or antike whatsoever of golde, silver or what you will.

'Is there no deceit in all these goodlye shewes. Yes, too many. If you will buy a chaine of golde, a ringe, or any kinde of plate, besides that you shall paye almost halfe in halfe more than it is worth (for they will persuade you the workmanship of it comes to so much, the fashion to so much, and I cannot tell what) you shall also perhaps have the golde which is nought, or else at least mixt with other drossie rubbage, and refuse mettall, which in comparison is good for nothing. And sometimes, or for the most part, you shall have tinne, lead, and the like, mixt with silver. And againe, in some things some will not strike to sell you silver gilt for gold … But this happeneth very seldome, by reason of good orders, and consitutions made for the punishment of them that offend in this kind of deceit, and therefore they seldome dare offend therein, though now and then they chance to stumble in the dark.'

Philip Stubbes, *The Anatomie of Abuses*, 1583 Book II, ch. 1.

was not at home. Nothing daunted, they swept inside to make their own search in the 'inner roome where his plate stood', but before they could get there one of Ward's servants hastily ran ahead and locked the door. Warden Molesworth heard the door shut, whereupon he challenged the servant, who said he had simply gone to see if his master was inside. Molesworth tried the door and then asked for the key, but the servant said that he did not know where it was. The searchers were not satisfied with this response, so they settled down to wait and 'remained there a good space'. After a while, they discovered that the key was with Ward's wife, but when she was asked to unlock the door she refused.

Tempers began to fray. Noon came and went and the wardens were tired, hungry and had other things to do, so they sent for further assistance. As soon as the reinforcements arrived, the searchers returned to the Hall, leaving two younger officers on duty with the Company almsman. They stayed until after 2 p.m., one stationed near the door of the inner room and the others just outside in a court at the back. At this point, Ward's wife took the opportunity to lock the entry door from the inside, shutting the wardens out. Then she drew the curtains. In the meantime, Ward had 'conveyed awaye that which was sought for' and had darted out of his back door into a yard and alley leading to Old Change and then down the street and round the corner, finally turning up at his shop door in Cheapside as though nothing had happened.

The wardens were furious and Ward was summoned to the Hall to explain his conduct. At first he flatly refused to go, and then after repeated requests he finally turned up, only to deny the charges. But there were witnesses who testified that they had seen him scurrying along the back alley with a bundle about an hour before the search began, and they asserted that he had been in the house when the wardens arrived and had slipped out of the back door when they came in through the front. The usual penalty for misdemeanours of

clockwise from top: BM 1914,4-23.11, A14218, A14237, A14228, A14230

this sort was a fine, but Ward's behaviour was such that the wardens recommended imprisonment. Although the matter was put to the vote and the wardens voted eight to five in favour, the ballot was mishandled, so Ward was let off with a hefty fine.

Matters did not end there, however. Nine years later, Ward (who had by this time moved from Cheapside to Southwark) complained that on the day the wardens had tried to search his premises, he had lost 'dyvers ringes, Jewells & other goodes he knowe not what'. The wardens were incensed. Not only had they come to his house to execute their authority by warrant according to the charters and ordinances of the Company, but now they were subjected to other abuse and slanders which they simply could not countenance. Ward had so aggravated his 'former offences' that they decided to refer the case to the lord mayor, and after a lengthy debate Ward was eventually fined £50 and his 'bad behaviour put on record'.[39]

As Ward's case shows, the searchers were often outwitted, and time and again their efforts to catch someone unawares were foiled. In 1629, for instance, the goldsmith Edward Rowland received an unwelcome visit from the Company wardens. He had minutes to put a plan in place as they approached his shop on the upper floor of the Royal Exchange in Cornhill. Lurking in the darkest recesses of his shop, Rowland left his servant in charge. When the searchers asked to see Rowland's stock, the servant said that he could not show them anything because he did not have the key, but would send for it. Another servant was sent to 'retrieve' it, and while everyone's back was turned Rowland slipped away. Some time later, the servant returned to say that he could not find the key and that his master had it. He then offered to get the key but explained that he could not show the work to the wardens himself. In some exasperation, the wardens appealed to the lord mayor, who sent an officer to break open the lock and impound the articles, which were promptly sealed up in various parcels with an inventory listing

their contents. One parcel was immediately despatched to Goldsmiths' Hall. When it was opened the wardens found several items of silver plate and a box containing 38 packets of pendants, bracelets and other jewels. The items were assayed and found to be 'most shamefully defective', so they were broken and destroyed. In the meantime, Rowland had returned to his shop, where he found the other sealed parcels awaiting collection. He ordered his servants to rip off the wrappings so that the goods could be secreted 'to some place where the Wardens had no means of finding them'. Rowland was summoned to appear before the officers of the Company and was sent to prison.[40]

Sometimes investigations were undertaken at the instigation of higher authorities. On Monday, 22 January 1620, two or three Company wardens and eight or more assistants formed a commission under the Seal of the Court of Exchequer to examine witnesses in a dispute between two jewellers, Jasper Tyan and Philip Jacobson, and others for debt. Three months earlier Tyan had bought a 'great rubie' from Jacobson for £400. It was only later that he realized that he had made a mistake: the stone was not quite what he had believed it to be and he soon discovered that it had been artificially enhanced and the 'edges coloured'. In his defence, Jacobson brought in six of his own witnesses, the jewellers George Heriot, Renatus Angelberger, Harman Burchart, Henrie Alman, Abraham van Kyndwen and Nathaniell Garrett. Five of the witnesses turned up to the hearing and the ruby was duly examined. A report was compiled and then three more witnesses were interviewed: John King the minister of the Dutch church, Balthazar Qerbier and Rembout Jacobson. All confirmed that their statements were true.[41] It is unclear what happened next. What is clear is that the production and use of counterfeit jewels, precious stones and pearls was a major problem for the Goldsmiths' Company.

Counterfeit jewels

Augustin Hiriart of Bordeaux, jeweller and self-styled 'expert at counterfeiting precious stones', made a fleeting visit to London in 1601.[42] During this time he was introduced to the politician and courtier Robert Cecil, who asked whether he could make 'rubis bales' (balas rubies or red spinels).[43] Hiriart replied 'that it appeared to him impossible'. But when he returned to London four years later, he wrote to Cecil to explain that he had experimented both in Italy and in France and was now able to make these stones to 'the greatest possible perfection, as Cecil may see if he wishes'. He then suggested that if Cecil were to show the stone to the 'cleverest jeweller he knows [they would not] value it at less than £3000' and that if Cecil were to buy it for the bargain price of £300 he could then claim to have the rarest jewel in England.[44]

Three years later the Worshipful Company of Goldsmiths heard that one of their number, Thomas Sympson of Cheapside, had been counterfeiting stones and setting them in gold. The wardens undertook a search of Sympson's house, where they found a great quantity of stones held to be of 'greate value which he privately shewed to divers of the Company affirming them to be right whereas in truthe they were counterfett and of noe worth'. So serious was the abuse, that the wardens summoned various stone cutters, workmen and others to a private inquiry. The Court Minutes for Friday, 8 October 1608 provide a detailed account of their findings.[45] The wardens discovered that Sympson had employed seven jewellers and lapidaries to make a large number of 'cristalls and other stones of noe worth to be cutt after severall fashions'. He had found a way to dye the crystals in artificial colours and by great cunning had transformed them to look like balas rubies of great price, which 'very probably might passe for stones [of value] 'upwards of £7000 to £8000'. It transpired that Sympson intended to send these counterfeit stones to 'forren Countryes',

especially Turkey, Spain and the Barbary Coast and had already approached Sir Thomas Lawe, the governor of the Turkey Company, for this very purpose. When the wardens spoke to Sir Thomas they discovered that Sympson had taken a number of his counterfeits to Lawe's house in December 1607, and had requested his favour that he might send jewels of great value to Turkey. Lawe wanted to know what these jewels were; Sympson had told him that they 'were greate rubies worth £7000 or £8000'. Sympson then asked if he could send the stones via Lawe's agent to the Great Turk, and a few days later returned bearing another 'great stone' which he claimed had come from a church in France.

The Company investigations continued. Two goldsmiths, Richard Millerd and John Tirrey, said that they had seen artificially coloured stones in Sympson's possession. According to Millerd, Sympson had planned to sell a particularly large counterfeit to 'some merchaunts' for £1,200 or £1,800, while Tirrey said that he had seen 'at severall tymes sundry stones artificially cullored which in his judgement appeared to be a greate vallue'. Other interviews followed and it emerged that Sympson had acquired several balas rubies of different sizes, from which he had made a large number of patterns in both clay and lead. He had then taken the moulds with lumps of rock crystal to various stone cutters in London: Roger Flynt, David Bowen, Haunce Nicasius, Walter Jackson and one Renatus (probably Leonard Renatus of Blackfriars).[46] The cutters were given a set number of crystals with corresponding clay and lead patterns 'as bigg as greate wallnutts' with instructions to fashion the crystals 'into the forme of [the] patterns'. Flynt made six, Bowen made five, Nicasius cut three large walnut-sized crystals with 'eight or nine of lesse sizes', Jackson prepared six stones, and Renatus cut a total of 29 and drilled 'many other stones made pendant fashion broughte unto him by one Flynte' (see overleaf). The counterfeits were so convincing that when Haunce Nicasius saw one in the hands of fellow goldsmith Peter

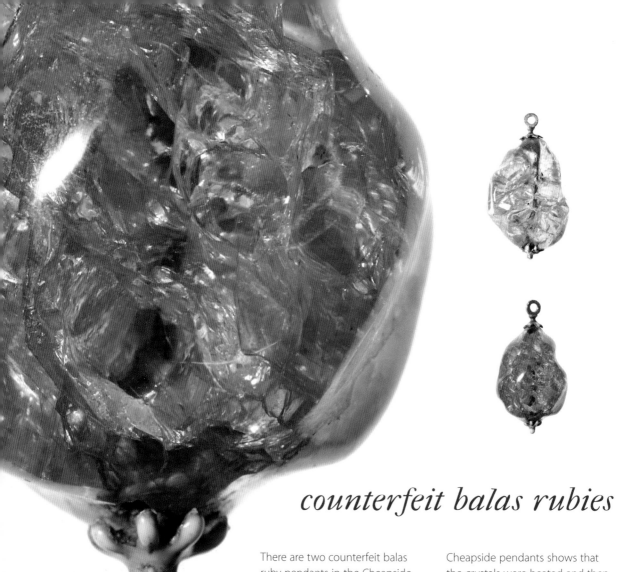

counterfeit balas rubies

There are two counterfeit balas ruby pendants in the Cheapside Hoard, and it is tempting to conclude that Thomas Sympson had a hand in their production. They are both fashioned from rock crystal, which has been cut, polished and dyed to represent a natural spinel. The rock crystal has been drilled, a gold rod has been inserted into the perforation and the rough edges are covered by white and black enamelled claws, top and bottom. How Sympson coloured his stones is unknown, but optical microscopy of the Cheapside pendants shows that the crystals were heated and then quickly immersed in a cold dye-impregnated solution. The thermal shock or quench-crackling opened up fissures in the crystals, enabling the red (now degraded) dye to filtrate through the stone to create a shimmering coruscation or 'firestone' effect. Whether the red dye was derived from mineralized salts, cochineal or some other organic-based sublimate is unknown. It is possible that the perforations were coated with dye to intensify the colour.

top to bottom: A14102 and A14103 actual size and enlarged detail

van Lore he mistook it for a genuine, highly prized stone, 'but looking better [upon it] found it to be one of the stones which he had cutt butt a fewe daies before'.

While the lapidaries were preparing the stones, Sympson asked a couple of workmen to produce some gold fittings. Peter le Sage set five of the counterfeits in 'open clawes … enamelled black and white' and one [K]amer (the name is almost illegible in the records)[47] was engaged to make two pins of gold to 'goe through two greate redd stones like rubie ballaces', but was not permitted to assemble the jewels himself; instead Sympson took them away. Some time later the jeweller saw 'five or six greate stones broughte into an artificiall cullor like rubie ballaces' in Sympson's house, which suggests that the stones were dyed after they were cut. Sympson kept his recipe to himself.[48]

Sympson's counterfeit balas rubies had brought great 'disgrace and discreditt … indignitie and scandall' to the Goldsmiths' Company, but matters took a graver turn when investigations revealed that he had taken several of his counterfeit stones to Robert Cecil, by this time lord treasurer of England. Apparently Cecil did not entirely 'dislike the devise used for the manner of culloring and incorporating … the stones' but deplored Sympson's actions in trying to pass off false stones for natural ones. The matter was promptly referred to the Company, which, Cecil argued, had sufficient power to both examine and punish 'abuses of that kind'. After much debate, the wardens, assistants and chief officers sent the Beadle round to Sympson's house to summon him to Goldsmiths' Hall. He refused to go. Two of the wardens were despatched to remonstrate with him, but still Sympson refused, making instead very 'slanderous and irreverent and insuffereable speeches … [and] plainely told them he would not come before them to the hall but sayed in a scornefull manner that after that daye he would forsake Cheapside and be noe more a goldsmith'. At this point the wardens' lost their temper, but as they made a grab for Sympson he made a 'violent escape'.

After all this trouble, the wardens were even less well disposed towards Sympson. Not only had he brought the Company into disrepute by making counterfeit stones, but he had also broken his oath by setting them in gold and refusing to appear before the wardens. The misdemeanours were compounded by his violent and scandalous conduct, and so the Court ordered that Sympson should be 'absolutely disgraced and dismissed from the Livery as a man unworthy to hold any grace or degree in the Company'. His offences were so serious that the wardens resolved to prosecute him with an indictment to the Mayor's Court or by warrant to the Star Chamber. Notwithstanding the severity of his offence, however, Thomas Sympson continued in his trade, and was eventually appointed one of 'Her Majesties' jewellers. When he died in 1633, he was accounted to be 'worth five thousand pounds' and his sons, Francis and John, who lived and worked for a time in one of the Hoard properties, inherited a sizable estate.[49]

How many of Sympson's counterfeit stones were exported is unknown. Some ended up on the Barbary coast, and it is possible that others were sent to the East Indies, where in 1614 the East India Company factors were reprimanded for selling counterfeit 'ballast rubies' to the locals, which not only made 'the people hate and detest us, before we settled amongst them' but also brought great discredit and embarrassment to the nation.[50]

The counterfeit business continued to be a problem for the Goldsmiths' Company, however. On 7 January 1622, the wardens sent a letter outlining their grievances to the solicitor general, Sir Robert Heath (1575–1649), with an appended list of 183 alien (immigrant) goldsmiths resident in London who were making counterfeit jewels. The petitioners complained that their livelihood had been taken away and their members impoverished, but they argued that this deplorable state of affairs could be remedied by reducing the number of 'alien'

goldsmiths working in London, and by compelling them to submit to the Company ordinances and making them work exclusively for English goldsmiths.[51]

Very little was done, and in 1624 it emerged that some goldsmiths, 'not understanding the business', had allowed strangers to sell counterfeit jewels below the standard value, and that these abuses had not been rectified because the Company was partly governed by some of the offenders.[52] Then, on 28 February 1629,[53] a petition was submitted by Thomas Crosse, goldsmith, to the 'Kings Majesty for suppressinge of counterfeit pearles and stones' and to redress other abuses.[54] Crosse and his fellow goldsmiths argued that the market was flooded with counterfeits, some imported but many made in London by both 'Strangers and Englishe' alike, and because it was often difficult to tell true from false, their trade had been brought into disrepute.[55] Also, as they were prohibited under the terms of their oath to 'make sell or put to sale' counterfeit wares, others were taking advantage. And, to make matters worse, certain 'ill disposed persons' had begun to loiter and lurk about the Court, City and suburbs, and were making it their 'common trade' to steal from the King and nobility silver and gold plate, chains, rings, necklaces, bracelets, buttons and other jewels. They were even stripping out gold and silver thread from richly embroidered coach upholstery, fringes and trimmings.

Even worse, so far as the goldsmiths were concerned, was that the precious metal was sold on to brokers, foreigners, pedlars, petty chapmen and 'gold end men' who had 'attayned to the arte and cunnynge to burne and melt gold and silver (which is the proper misterye of the goldsmiths)'. By so doing, they had influenced fashion by recycling and altering items for resale, and, perhaps most significant of all, had materially changed the proportions of the metals and subverted official standards for the alloys. They could also sell these goods freely and, for the most part, escape undetected. The petitioners requested that a Royal Proclamation be issued, prohibiting

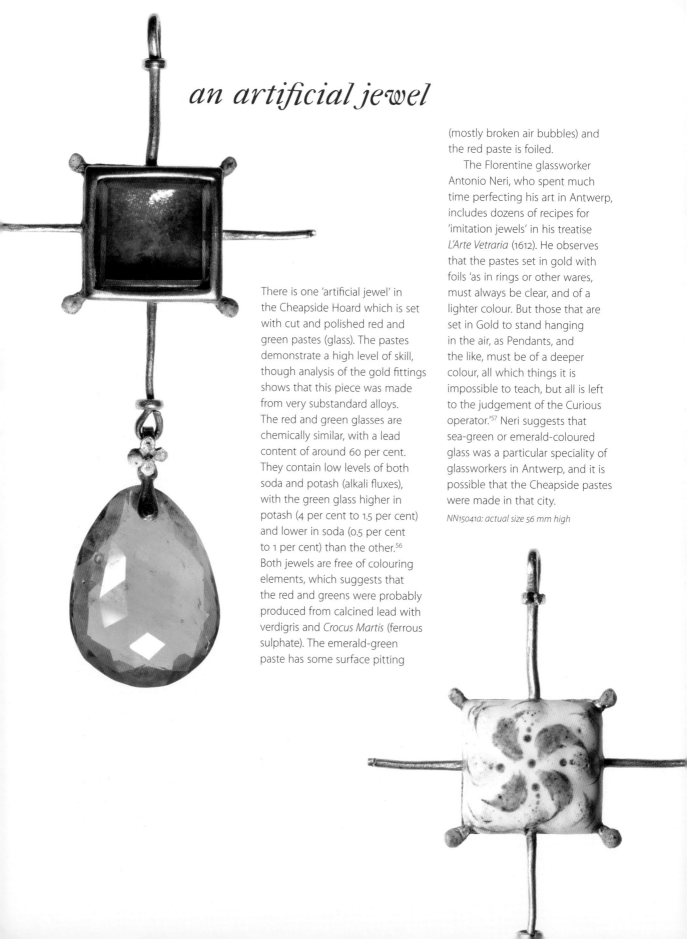

an artificial jewel

There is one 'artificial jewel' in the Cheapside Hoard which is set with cut and polished red and green pastes (glass). The pastes demonstrate a high level of skill, though analysis of the gold fittings shows that this piece was made from very substandard alloys. The red and green glasses are chemically similar, with a lead content of around 60 per cent. They contain low levels of both soda and potash (alkali fluxes), with the green glass higher in potash (4 per cent to 1.5 per cent) and lower in soda (0.5 per cent to 1 per cent) than the other.[56] Both jewels are free of colouring elements, which suggests that the red and greens were probably produced from calcined lead with verdigris and *Crocus Martis* (ferrous sulphate). The emerald-green paste has some surface pitting (mostly broken air bubbles) and the red paste is foiled.

The Florentine glassworker Antonio Neri, who spent much time perfecting his art in Antwerp, includes dozens of recipes for 'imitation jewels' in his treatise *L'Arte Vetraria* (1612). He observes that the pastes set in gold with foils 'as in rings or other wares, must always be clear, and of a lighter colour. But those that are set in Gold to stand hanging in the air, as Pendants, and the like, must be of a deeper colour, all which things it is impossible to teach, but all is left to the judgement of the Curious operator.'[57] Neri suggests that sea-green or emerald-coloured glass was a particular speciality of glassworkers in Antwerp, and it is possible that the Cheapside pastes were made in that city.

NN15041a: actual size 56 mm high

persons from selling or wearing counterfeit pearls or stones, 'coarse' (substandard) gold and transporting the same overseas.

They asked that only goldsmiths or licensed officers of the Mint should be able to work with precious metals, and they further requested that all others be prohibited from defacing, melting or altering the property of any jewels and plate. In addition, they requested that none should covertly buy, sell or pawn the same, except from the stall or shop of a member of the Goldsmiths' Company, as established by the Company charter and City regulations.

The brokers were quick to challenge the goldsmiths' accusations, arguing that if a goldsmith was discovered selling counterfeit jewels, they could escape punishment by claiming that they had bought the items on the open market. Whereas, the brokers maintained, they had to be far more careful about what they bought in the first place since their trade depended on it. They were also bound by statute not to 'alter the propertie of their severall bargains', and, most importantly, they kept a register of all their purchases so that any stolen items 'may be easily founde out'.

The wrangling continued, and after much toing and froing it was proposed to set up an Office of Registry for the City of London and its immediate environs, in which the brokers and dealers could 'register daily all such goods as they buy or take to pawne'. In this way, stolen goods could be identified and where possible returned to the owner, or some other restitution made. The recommendation was not popular. The brokers said that they had their own system that worked perfectly well and that the selling of counterfeits was not unlawful so long as the seller notified the buyer. The goldsmiths, for their part, thought that it would be a 'nuisance' to keep a separate register of this kind and that it would hamper free trade.

Eventually, the whole matter was reviewed by the lawyer Lord Coventry (1578–1640) on behalf of the Crown and he made a number of recommendations in his report which was

submitted to parliament in October 1634.[58] Coventry was of the opinion that if imports of counterfeit stones, pearls and jewels were prohibited, they would simply be brought in by stealth, and that as things stood counterfeits were imported with other fripperies and trinkets and so were subject to import duties. He did not believe that people were deceived by them, and could see no reason why 'they should abate the value of true ones than that candlesticks and cups of pewter should abate the value of silver'. Also, if everyone who now wore counterfeits were suddenly to wear the genuine article, this would waste a great deal of the country's treasure, which could be put to better use. And as far as the export of counterfeits was concerned, they should be regarded as 'mere merchandise' subject to the usual customs checks and levies, and the laws of supply and demand, rising and falling in price in the same manner as any other commodity; and as they were not reputed to be part of the 'treasure of the kingdom' they could be exported with impunity. Neither could he see any reason to forbid brokers and others from 'buying, selling or pawning gold and silver of any kind' and forcing people to take everything to a goldsmith's shop, or from pawning or selling jewels and precious metals to a neighbour if they so wished. But he did recommend that 'all good means' should be employed to prevent foreigners and 'others not goldsmiths' from melting plate and jewels, or making substandard wares, and that those who made a living from stripping out precious metals and all receivers of stolen goods should be restricted. Coventry expressed the view that the Goldsmiths' Company had sufficient powers of regulation and enforcement already, but recommended that they should receive support from the lord mayor and aldermen. Though Coventry felt that a Royal Proclamation was unnecessary, two years later the attorney general was ordered to prepare a proclamation restricting the export of 'counterfeit jewels, pearls, pendants, chains and false stones' and prohibiting the wearing of the same in any of the King's dominions.[59]

Specialization

> Until a man grows unto the age of 24 years, he (for the most
> part though not always) is wild, without judgement, and not of
> sufficient experience to govern himself, nor (many times) grown
> unto the full or perfect knowledge of the art or occupation that
> he professes, and therefor has more need still to remain under
> government, as a servant and learner, than to become a ruler, as
> a master or instructor.[60]

At the beginning of the seventeenth century there were com-
plaints that the 'true practice of the art and mystery of the
Goldsmithry' had begun to decay and that goldsmiths were
no longer skilful in all aspects of the craft, but were becoming
specialists. There were those who could engrave and chase and
'goe no farther'; some who could gild 'and do hardly anything
else';[61] and, according to the Goldsmiths' Company minutes
of 1607, there were very few workmen who could 'finish and
perfect a piece … without the help of many and several hands'.[62]
The trade was truly divided. As Hannibal Gamon, author of
The Gouldesmythes Storehowse (1604) noted, there were four main
branches: first, the silver worker; second, the gold worker; third,
the refiner; and fourth, the merchant. Jewellery fell under the
province of the gold worker, but even here, there were divisions
and specialists. Some made jewellery of all sorts, but most
focused on a particular aspect of the craft, and there were ring
makers, wireworkers, button makers, brooch makers; makers of
bracelets, chains and borders, pearl piercers, enamellers, stone
cutters and so on. Even within these fields there were divisions
and degrees of expertise. Peter Hudlay from Germany is simply
described as an 'enameller' in 1635, though it is unclear what sort
of enamelling he did and it is by no means certain that he worked
in the jewellery trade.[63] John Wright of Huggin Lane, on the
other hand, was a specialist; he was given the task of making and
mending collars with the City arms and 'ameling [enamelling]
them anew'.[64] Edward Cragg supplied rings to other goldsmiths
and was known particularly as 'Cragg the enameld ringmaker'.[65]

This cameo, in white, blue and brown banded agate, illustrates a scene from Aesop's fable of 'The dog and the shadow'. In the fable a dog runs off with some meat which he has snatched from a butcher's stall. Rushing to the river to escape with his prize he starts to cross a bridge and then notices his reflection in the water below. Mistaking his 'shadow' for another dog with a larger piece of meat, he makes up his mind to have that also. As he opens his mouth to snap at the 'rival' dog, the meat drops into the water and is never seen again.

The large horizontal crack across the stone has been artfully disguised by aligning it with the edge of the plank, and the engraver has skilfully exploited the colour banding by varying the depth of the carving to achieve perspective and variations of tone. No attempt has been made to depict the dog's reflection but the animal's smooth glossy coat, the jagged foliage and the foaming white water have been executed with considerable skill. In the far distance, the sun blazes down on a town with an arched bridge leading to a mountainous island surmounted by a castle. A waterfall cascades into the river, which becomes a raging torrent. The dog occupies centre stage and gazes at his reflection in the water below. A large tree overhangs the bridge and the verdant riverbank is strewn with boulders and tree stumps.

While the cameo was undoubtedly appreciated for its aesthetic qualities, its

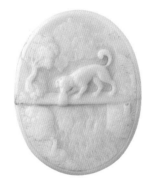

the *Aesop cameo*

'Whereby, like Æsop's dog, men lose their meat;
To bite at glorious shadows which they see;
And let fall those strengths which make all states great
By free truths changed to servile flattery.
Whence, while men gaze upon this blazing star,
Made slaves, not subjects, they to tyrants are.'

Fulke Greville, Lord Brooke (1554–1628),
Caelica, 1633

Emblematic literature, illustrated proverbs and animal fables were an established part of medieval culture, but *Aesop's Fables* really came to popular attention with the spread of Renaissance humanism and the advent of the moveable-type printing press. By the early 1500s the text was an international best-seller, with Greek, Latin and vernacular editions appearing in Milan, Venice, Utrecht, Ulm, Strasbourg, Leiden, Antwerp, Basle and Lyons. The first English edition was printed by Caxton in 1484, and by the early 1500s the *Fables* had become a standard text in London classrooms. Schoolboys probably appreciated the woodcut illustrations and entertaining stories, but the text also gained the approbation of grammarians and schoolmasters who embraced humanist philosophy.

With its blend of classical and Christian ideals (some editions have biblical texts and references), delightful images and amusing stories, the popularity of the *Fables* among the public at large

artistic merits as an archetypal Renaissance gem are of secondary importance to its subject matter. Representations of *Aesop's Fables* in the visual and decorative arts seem to be rare before the seventeenth century, and so far as is known this cameo is the only one of is kind.

part of a set of cameos illustrating other fables or was it made to commission for someone for whom the subject had particular significance and appeal? Whatever the truth, contemporaries cannot fail to have been struck by the incongruity of a precious gem with the implicit moral message of *vanitas*, 'beware lest you lose the substance by grasping at the shadow', or, according to Caxton's translation, 'for the love of a vain thing men ought not to leave that which is certain'. Contemporaries would have fully understood and appreciated its significance and no doubt appreciated the paradox.

Even though the subject matter of the cameo is clear, the inspiration for its design is far less certain. None of the illustrated editions of *Aesop's Fables* has a very similar image, although the placement, posture and outline of the dog closely resemble the naturalistic etchings of Marcus Gheeraerts the Elder (1520–1590) which were reproduced in Dutch and French editions of the *Fables* in 1567 and 1587. Aspects of the design and composition also recall the fantastic landscapes by Netherlandish artists of the late sixteenth and early seventeenth centuries, among them Pieter Bruegel the Elder (c. 1525–1569), Johannes Sadeler I (1550–1600) and Paul Bril (1554–1626). The Gothic-style spire certainly suggests a north European design source, and it is possible that this gem was carved in the Low Countries, or possibly even in London, in the late sixteenth or early seventeenth century.

A14266: front and back views actual size and enlarged

was immense and hundreds of editions, translations and compilations poured off the European printing presses during the course of the sixteenth century. By the early 1600s, the stories were an established part of European popular culture, and it is not surprising that a scene from the *Fables* was considered an appropriate subject for a gem. Why 'The dog and the shadow' fable was selected for representation is unclear. Was it

It is just possible that some of the enamelling in London, and indeed in the Cheapside Hoard, might have been influenced by the Hungarian enameller Mihály Sommer, a goldsmith from Braşov (now in Romania) who apparently worked in Turkey but also travelled across Europe, spending time in Germany, the Low Countries, Sweden, France and England.[66]

Stone cutters also specialized. There were those who worked more or less exclusively on diamonds and those who focused on rubies and sapphires. There were cutters of emeralds, cutters who worked on amethysts, garnets and rock crystals (see following chapter), as well as those like Sophia Antine (from Düsseldorf) in Blackfriars and Cornelius Johnson (from Brussels) in Coleman Street who were professional agate cutters.[67] There were even cutters who specialized in cutting stones for particular types of jewel, such as the Antwerp cutter Harwick (Herwijck) in Tower Ward (p. 86), who was posthumously described as 'a cutter of stones for ringes'. Even though detailed records for specialist activity are hard to come by, it is clear that some crafts were virtually monopolized by particular community groups. Most of the stone cutters (including the diamond cutters and polishers) came from France, the Low Countries and Germany. Although Jacques Defryes, a Norwegian working in Langbourn Ward, described himself in 1618 as a 'pearl-piercer by profession',[68] this craft was evidently perfected and largely dominated by the Dutch (see p. 117).

This minute division of labour certainly did not mean a dilution of skill; in fact quite the reverse, since each component, every step in the manufacturing process, required high levels of accuracy and expertise. Even in a specialist workshop one piece might pass through half a dozen hands, and it is probable that artisans were known not just for making a particular type of jewel but also for the processes that they employed. The trade relied on the skill, entrepreneurial flair and, often, semi-independent status of its workers, whether they were itinerant, had their own workshop or shared or rented space

top to bottom: A14012, A14000, A14013, A14014, A14154, A14155, A14001, actual size; enlarged detail of A14012

wirework pendants

On 5 April 1639 the Goldsmiths' Company was asked to settle a dispute between three goldsmiths, William Goble in Cheapside, Mr Cockyne in Holborn and Edward Vaughan in Foster Lane, 'in respect of making of wirework jewels' worth two shillings. The wardens found all three at fault. When the gold was assayed and was discovered to be much worse than standard they decided that Goble should bear the loss of the two shillings, and pay a fine of three shillings for selling the articles.

Cockyne, who commissioned the work, and Vaughan, who made the articles, were fined five shillings each.[69]

Wirework jewels were evidently popular, and the Cheapside jeweller Nicholas Herrick had several in stock including gold wirework 'borders' (decorative trimmings stitched to a garment) and other kinds of unspecified 'wire work with a few ragged pearle amongst it' valued at £5; similar perhaps to these pendants from the Cheapside Hoard.[70]

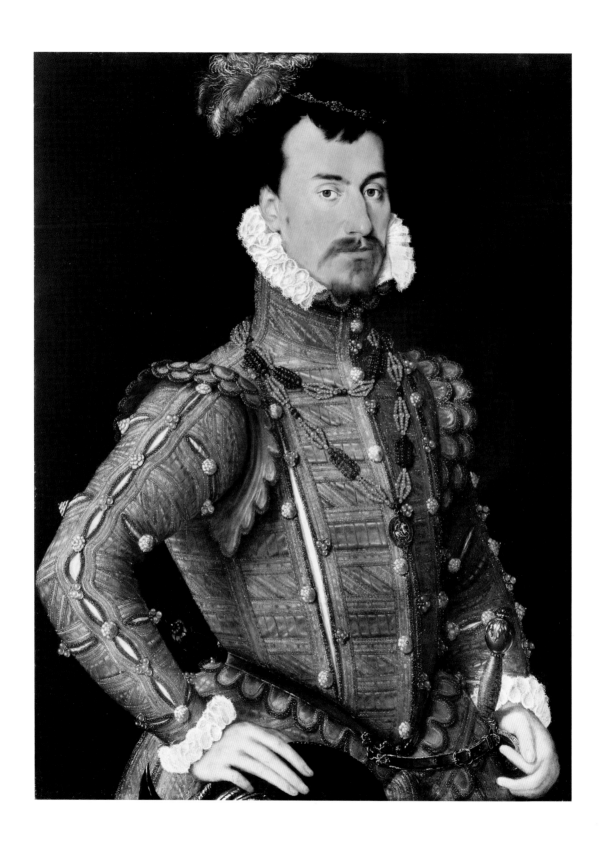

with someone else. After all, accumulated knowledge and skills only came through training, experience and time; as Gamon argued, the artisan had to labour to perfect his skills, in order to be 'singular in the art' or the mystery of the goldsmith.[71]

The blend of acquired skill and inspired intuition that characterizes great craftsmanship is demonstrated in the Cheapside Hoard. Although it is not possible to identify individual makers or workshops, it is clear that the jewels were made and assembled in a complex, multi-stage process. Jewels of apparently 'simple' design, such as the group of ten gold wire pendants decorated with alternating bands of enamel and pearls (p. 81), were in fact extremely complex to make. At least 27 separate processes were needed to produce one pendant, and before production could begin the materials had to be sourced, ordered and prepared. Wire of the right gauge and alloy had to be made before it could be cut into strips of varying length and arranged in sets according to size. A total of six rectangular strips, 13 rods and between 73 and 94 round-sectioned rings of different diameter were needed for each pendant. Pearls graded for colour, shape and size were drilled and sorted into sets (usually 31 for the cage component of the pendant and 12 more for the spray above). Spherical pearls of graduating size were used for some pendants, and natural half-pearls (or specially cut pearls) were required for a design variant with closed-back collets. Finally, white and black enamels were prepared.

While some aspects of the manufacturing process could have been outsourced to speed up the production process, most of the tasks were presumably done in-house and divided up within the workshop. One person or a small team probably concentrated on one aspect of the work until the requisite number of units were ready and then a small assembly line was set up for batch production. The exact sequence of production is uncertain but it is likely that the rings forming the collets for the enamels and pearls were made first, since these were the building blocks needed to construct the main elements

Portrait of Robert Dudley, Earl of Leicester (c. 1560–65), attributed to Steven van der Meulen (c. 1543–1563). Dudley wears a chain fashioned from gold wire cages set with pearls. Caged pearl chains were favoured by both men and women, and there are many examples in portraits. The Cheapside Hoard pendants were probably worn as earrings.

Oil on oak panel, by kind permission of the Trustees of the Wallace Collection, iP534

of the piece. After this, sets of rectangular sectioned rings of varying diameter were soldered to six wire rods to form a line of *cloisons* or cells for the enamel. Some pendants have seven discs in a row and others have nine. Each of the small *cloisons* was carefully filled with opaque white enamel and fired. Black enamel pellets were then applied to each cell for decoration and the whole unit was fired again. The enamels were polished. At some point, strips of round-sectioned wire were fashioned into rings of varying diameter, and these were arranged into sets by size and soldered together into bands for the pearls.

After this, the setting out process could begin. All of the elements needed to form the cage were arranged around a base collet like the spokes of a wheel. The rods of enamel and the ring bands were soldered to the collet in an alternating sequence and then the wires were gradually bent and manipulated upwards to create a pear-shaped cage. Once the requisite shape had been achieved, the wires were gathered together at the top, the suspension loop was inserted and the piece was soldered. Any bits of extraneous metal were removed and the rough edges of the wires were covered with a sexfoil-shaped collar. More solder was added to keep the structure intact and reinforce the joins. The lobes of the decorative collar were embellished with white and black enamel, fired twice and polished. At this point the pearls could be attached to the cage. Six strands of wire were used, one for each of the pearl bands. One end was coiled around the rib at the base of the cage and then the pearls were threaded on to the wire in a linear or perhaps circumferential sequence, starting with the largest. Each pearl was roughly positioned in its ring and then the wire was twisted underneath and tensioned around an adjacent strut so that they were part-supported and part-suspended in their settings. In a separate operation, rings and rods of round wires were soldered together to form a spray. Pearls were threaded on to the spray and the tips of the wires were cut and splayed out to retain them. Finally, the cage and spray were linked together.

The techniques of manufacture, design features and the composition of the alloys suggest that the pendants were made in the same workshop. The enamels show signs of thermal and mechanical stress and there are irregularities in the wires and temperature fluctuations in the soldering. Most of these manufacturing faults are only visible under high magnification, however, and as they do not detract from the beauty of the jewel they would certainly not have deterred a customer from making a purchase. The only obvious problem is the poor condition and, in some cases, loss of the pearls. Whether this damage occurred before or during burial is unknown.[72]

Foreign competition

The transformation that took place in the occupational structure of Goldsmith's Row in the early seventeenth century was part of a whole series of changes that affected the organization of the goldsmiths' trade at this time. The most profound change came as a result of the great influx of skilled artisans from the Low Countries and France in the last decades of the sixteenth century – and for the next sixty years or so the finest jewellery in the capital was 'seemingly made either by strangers or under their influence'.[73]

The immigrant community was largely concentrated in areas outside City and guild control, in the 'liberties' and 'exempt places' of Whitefriars and Blackfriars bordering the Fleet river and in the peripheral wards of Aldersgate and Farringdon Within. Charing Cross, Covent Garden, St Martin-in-the-Fields, the Strand and Fleet Street were popular locations and there were small groups in Clerkenwell, Hackney, Wapping and in several parishes around the north and eastern edges of the City. The Ward of Cripplegate Within was a favourite haunt for diamond cutters and polishers, though some, like Jacob Grote, a cutter from Sweden, lived further east in the parish of All Hallows on the Wall.

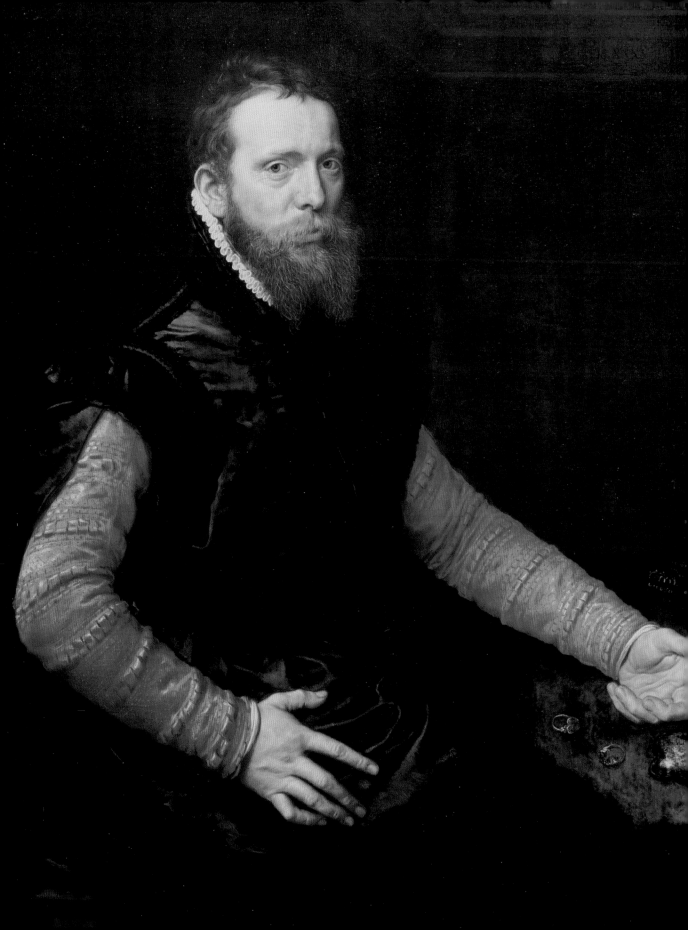

The 'liberties' attracted 'a great multitude of strangers and aliens born out of [the] realm' as well as 'foreigners' – who were not citizens of London, freemen or members of a guild[75] – and the residents enjoyed certain freedoms and privileges denied to other citizens.[76] For the most part, they were left to manage their own affairs, and, as the parishioners of St Anne's Blackfriars argued in 1580, they could do this very well. The City constable had no powers of arrest; the guilds could not conduct searches unless they had a court order or the residents' cooperation; they had immunity from City taxes, laws and customs; and, perhaps most important of all, their artificers and craftsmen (whether they were freemen of the City of not) could practise their trade or 'misterie' without civic or guild interference.[77]

By the late sixteenth century, tensions between the non-free and free community, between native-born and aliens and strangers, had reached breaking point. In 1574, London citizens were told that they could not take on an apprentice whose father was not an Englishman, or born 'within the Queen's dominion'.[78] Then, in 1606, an Act of Common Council decreed that the strangers and foreigners who had lately flouted the city's laws and customs and found all sorts of 'sinister and subtile means' to defraud and circumvent them by setting up shops in private and secret places could no longer do so with impunity. Instead, only those who had served a seven-year period of apprenticeship, were members of a guild and had received the freedom of the City of London could 'sell or put to sale any wares or merchandizes within the said city or liberties … or keep any open or inward shop, or other inward place or room, for shew [or] sale'. A £5 fine was imposed for any breach.[79]

These measures were welcomed by the Goldsmiths' Company, which had already introduced its own regulations to protect its trade interests. Stranger goldsmiths and jewellers were given special dispensation to work in London so long as they obtained a licence to do so. This meant that they had to

Portrait of goldsmith Steven van Herwijck (c. 1530–1565/67) by Anthonis Mor van Dashorst (1565–1621). Van Herwijck, a native of Utrecht, was a renowned medallist and sculptor. He worked in Poland, in various cities in the Low Countries and (between 1562 and 1563 and from 1565 until his death) in London. There is some suggestion that he might have been a 'cutter of stones for rings', presumably an engraver of heraldic badges and seals.[74]

Oil on panel, dated 1564, Royal Picture Gallery Mauritshuis, The Hague; inv. no. 117

present themselves to the wardens at Goldsmiths' Hall in Foster Lane, swear an oath to obey the ordinances of the Company, and pay an admittance fee of three shillings. In addition, they were required to provide some kind of proof – a letter of testimonial or curriculum vitae – to show that they were honest workmen with proven skills and abilities and that they had come to London for genuine reasons. After all, the Company did not want to be saddled with rogues who would bring the trade into disrepute. Often, however, it proved difficult to obtain the proofs needed and some strangers obtained a licence before the Company received their supporting letter of testimonial. Eventually, it was decided to tighten the ruling, and in 1574 no 'stranger born' could obtain a licence until the requisite proof had arrived.[80]

From 1558 to 1598 over 500 stranger masters and journeymen were accepted into the Company. Of these 40 per cent came from Antwerp and 29 per cent from other cities in the Low Countries; 16 per cent came from France and 14 per cent from Germany.[81] The remaining 1 per cent comprised workers from Poland, Sweden, Norway, Italy, Spain and Portugal, but records show that a good number had worked in Antwerp before they arrived in London. The number of stranger goldsmiths admitted to the Company declined rapidly in the seventeenth century; only one received a licence between 1624 and the Great Fire in 1666.

The ratio of stranger to English-born goldsmiths in London in the first half of the seventeenth century was almost certainly higher than Company records and other official figures suggest. It is clear from inventories, court records and other accounts that a large number of stranger goldsmiths and jewellers operated independently of guild control and saw no need to obtain a licence to practise their trade. Among them were those who had royal appointments and those with letters of denization, who were granted special rights and privileges which entitled them to purchase land, set up a shop, apprentice their children

The Syndics of the Amsterdam Goldsmiths Guild, 1627, by Thomas de Keyser. Loef Vredericx (*left*), holds tongs with a cupel – a small porous vessel of bone ash used for refining and separating precious metals for assay. The chief assayer, Jacob le Merchier (*seated right*), clasps a set of touch needles.

Oil on canvas, Toledo Museum of Art, Toledo OH, 1960.11

to English masters and employ up to four stranger journeymen. In all likelihood, many of the stranger and non-free goldsmiths were content to work in relative isolation. As one historian has put it,

> they worked hard and independently within their own circles. Except in times of economic or social stress, or when molested by informers or by a busy-body government … they were permitted to pursue their activities with little interference. It is

of interest that, often when troubled, they felt sufficiently secure to protest in no uncertain terms.[82]

By no means all of the immigrants who came to London for work had advanced skills and knowledge, and records suggest many came to acquire new techniques and gain experience before moving elsewhere. Gerrard Pulman (see following chapter) from Westphalia spent two years in London as a journeyman for the goldsmith Nicasius Russell, but then travelled to Africa and other parts of the world as a gem dealer and jeweller. But London was not the only city offering crucial vocational training; the sons of first-, second- and even third-generation immigrants travelled widely to perfect their trade and extend their network of contacts. Nathaniel Hardrett, a resident of Blackfriars and the son of a prominent French immigrant jeweller, drafted a will in 1613 because he purposed for his 'prosperity and good' to travel to France where he was born and to visit 'other places beyond the seas'.[83] How long Nathaniel stayed abroad is unknown, though he was evidently back in London by 1637. The extent to which these craftsmen were able to influence taste and fashion, 'practise their science', introduce new techniques and develop their skills and contacts, is very difficult to assess. What is certain, however, is that the community of goldsmith jewellers in London was truly cosmopolitan; their trade networks were sophisticated and diverse and their work, as John Mabbe the Younger argued in 1576, was 'made and wrought, as well in this Kyngdome of England as beyond the seas ... for the service of Us and our Nobilitye'.[84]

A world encompassed

T HE CHANGES that took place in the pattern of English overseas trade in the late sixteenth and early seventeenth centuries had a direct impact on London, the principal port and commercial hub of the nation. New mercantile companies were formed, new trade routes were established, the market for English goods expanded, and English ships and merchants had direct access to sources of supply. Although it is impossible to measure the volume of English overseas trade and its true impact on the national economy, the greater part was funnelled through London. The capital's size and prosperity were a source of national pride but foreigners were also impressed; when the Swiss tourist Thomas Platter visited London in 1599, he observed that

> most of the inhabitants are employed in commerce; they buy,
> sell and trade in all corners of the globe, for which purpose
> the water serves them well, since ships from France, the
> Netherlands, Germany and other countries land in this city,
> bringing goods with them and loading others in exchange for
> exportation.[1]

As the flow of exotic materials from the Orient and New World increased, Londoners' enthusiasm for new-fangled fashions reached extraordinary heights, 'with monstrous ruffes … a quarter of a yard deep', crested wire-work hair ornaments, vast farthingales, feathered caps, richly embroidered cloths and sparkling jewels.[2] Even the Queen, as Francis Bacon rather unkindly put it, 'imagined that the people who are much influenced by externals, would be diverted by the glitter of her jewels from noticing the decay of her personal attractions'.[3]

previous page Seventeenth-century travel chest and writing materials.

Museum of London collections

Most of the trading companies hoped to find precious stones and metals to force their European competitors 'out of trade to idleness',[4] but it was a little while before they realized that they needed on-the-spot expertise. Some of the companies learnt the hard way. The Virginia Company was so keen to make a quick profit for the colonists and their backers in London that it filled the first ship that returned to England on 10 August 1607 with 'gilded dirt'. When the cargo was tested in London the dust 'turned to vapore'.[5] The need for specialist advice was abundantly clear, a point rammed home by John Saris, the East India Company factor in Bantam, who wrote to London in 1608 in some exasperation that he had 'many times' appraised the Company of the Flemings' trade in Sukadana diamonds and 'of their manner of dealing for them for gold'; he saw no reason why the English should not do the same, except that the Flemings had 'a little better instructions from their masters touching all sorts of jewels, than hitherto we have had'.[6] Steps were taken to improve the situation, and in 1609 the jeweller Anthony Marlowe was the first specialist to be contracted by the East India Company to purchase 'Diamonds, Bezar stones, Muske & other rarities (whereof hitherto we have had none)'.[7] Within a few years, most of the East India Company trading posts and factories employed jewellers on short- or long-term contracts. John Browne signed a contract for five years in 1614, and in the same year the jeweller John Milward was 'entertained in the Company's service at 100 marks (£66 13s 4d) a year'.[8]

There was usually a delay of 12 to 18 months between the placement of an order and its delivery, so the Company jewellers played a key role. They acted as principal agents and brokers for the factors and negotiated deals with local suppliers and gem merchants. With their intimate knowledge of the home market they were also able to provide a valuable service for their London-based colleagues, procuring stones of the right size, colour and quality and at the best price. Most were honourable and hard working but a few began to set up

scent bottle

'Tell, if thou canst, (and truly) whence doth come
This Camphire, Storax, Spiknard, Galbanum:
These Musks, these Ambers, and those other smells
(Sweet as the Vestrie of the Oracles).'

Robert Herrick, 1648 [9]

This richly bejewelled scent bottle is a fitting receptacle for rare, exotic and costly ingredients. The vessel was designed to rest on its base or hang pendant-fashion from a girdle or neck chain; the narrow neck and tight-fitting screw-cap would have helped to minimize spillage and evaporation. The shape and compartmentalized design are suggestive of a segmental pomander, and the contents were no doubt used in a similar fashion to ward off 'pestilential airs and noxious stinks', for scenting gloves and handkerchiefs and for dabbing on the skin. For nothing, wrote the physician William Vaughan in 1612, 'can so exhilarate and purifie the spirits as good odours'. [10]

It is possible that the gemstones were chosen as much for their emblematic and metaphysical significance as for their beauty. Rubies were commonly used as amulets against the plague and other contagions, and, according to Pierre de la Primaudaye in *The French academie: Fully discoursed and finished in foure books*, published in 1618, diamonds 'beeing tied to the flesh of the left arme [do] hinder and withstand the feares of night', while opals,

'which for variety of colours [are] accounted amongst the most precious stones [are] very good for the head, and comfortable to the sight'. [11] Magical and therapeutic qualities were also ascribed to the animal secretions and plant extracts used in perfumes, and some oils and essences were considered to be particularly efficacious. Lavender, especially if combined with cinnamon, was used to prevent convulsions; rose, lemon and violet scents were useful for 'Sudden Faintings and Swonning', while musk (from the scent glands of the musk deer), an essential ingredient in most perfumes, had a reputation for relieving melancholy. [12] Ambergris (a waxy substance from the digestive tract of the sperm whale), used in most aromatic compounds, was held to protect the wearer from plague.

The Privy Purse Expenses for the Elizabethan and Stuart courts include many references to exquisitely wrought containers for pomanders and perfumes, but some of the best evidence comes from the accounts of the royal apothecaries, who supplied sweet bags, distilled waters and perfumes both for the monarch's own use and for the laundresses,

barbers, grooms and coachmen. The privy chambers and state rooms were sprinkled with orange, lemon and rose waters, and even the royal coaches and barges were scented so that the monarch was enveloped by the perfumed air. [13] Elizabeth favoured lighter perfumes of the sort described by Shakespeare as 'summer's distillation left'. [14]

Precious metal casting-bottles and pomanders of sixteenth- and early-seventeenth-century date have survived in some numbers in European collections, but heavily enamelled, gem-set examples are rare. The Cheapside Hoard scent bottle is particularly distinctive because it is so richly bejewelled on an enamel ground, and it is the only one known of its type with gem-set plaques and a gem-set chain, though two other bottles of similar size, shape and probable date, with a white enamel ground studded with emeralds and rubies, have survived among the collections of William Henry Cavendish-Bentinck, third duke of Portland (1738–1809). [15]

A key element of the decorative scheme on the Cheapside Hoard scent bottle is the use of 'peascod' ornament in both the enamel work and the

pierced and gem-set strapwork. The peascod or peapod ornament derived from the garden pea (*Pisum sativum – Papilionaceae*) was an extremely popular motif in Tudor England, and designs incorporating the blooms, buds and trefoil stem of the plant feature widely in Elizabethan embroidery and decorative arts.[16] Peapod designs were also in vogue in France during the early seventeenth century, and it is possible that the ornament on the Cheapside Hoard flask was inspired by designs printed by Henry Toutin in 1628.[17]

Why the scent bottle was buried among the stock of a London goldsmith is unknown. Was it made to commission? Had it been brought in for alteration or repair? Is it the product of a Parisian or a London workshop? These questions remain unresolved, but this precious container, filled with an alluring blend of exotic eastern fragrances, must have been a powerful signifier of the owner's wealth and status: a potent expression of England's mercantile expansion and global trade.

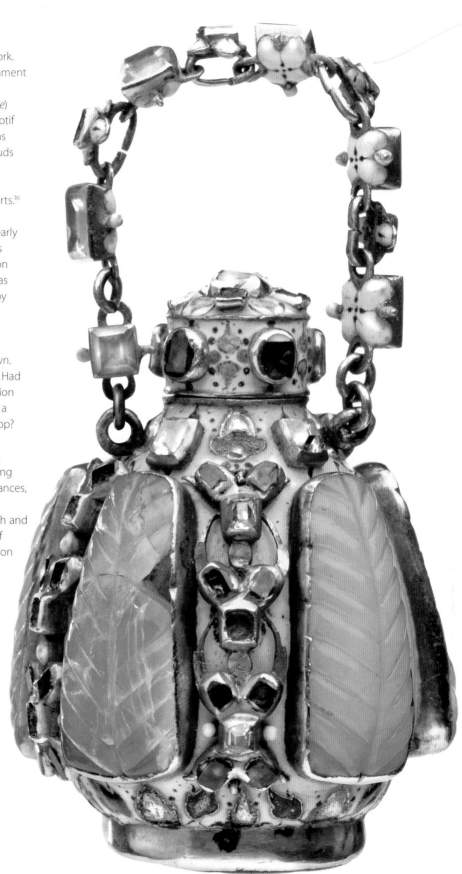

A14156 shown enlarged and actual size. Enamelled gold, opals, opaline chalcedony, diamonds, rubies, pink sapphires and spinels

on their own account. In 1615 the East India Company found that Hugh Greete, 'skilful in jewels and stones', had been engaged in private trade and had 'cozened them', ostensibly buying diamonds for the Company's use, while removing the best for himself. When Greete was challenged he complained that he had written four times without receiving a response to his question regarding the current rates for diamonds in England and had been 'forced to by them at hap-hazard'; had he been given more money, he said, he could have made 'every hundred a thousand'.[18] Despite his protestations of innocence, for this fraud and various 'other misdemeanours' he was sent home a prisoner in irons.[19]

One of the most striking features of the Cheapside Hoard is the variety and quality of gemstones. Some are readily identifiable to a specific country or region. Among these are emeralds from Colombia; heliodors from Brazil; chrysoberyls, spinels, moonstones, sapphires and iolites from Sri Lanka; rubies, chalcedony, diamonds and garnets from India; lapis lazuli and turquoise from Afghanistan, Iran and the Sinai Peninsula; peridots from the Red Sea Island of Zebriget; malachite and azurite from Russia; and rock crystal and amber from Continental Europe. Pearls and other stones are much more difficult to source, but all reflect London's international trade networks in an age of global conquest and exploration.

Nothing is known about how the Cheapside Hoard gem material arrived in London. By remarkable chance, however, a collection of documents has survived which offer an extra-ordinary insight into the nature of the trade and go some way to answering how gems arrived in the capital, where they were cut, and to whom they were sent. The following chapter is entirely drawn from these records, which cover the period from 1631 to 1641. They are presented here as a case study to illustrate London's role in the international gem trade. Some of the evidence comes from East India Company Court minutes and correspondence, but the largest part is derived from a series of

legal documents, mostly in the form of affidavits, petitions and witness statements against the Earl of Lindsey and the Master of the East India Company. The petitions were submitted to the House of Lords by two Dutchmen: Dr John Higenius, administrator 'of the goods of Gerrard Pulman, late of Westphalia, deceased at sea in a ship of the East India', and his agent and attorney John Guile. Their complaint, neatly summarized in a written statement of 28 April 1637, is given here in full:

> Gerhard Polman, gem merchant and jeweller after traversing many countries in search of precious stones … in the year 1631 put himself on board an English East Indiaman in Persia on his way home. He had with him a large collection of gems and precious stones, collected during the previous thirty years. On the homeward voyage Polman was poisoned by Abraham Porter, surgeon of the East Indiaman, and his goods were divided among the crew of the ship. The crime becoming known, parts of his estate ultimately came into the hands of the East India Company; of the Earl of Lindsey, to whom letters of administration were granted in trust for the true heirs; of Nicholas Pope, goldsmith in Fleet Street, and Rachael, his wife; of one Nowel, a goldsmith on Holborn Bridge; and also of Christopher Adams. Against these persons Heigenius now seeks justice.[20]

A board of enquiry was set up to investigate the matter and during the course of 1641 a team of commissioners under the Great Seal of England were granted special powers to examine the 66 witnesses. Their depositions, entered on a vast parchment roll of 30 skins, form the basis of the following account, which starts in Persia, covers the voyage back to England and follows the trail of gemstones and jewels among the goldsmiths' and jewellers' shops in London. Everything in the following account is derived entirely from the witnesses' statements, and as far as possible they have been allowed to speak for themselves.

By remarkable chance the ship's log, 'A Journal kept by me John Vian from England to Endie and Persia and from thence backe again…', also survives, providing graphic details about the voyage, weather conditions and the various ports of call.[21]

Also surviving, and included here, is an inventory of the stock of one of the goldsmiths who received some of the stolen gems and jewels.

Together, these sources provide a very colourful and detailed picture, and provide new insights on the nature of this complex trade and the work of the jewellers, goldsmiths and gem cutters in London. Almost all of the information presented in the following pages is published here for the first time. Items from the Cheapside Hoard have been used both to illustrate the text and to provide additional information on the international gem and jewellery trade.

Persia

The order came at dawn on the 16 January 1631. Signals were exchanged and the hands went aloft to unfurl the sails. The cargo hatches were secured and then, with the clink and rumble of chains, five East India Company ships and four Indian junks weighed anchor and moved into the Swally channel on the Gujarat coast. One by one the *Royal James*, *William*, *Blessing*, *Discovery* and *Reformation* slipped across the sand bar at the harbour entrance. The guns were run out and hands were sent to the mastheads to keep a sharp lookout for Portuguese warships, which were gathering in the south. The offshore winds were light and the sails hung limply against the masts. But just after midday, in a freshening breeze, the fleet began to make headway through the Bay of Cambay and the course was set for the Persian Gulf.[22] Three weeks later, as the towering cliffs of the Arabian Peninsula came into view off the port bow, the fleet entered the Straits of Hormuz, and at sunset on 7 February 'greatly to the rejoicing of the merchants and peoples' dropped anchor in a broad bay beside the town of Gombroon on the Persian coast.[23] Gombroon was a natural haven for merchant ships. Encircled by hills to the north, and protected on its seaward side by a large fort and the islands

of Qishm and Ormuz, it was an *entrepôt* of commercial and strategic importance and the principal trans-shipping port of the Silk Road. The town, 'in compasse about two myles', with gardens, springs and houses of sun-dried bricks, was largely abandoned in the heat of summer, but in winter 'merchants of sundry Nations; English, Dutch, Persians, Indians, Arabs, Armenians, Turks, Jews' thronged the bazaar, warehouses and quays.[24] Camel caravans from Isfahan and Afghanistan brought silks, carpets, almonds, dates, rhubarb, pomegranates, currants, oranges, rosewater, precious stones, sherbet and flowers; dhows from Zanzibar and Bahrain brought dyestuffs, spices and pearls, and the English ships discharged their cargoes of broadcloth, calico, quicksilver, saltpetre and tin.

'a jeweller of good estate'

While the *Discovery* and her sister ship the *Reformation* rode to anchor four miles south of Gombroon,[25] the merchants, factors and East India Company agents negotiated the shipping manifests and the bills of lading. Most of the crew went ashore. As they wandered through the narrow streets, two shipmates from the *Discovery*, Edward Castleton, trumpeter, and Christopher Addams, carpenter, came upon the house of a Dutch jeweller and there saw 'lyinge loose upon the windowes … and alsoe in boxes … divers and sundrye ringes with stones in them of severall cullors' with piles of cut and polished red, green, grey and yellow stones.[26] The mariners were welcomed with great courtesy, and over the following days and weeks many of their shipmates beat a path to the jeweller's door. The jeweller also entertained several of the chief officers and gave them lavish presents of rings and stones.[27]

Then rumours began to circulate that Gerrard Pulman, a 'very honest man … of good estate'[28] worth over a 'hundred thousand powndes in jewels',[29] had made arrangements with the East India Company for his safe passage to England on board the *Discovery*. One hundred pounds exchanged hands and

Letter from The Great Moghal Jahangir of
Persia to James I, King of England, 1617

When your Majesty shall open this letter let your royal
heart be as fresh as a sweet garden. Let all people make
reverence at your gate ... [let] all monarchies derive their
counsel and wisdom from your breast as from a fountain.
... I have given my general command to all the kingdoms
and ports of my dominions to receive all the merchants
of the English nation ... that at what place they choose to
live, they may have free liberty without any restraint; and
at what port soever they shall arrive, that neither Portugal
nor any other shall dare to molest their quiet; and ... I have
commanded all my governors and captains to give them
freedom answerable to their own desires; to sell, buy, and to
transport into their country at their pleasure.

 For confirmation of our love and friendship, I desire
your Majesty to command your merchants to bring in their
ships of all sorts of rarities and rich goods fit for my palace;
and that you be pleased to send me your royal letters by
every opportunity, that I may rejoice in your health and
prosperous affairs; that our friendship may be interchanged
and eternal.

 Your Majesty is learned and quick-sighted as a prophet,
and can conceive so much by few words that I need write no
more.[30]

Letter from Shah Sefi the First, Emperor of Persia,
to King Charles I of England, October 1630

[I have] commanded my ministers to comply with the
English merchants in going and coming after the speediest
and most perfect manner and to further in all matters the
bonds of unity and concord which have hitherto existed
between his Majesty and the Emperor's grandfather and
to confirm and every day more and more to increase the
same. His ports are always open both to the commerce and
embassies of the English nation at any time that they have
business and affairs in these parts.[31]

Map of Arabia and Persia from
Abraham Ortelius, *Theatrum Orbis
Terrarum* , c. 1570.

Mr Haynes, president of the Company in Persia, climbed on board to make the necessary arrangements with the fleet commander and inspect Pulman's quarters. The ship's lamplighter overheard their whispered conversation, and noted that the master was instructed to 'have a speciall care of the jeweller in the voyage [so that] he should want for nothinge therein'.[32] Pulman was given the best cabin, and a few days later, being infirm and 'sickleye', was winched on board in his bed. Bundles of bedding and the rest of his possessions followed. Chests, caskets and bolts of gold and silver cloth were hoisted onto the deck. A large chest bound with nailed cord 'a yard and a half in length and half a yard in breadth and height', which took three men to lift, was stowed in his cabin. Next came an unlocked trunk full of 'working tooles as were belonging to a goldsmith: files, anvils, sheares, plyers, raspes and such like', together with a very large rough green stone, eight or so inches in length and two inches in compass. Three more locked boxes, of different shapes and sizes, and sundry small caskets all securely locked, were brought on board. Finally, a massive sea chest that was too large to fit in the cabin was manoeuvred into a space under the half-deck, 'beinge conceaved to be one of the safest places' in the vessel.[33]

Watercolour of Gombroon (Bandar Abbas) in *c.* 1704 by Cornelis de Bruyn. According to Robert Sherley, head of the English mission to Persia, the port of Gombroon was 'the best and strongest among the Persian King's dominions'.

National Archives of the Netherlands, inv. no. 29

The voyage

On 18 March the fleet set sail. The *Royal James*, *William* and *Blessing* departed for the Indian port of Surat and the *Discovery* and *Reformation* took a southerly course for England.[34] With favourable south-westerlies, the ships made good progress and the crews settled to their tasks. But the passenger on the *Discovery* attracted a great deal of interest. The ship's quartermaster, John Phillipps, a Fleming, in whom Pulman placed much trust, was appointed to attend to him, and the hands observed that they were often closeted together, whispering and talking in Dutch. Then Phillipps told the officers and crew that Pulman had brought with him a 'great diamond about his necke which cast such a lustre of candles burning whose worth was such that noe man knowe well what to value yt' and, that he also wore, next to his skin, a girdle with several compartments or pockets containing a great many diamonds and other precious stones, worth £150,000.[35]

'closelye filled and packed with jewells for shining'

The crew were intrigued. The more they heard the more they wanted to know. They sought every opportunity to spy and

made various excuses to visit Pulman's cabin, where 'usuallye and dailye [he was employed] in cuttinge and polishing pretious stones and settinge of them in ringes and jewels and in devisge of other works belonging to a gouldesmith or jeweller'.[36] Christopher Addams noticed that the large chest in Pulman's cabin contained two small boxes and at least 20 bags filled with precious stones and pearls, various pouches with gem-set rings and loose stones wrapped in cloth of tissue, and that it was 'so closelye filled and packed with jewells for shining that [they] thought the caben was a fire'.[37]

Nine weeks later,[38] the *Discovery* and *Reformation* made landfall on the island of Mauritius to take on fresh water and supplies. While the ships swung on their anchors in Turtle Bay,[39] most of the crew disembarked to wash in a fast-flowing river. Pulman joined them, wearing the pouch around his neck and the leather belt which contained his most prized gems. As he waded out into the stream and stooped to bathe, the current dislodged his greatest treasure: a rough diamond of the 'bignes of a walnut', valued at £60,000, and to his horror it vanished in the flood.[40] The shock was so great that he let out a piercing shriek and wail 'and did proffer to such of them present as shoulde find the same greate rewardes'. But, after a frantic search, Pulman returned to the ship empty-handed and bowed down with grief.[41]

Two weeks later Gerrard Pulman was dead.[42] His body was stripped and 'heaved over boorde'.[43] The following day, the captain, purser and other officers entered his cabin. Some of the chests were removed to the steward's quarters and the lids were nailed down.[44] Other chests were taken by the captain and officers to their cabins,[45] and the master commanded the boatswain to bind the large chest under the half-deck with 'coardes for the better securing thereof'.[46] The keys for the chests and caskets were given to the purser.

'The ship's Commanders have to watch
their men as a cat watcheth mice'[47]

A few weeks later, Captain Bickleye died as the ships were passing the Canaries. Though some of the chief officers took 'order for safe keeping of [the goods] which were laid up [and] lockt up until the East India Companye might have the viewe of them',[48] some of the ship's company conspired to steal Pulman's treasure. The very nature of the crime required stealth and secrecy, and there were muttered conversations, whisperings and signs. Then on a particularly dark night John Phillipps, Christopher Addams, Edward Castleton and Abraham Porter, the surgeon, broke into one of the chests which had been moved to another part of the ship. Addams used his carpenter's skill to prise open the bottom of one of the chests; as the board came away bags of pearls and precious stones fell to the deck. They divided the spoils between them.[49] A few days later Addams broke into another cabin, where he filled a large box with more jewels and hundreds of precious stones. He also helped himself to several bolts of gold and silver cloth. Then, as he pulled out a length of fabric to inspect it, spills of paper dropped to the floor; to his delight, each spill concealed a ring and there were many more tucked within the folds of fabric.[50]

After a very stormy passage in the North Atlantic, the ships finally arrived at the western approach of the English Channel. Then, in an oily, quiet sea, the winds began to back, the sky darkened and, just as they were passing the Isles of Scilly, they were hit by a sudden squall. A violent gust slammed into the rigging, and before they could reduce the sails the *Discovery* broke her foreyard. The spar snapped in half, the forestay bolt was wrenched from the deck and the foretopsail blew away. With much of the canvas in ribbons, part of the spar on deck and part dragging alongside, the ship was in extreme peril. And it was then, with pandemonium on deck while the hands were desperately trying to take in the yard, that the conspirators

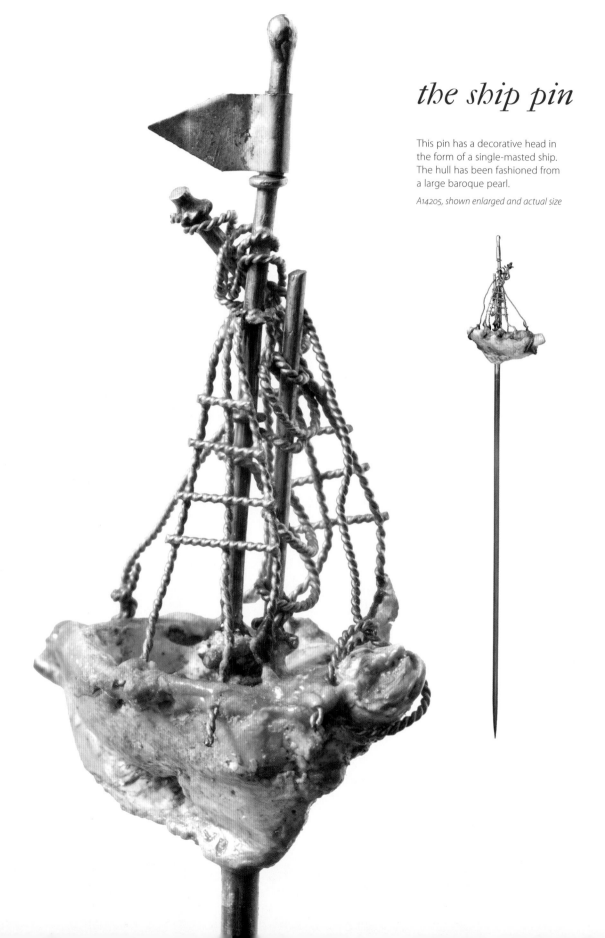

the ship pin

This pin has a decorative head in the form of a single-masted ship. The hull has been fashioned from a large baroque pearl.

A14205, shown enlarged and actual size

made for Pulman's caskets, being the 'best opportunitye for the breaking open thereof'.[51] Christopher Addams seized several small boxes, and in the safety of his carpenter's workshop he tipped out the stones to view them. There were hundreds of precious stones, many cut and polished; several rings; and a large jewel set with two emeralds and a ruby, and in the middle a huge white stone two inches square in the form of a heart set in gold, which 'did cast in the darke an extraordinary great lustre'.[52] But when he tried to put them back again, he found that he 'could not for that [he] knowe not howe to place them in manner as theye were before'.[53]

The Downs

While the storm raged for sixteen hours, the *Discovery* had to lie ahull and 'durst not lay any sayll'; then gradually the wind abated, and in heavy seas, hail and fog the ship wore on towards the Lizard where it met a French vessel from St Malo. News was exchanged and the French skipper handed over some apples and three small bottles of wine for the crew.[54] Days of calmer weather followed and on the 13 November the ships arrived in Dover, where Captain Bickell, as an officer of the East India Company, was carried ashore for burial. The following day, the *Discovery* reached the shelter of the Downs, 'over against Deale' on the north Kent coast. While the ship rode to anchor to wait for a pilot and enough wind to bring her around the North Foreland into the Thames estuary, the East India Company sent out a flotilla of small boats to remove some of the cargo to lighten her.[55] Addams took advantage of the two days' wait to jump ship with his booty[56] and he 'conveyed into a hoye the box [of jewels] together with divers bags and other goods' and sailed around to Blackwall, on the north-eastern shore of the Isle of Dogs. Making his way to the house of John Hedd, a fellow shipwright, where he stayed overnight, he took out some of the jewels to show his hosts and their children and serving maid. Early the

next morning he asked Hedd's wife if he could borrow one of her husband's hats so that he could travel incognito, and in regard of her 'curtisye … shewed her a handful of stones of severall cullers and wisht her … to make choice of one … whereuppon she did take one red rownde stone'.[57]

Having stowed the booty in Hedd's house, Addams went up to London to see his cousin James Smyth, a carman. Later that day he returned to Blackwall, where he stayed until after midnight; then, hailing a wherry, he transferred all of the goods to Puddle Wharf in the City of London. Smyth was waiting with his horse and cart. Together they heaved on to the cart one large chest, several small boxes, various bundles and a great pack of East India quilts. The only outstanding item was a special 'black box', which, despite his cousin's entreaties to lay it on the cart or let him 'carry it under his arm', Addams simply refused to give up. Smyth's curiousity was aroused, but when he asked what it contained he was given a quick glimpse of some agate-hafted knives 'as he conceived them to be',[58] before the lid was slammed shut. As they trudged through the streets the weight of the black box became too much and so Addams reluctantly allowed Smyth to place it on the cart. Finally, after much effort, they arrived at Smyth's house at the sign of the Cock in Cloth Fair at four o'clock in the morning.[59] The following night they took the treasure to the house of Susan Bradaye in Hockley in the Hole, near Clerkenwell.[60]

Meanwhile, word of Pulman's treasure had spread among the fleet at the Downs. The East India Company agents and officers were notified and rumours of Pulman's fortune reached London. Edward Castleton, the ship's trumpeter, had also jumped ship with some of the booty. Having made his way to the capital, he sought out James Sympson, a goldsmith in St Botolph's Aldersgate, who dropped everything to rush down to the coast. As soon as it was dark, Sympson made his way out to the ship, where he saw 'manye of the mareyners beinge then on the decke in their watch and within hearing … haveing

hardstone tablewares

Tablewares made from precious and exotic materials were not designed for actual use but were kept for display where they could be admired by the privileged few. The small collection of hardstone objects in the Cheapside Hoard reflects the refined tastes, connoisseurship and affluence of the seventeenth-century collector and contemporary interest in the natural world. The banded and variegated agates include a broken knife handle, several finely carved and partially worked spoon bowls, a rim sherd and a couple of bowls.

The Chinese nephrite jade (A14083) was probably traded via the Silk Route, but the handle is stylistically European. Even chipped, fractured and incomplete objects had a value and the hardstones in the Hoard were probably retained in the jeweller's stock for reuse.

clockwise from top left: nephrite jade knife handle A14083; agate knife handle A14317; agate spoon bowls A14080, A14078; rim fragment from a bowl A14181; calcite bowl A14345; agate bowls A14091, A14206

lightes with them [talking] privately one to another that a great sea chest of five foot long … with more chests and boxes in the hold were full of jewels and pretious stones'.[61] Sympson listened attentively. Then John Phillipps emerged from the shadows to speak with him. Phillipps told him about Pulman's death, and Sympson promised to keep his confession secret on the understanding that he was given a good deal and could be 'made a man for ever in his profession as a jeweller'.[62]

Gravesend

By the time the ship arrived at Gravesend a small party of jewellers, goldsmiths, gem merchants and dealers were waiting. John Arson, a jeweller, with a shop in the Strand near Charing Cross, was one of them. As soon as he climbed on board, the surgeon, Abraham Porter, produced some 'white cornelian beades readye strunge to the quantity of half a bushel'.

'View of Greenwich' c. 1620–30, showing the Isle of Dogs with the deep-water harbour at Blackwall (far right) and London on the skyline (left). *64.52*

Arson was later seen in the company of a Frenchman in both Gravesend and Woolwich, where it was reported that he had purchased a good number of pearls and precious stones.[63]

Rumours began to circulate that 'a certeyne [French] jeweller' had visited the *Discovery* and interviewed the sailors to find out if they had any jewels to sell. Whether this was Arson or his compatriot or someone else is unclear. Before long other French jewellers began to arrive and the mariners instructed them to bring the money 'in their purses and meet them ashore in a wood neere Gravesend … where they would shoe them the choice of good jewells and afforde them goode bargains'.[64] A small group of French jewellers who had repaired to the wood bought up a goodly stock of jewels and then left immediately for France. Not to be outdone, many London jewellers arrived on the scene. James Sympson and the jeweller Anthonye James joined forces with fellow goldsmith John Nowell to buy some of the jewels, and bargains were struck with several sailors,

including John Phillipps of the *Discovery* and his friend George Newell of the *Reformation*.[65] There was so much trade that the goldsmiths hired a private chamber in a local hostelry to view the jewels.[66] John Nowell brought £40 with him and returned home with a 'small boxfull of rough diamonds' with the promise of more to come.[67]

On 24 November 1631, the *Discovery* arrived at Erith. Over the next three weeks, lightermen and stevedores began to discharge the cargoes. Pulman's goods were removed to the Custom House nearby,[68] and it was there that one of the East India Company officials saw a very large chest containing a linen bag filled with rough turquoise, agates, topaz, cornelians and some 'peeces of enamel'. Below this was a large leather bag holding hundreds of chalcedonies, agates, topaz, cornelians, heliotrope, cat's eyes and various other stones, with two or three silver rings set with agate, a couple of cornelian rings and twenty bracelets of agate beads. They also found some gold and silver cloth, some loose topaz, books of calico and an Indian bow with arrows, as well as 'certeyne instruments belonging to a goldsmith or jeweller'. The trunk was only half full.[69]

London

'be contented for wee are made for ever'

Shortly after the *Discovery* arrived in London, Robert Bertie, 1st Earl of Lindsey (1582–1642), privy counsellor, Lord Lieutenant of Lincolnshire and a Knight of the Garter, was granted letters of administration for Pulman's goods. He immediately employed agents to track down the thieves and their accomplices.[70] To help him recover the jewels, the governor of the East India Company, Sir Maurice Abbott, sent the earl a 'leatheren strippe or pouche wherein was conteyned divers writings which were belonging to the saied Pulman'[71] and Richard Swinglehurst, undersecretary of the East India Company, was engaged to search the goldsmiths' and jewellers' shops.[72]

cat's eyes & moonstones

Yellow green chrysoberyls with a pale grey or white flash, popularly known as cat's eyes, came from Sri Lanka. They were greatly loved by the Indians and Chinese, 'whither they be carried and better soulde then any other stones', but were disregarded by the Portuguese.[73] English gem merchants tried to bargain for the best stones for their clients, since cat's eyes were believed to increase wealth.

The cat's eyes in the Hoard are open-set so that the stone could touch the skin. The Hoard also includes several unset moonstones, a ring with a moonstone cameo frog and a very rare Sri Lankan fibrolite.

Believed by some to have been formed in the body of a snail, moonstones in red, white, purple and the lightest greens, blues and greys were mined in Persia and Sri Lanka. One seventeenth-century gem merchant suggested that the stones waxed and waned as 'the mone dothe' and recommended putting them under the tongue or to the lips, to bring 'foreknowledge of things to come'. Moonstones were also worn to arouse tender passions. They are seldom mentioned in London records, although on 30 April 1613 one Londoner who was assaulted on the highway in Clerkenwell lost his sword, worsted stockings, silk purse and several rings, including one set with a moonstone worth £3.

above: moonstones (from left) A14367, A14323, A14314; fibrolite A14342; below: cameo frog ring A14243; cat's eye rings (from left) A14239, A14238, A14240 (front and side)*

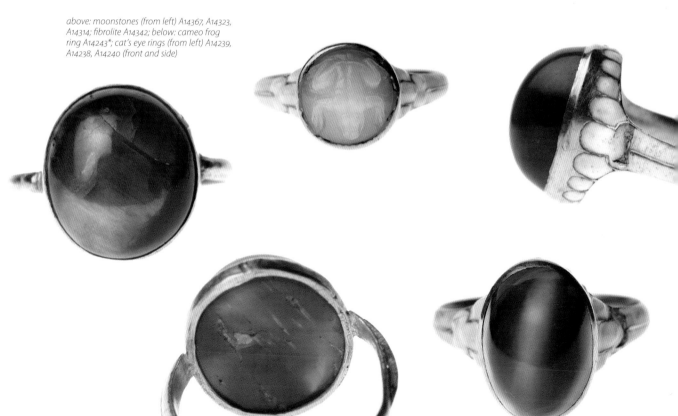

In the meantime, Christopher Addams had been busy. Having deposited most of the jewels in Susan Bradaye's house in Clerkenwell, he set about trying to sell them. A couple of days after he arrived in Hockley in the Hole he stuffed his pockets full of pearls and precious stones of 'divers and sundreye cullers most … beinge cut and polished … to the quantity of three pintes' and set off to find a goldsmith. More or less on the off chance, he arrived at the shop of Nicholas and Rachael Pope in Fleet Street. Addams began to pick over the goods on their stall, and while he was playing idly with a 'cheyne of pearles' Mrs Pope eyed her customer with some suspicion. After a certain amount of shilly-shallying and general chit-chat, Mrs Pope – who subsequently observed that 'that he did looke like one that woulde rather sell then buye' – asked him outright if he had 'any such to sell'. Whereupon Addams said that he did and followed her into the shop, where he drew out a bag of pearls. Rachael Pope asked 'whither he had any more', in response to which Addams emptied his pockets, placing two or three more bags of pearls and one bag of stones on the counter. Nicholas Pope was summoned and in his presence the pearls and stones were appraised. A bargain was struck and Addams agreed to sell the lot for £22.[74] He received £13 for pearls at 2s 6d the ounce and £9 for stones, but the wily Popes only gave him £20, holding back £2 until 'suche tyme … [as he could] bringe more to be sould'.

Later that day, the goldsmith John Critchlowe was passing by Pope's shop when he was summoned inside to see the pearls and a bag of blue sapphires. He was also shown another bag containing four agates, four cornelians, chrysolites and amethysts of 'noe greate value'. Pope then asked what he would say 'to a bagge of diamonds but showed none'. In Critchlowe's hearing he told his wife that she should be 'contented for I hope wee are made for ever [and] that god had blessed [us] well that daye for that he had bought that good bargaine that morning'.[75]

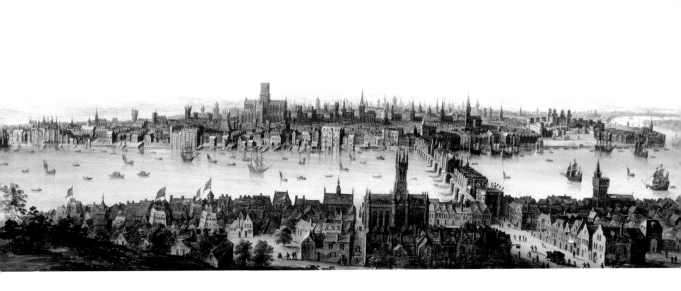

In the meantime Addams went on a spending spree. After a celebratory drink in a Tower Hill tavern with other mariners, he took out a dozen coloured stones, some of the 'bignes of smale nutes some bigger', which he boasted had come from Pulman's treasure.[76] He then showed the assembled company a leather belt of three fingers' width fastened with a buckle of gold or silver gilt, to which three or four button-sized cut and polished white stones were fastened. Only part of the belt and its contents was visible because Addams kept the rest hidden under his britches, codpiece and pocket.[77]

The spending and drinking continued, but unfortunately the carpenter and his cronies had loose tongues. At the Three Tun Tavern in Fleet Street, Addams started to talk about the *Discovery* and then drew out a parcel of thirty or more cat's eyes and yellow, blue, red and green stones, most cut and polished, transparent and 'verye cleere [and] as broade as the nayle of a mans thumbe and the thickness of a mans forefinger', together with a finely woven net bag containing pearls of the size of 'ordinary buttons worne at a mans dublet'. Stones were held up to the light, pearls passed from hand to hand, bags of stones were tipped onto the table and one very large pearl, worth '£200 at the least', fell through a gap in the floorboards.[78]

Painting of London from Southwark, c. 1630. This is the earliest known painted view of the capital.

Oil on panel, not signed or dated, 92.7

After another night on the town, Addams fell into a ditch near Holborn Hill, spilling a 'handkercher full of stones and jewels' on the ground. Some 'cast suche a shimmering lighte or lustre like gloe wormes' that they were easy to pick up, but others were lost in the mire.[79]

Rings and other jewels were given to friends and female relatives.[80] Addams showed a barrel of coral to Tomison Roberts, a cook at the sign of the Shovel in Saint Katherine's by the Tower,[81] and in a cookshop in Shoe Lane, in full view of the other diners, he brought out a net purse containing a fair white stone a quarter of an inch square, set in gold with another white stone or pearl pendant and just under a quarter of a pint of 'faire transparent stones some green, some red, blue and white'.[82]

Three days after his first visit to Pope's shop, Addams returned with his friend James Hubbard.[83] As they looked at the stall, Mrs Pope rushed out of the shop and informed Hubbard that she would 'deale with Addams onlye', dismissing him with the remark that 'the bargain they were about to make had nothing to do with him'. And so while Hubbard loitered in the street, Addams was promptly ushered inside, the entry door was shut and he was taken upstairs to a chamber above the shop where they could conduct their business in private. Over two quarts of pearls, including 7 or 8 ounces of 'verye faire pearle some as big as ordinary buttons' and lesser pearls worth 7s 6d the ounce, spilled onto the table along with green, red, white, yellow and other coloured stones 'of the bignes of a man's thumbe and moste of them cut and polisht'. Rachael Pope bought the lot for £40, adding a further £2, which was the outstanding amount owed to Addams from the first sale.

Shortly after Pope acquired the first batch of pearls and stones from Addams, John Parker, a fellow goldsmith in Newgate Market, was invited into Pope's shop, and was there shown some 24 lb of pearls, which he estimated to be worth upwards of £3 per ounce. This quantity of pearls was all the more remarkable because there 'was not at that tyme such a

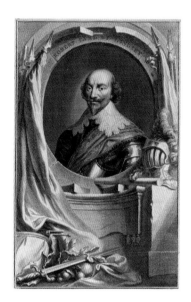

Robert Bertie, 1st Earl of Lindsey, by Jacobus Houbraken, after Cornelius Johnson, engraving, 1742.

National Portrait Gallery, NPG D27026

quantitye of pearle to be fownde in London'. They were kept in a white painted wooden box about a foot in length, eight or so inches in breadth and four inches in depth, which was placed behind the shop counter, with four more bags besides.[84]

The comings and goings in Pope's shop attracted the attention of his neighbours, who became increasingly curious. Some were warmly welcomed. The London apothecary Balentine Fyge was shown about a pint of 'rough white stones … to the bignes of ordinarye white pease', which Pope thought were of little value.[85] Fyge's opinion was of little consequence, but Pope was far more circumspect in his dealings with fellow goldsmiths, who tried their utmost to find out what was going on. The goldsmith Thomas Crosse, who had a shop nearby, was especially intrigued, but when he tried to take a closer look, Pope removed the pearls from the counter and 'kept them up close' so that Crosse could neither assess the quantity nor estimate the value.[86]

Rumours, accusations and counterclaims were rife. One London jeweller, known only in the records by his surname, Bishoppe,[87] heard that Pope had bought pearls for *2s 6d* the ounce, though they were worth considerably more. The jeweller Herman Marshall of St Giles Cripplegate said that Pope told him that he 'wished that he had a pearle piercer from holand for that he had worke ynoughe for him to doe for a longe tyme'. The goldsmith Frauncis Hall in Foster Lane 'heard that Nicholas Pope had brought of a seafaring man a hatfull of pearles of a greate value and leather bagge of stones which were reported to be dyamondes and other stones worth manye hundred thousand poundes', but he had also heard rumours that the stones were 'counterfeit and of little value'. When he mentioned the whole affair to one of his neighbours, the jeweller Humphrey Beddingfield, who had actually appraised some of the stones and pearls at the Custom House, Beddingfield told him that Pope 'had bought a good bargaine'.[88]

By this time, the Earl of Lindsey's claim to the treasure was well known. Word was out on the streets and the London jewellers and gem cutters were on the alert. So when Addams made yet another visit to Pope's shop with two pockets full of pearls, beads and stones, Pope informed him that he could not buy any more because the Earl of Lindsey had a 'graunte of his majestye of certeyne jewells that were about that tyme brought into England from the Easte India and had made first inquiry for the same jewells', and advised Addams to lie low and 'turne oute of the waye'.[89]

The warning came just in time, because a few days later Pope had an unwelcome visit from one of the Earl of Lindsey's agents. An inventory of pearls and jewels was duly compiled and the confiscated goods were promptly placed in a box to which the seal of the agent was affixed. This document, a single page of folded paper, survives in the National Archives.

Pearles and Jewills sent and wayed at the howse of Mr Nicholas Pope of Fflete Streete London Goldsmith beinge those wch hee confessed hee bought of Christopher Adames saylor

1. Impremis one longe bagge of seed pearle weighing 91 ounces
2. Item one bagg of seed pearle weighing 57 ounces
3. Item one bagge of [...] pearle wighing 20 oz
4. Item one pcell [parcel] of ragged pearle unwaighed –
5. Item one bagge of ragged pearle weighing – 25 oz
6. Item one bagg of Topasses –
7. Item one bagg of watersaphires blew –
8. Item one very great yillowe Topas stone –
9. Item a paper of Amatists [Amethyst] Beades –
10. Item one paper wherein are Chrosolytis Agates
11. Cristalls Beades pr. of [...] fortie –
12. Item twoe smalle pcelle of Rubee smalle
13. Item one paper of lapis lasule
14. Item one paper of garnette white stones Amatists &c
15. Item one piece of Redd cloth wherein is powder of Rubies.

All theise are sealed upp in a Boxe with the seale of me George Longe

(also signed George Longe, Robet Flolkingham, Robt Markham and Tho. Widmill).

National Archives SP 46/78/fo. 194, 23 January 1631

23 January 1631.

Pearle and Iewells lent and wayed att the howse of mr Nicholas Pope of Alde: in the citie London Goldsmith beinge those w[hi]ch her consisteth he bought of Capt. Steaven Taylor.

The bagges are marked thus :—

1. Inprimis one longe bagge of seed pearle waighinge 91 ounce f. 91. 0300 : :.

2. Item one bagge of seed pearle waighinge 57 ounce. ——— 57. o^z : :.

3. Item one bagge of enterelate pearle waighinge ——— 20 o^z 0 ounce

4. Item one q[ui]ll of ragged pearle unwayghed]

5. Item one bagge of ragged pearle waighinge] $25 o^z 0 ounce

6. Item one bagge of Topasses.

7. Item one bagge of water saphires blew.

Item one birry great yellowe Topas stone.

Item a paper of Amatist Beades.

Item one paper wherein are Chrisolytes Agates
One table beade or of diall stones.

Item two smale q[ui]lls of Amber smalle.

Item one paper of lapis lasule.

Item one paper of garnette w[i]th some Amatistes or...

Item one box of seed Beades wherein is powder of Amber

All these ar sealed vpp in a box w[i]th the seale of mr
George Lowe.

George Lowe
Robert Holbury elder
Robert Marke elder
Tho: woodall

lapis lazuli

There is a chain set with lapis lazuli in the Cheapside Hoard. One stone has a highly stylized figurative intaglio (engraving) on the reverse, which was almost certainly cut in the late sixteenth or early seventeenth century. Similar examples are known in Padua and Bologna, and it is now thought that they were mass-produced by one or several closely related workshops in Milan. In 1646, the London physician Sir Thomas Browne suggested that lapis lazuli 'hath in it a purgative faculty'.

A14198 and enlarged detail

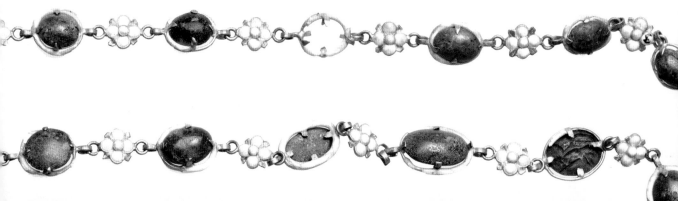

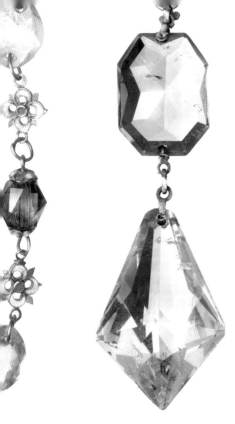
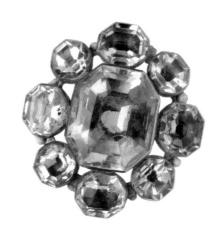

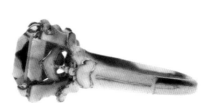

amethysts

The Cheapside Hoard contains a large number of cut and polished amethysts ranging from the lightest pale purple to an intense deep purple red. Some are loose, but many are set in brooches, pendants, chains and rings.

Amethysts were considered to have the power to sharpen intelligence and business acumen and to have a sobering effect on violent passions and drunkenness. The paler stones, sourced from Ethiopia, Bohemia, Ballagat (Albania) and Brazil, were 'little esteemed' in London, but amethysts of the 'best sorte' from India and Sri Lanka were greatly prized, though they were harder to cut and engrave. Most of the so-called 'Amatist Orientall' was exported from Gombroon in Persia, from the ports of Galle and Colombo in Sri Lanka and from Goa in India, 'wheare they make beades of them, seale ringes and sutche like thinges'.[90]

The London jeweller Gregory Barker had a number of amethysts in stock and an inventory of his goods in 1607, lists amethyst pendants, amethyst 'eare ringes of gold enamelled with collars' (opposite, top left), amethysts 'cut with lozenges' and an amethyst 'cut like a harte'. James I gave a heart-shaped amethyst to his wife Anne of Denmark.

from top left: pendant A14119, chain A14108, pendant A14367c, brooch A14367b, ring A14228; loose stones from top A14325, A14330, A14357, A14020, A14341; bead A17756; all shown at twice actual size.

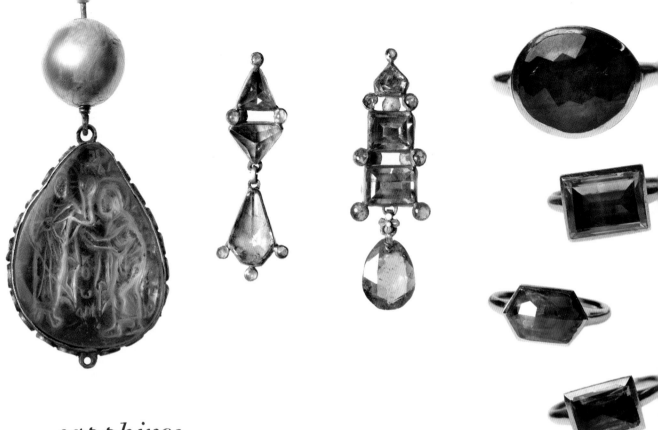

sapphires

Sapphires were sourced from Pegu in Burma and from Calicut, Kerala, Visnagar in India, though the best, with a 'coullor of Azure', came from Sri Lanka. According to one seventeenth-century writer, 'he that weareth the stone about them shoulde leade a most chaste lyfe'. Sapphires were also worn to protect the wearer from poison. The deepest blue stones were used to soothe sore eyes and 'comforteth and rejoiceth the harte'.[91]

The Hoard contains a wide variety of sapphires, ranging from the darkest blue to pale pinks and light grey-whites. Among the finest are two large rectangular stones from Sri Lanka (p. 162) and a remarkable Byzantine cameo of white sapphire depicting the Incredulity of St Thomas (top left and p. 179). Some of the sapphires have been foiled (a thin layer of metal is put under the stone) to obscure internal imperfections and intensify the colour. Rings with similar shanks to A14248 have been found on the wreck of the Spanish treasure ship *Nuestra Señora de la Concepción*, which sank in 1638.[92]

Sapphires feature in many jewellery inventories of the late sixteenth and early seventeenth centuries. In 1600, Hugh Kayle of Lombard Street had 53 gold rings set with sapphires as well as 70 loose sapphires 'very foul and ill coloured'. The jeweller John de Granade had sapphires of 'Ovall fashion with a great cloude havinge a flame in them and dymme', with sapphire 'ringes of mean price'.

clockwise from top left: cameo A14158 pendants A14018, A14109; rings A14247, A14245, A14249, A14248 (front and side); aigrette A14161; all at twice actual size.

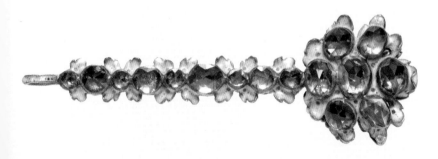

Shortly afterwards, the jeweller James Sympson saw Pope buying 'seede pearle in Cheapside and Lombard Street in several goldsmiths shoppes [though from] whom or howe muche' he did not know. Whether Sympson made this comment to further implicate Pope is unclear. It seems odd that Pope was buying pearls when he clearly had more than enough to deal with, unless he was attempting to replace stock lost as a result of the suit of the Earl of Lindsey. Five years later, when Pope met the jeweller Veiminge in Blandford, Dorset, he boasted that he had overturned the earl's suit and had purchased Addams's hoard for £200,[93] which suggests that the stones and pearls recovered by Lindsey's agents represented a fraction of the total that Pope had acquired from Addams.

As soon as Addams left Pope's shop, he returned to Hockley in the Hole and made his preparations for escape. He gave a 'woman at Snow Hill a handful of pearles' and started to hide boxes, caskets and loose stones around Susan Bradaye's house.[94] Then, taking heed of Pope's warning, he bought a horse at Smithfield, loaded up a cart and left London for his home in Bashley, near Milford in Hampshire. As soon as he arrived, he placed a box of jewels in his barn under some 'wheate sheafes', but when he heard that Lindsey's agents had tracked him down he quickly removed the goods to his cousin James Elliot's house in Arnewood, a couple of miles away. Once there he opened one of the boxes upon his bed and took out a bag of pearls weighing about 18 or 19 ounces and several precious stones. Then he locked the box. The next morning he buried it inside a neighbours barn, 'being a stones cast distant from Elliott's house'. Pulman's precious belt with its stones was buried under the roots of a tree.[95] After this he rode to Lymington to the house of James Dumneade at the sign of the Naggs Head where he had arranged to meet a pedlar and his wife. Addams took out the bag of pearls, but as he poured them out, 'beinge verye faire rownde and smooth … by reason of theire rowndness', they ran off the table on to the floor. The pedlar, his wife and

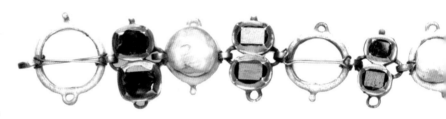

pearls

Though pearls feature prominently in inventories and portraiture, they are poorly represented in the Cheapside Hoard. This may be due to the conditions and length of burial, for many of the surviving pearls show marked signs of decay; and there are at least 1,356 empty settings for pearls, which either rotted away or were removed prior to burial. It is also possible that the Hoard included strings of pearls and bags of loose pearls that suffered a similar fate. The 126 surviving examples range in size from a few grains to seven or more carats. The largest and best are an almost complete sphere of 11 mm diameter (p. 122) with wonderful orient lustre, and an equally imposing baroque pearl which has been carved and drilled to form the hull of a ship,

complete with gold mast, rigging and rotating pennant (p. 106). One chain (A14071) has settings for 506 seed pearls, though just seven have survived.

According to Hannibal Gamon in 1604, there were pearl fisheries in the Spanish Indies, in the South China Sea, around the coast of Borneo and between Ceylon (Sri Lanka) and the Cape of Comorin. Surpassing these by far, in terms of both quality and price, however, were pearls from 'the steightes or Sinai Persias, in the places called Baraya, Calvia, Culfor, Camaron and Bassora from where they are brought into Ormus, & Goa'. During the summer and especially in the month of August, naked divers descended to depths of ten, twelve, even twenty fathoms (60–120 feet), with

baskets bound to their backs.[96] A European traveller who visited the pearl fisheries in India in the 1660s told the natural philosopher Robert Boyle that they did 'not use weights but swamme to ye bottom with their heads downwards', with a rope around their waists to 'be drawn up by'.[97]

Once landed, the baskets of oysters were tipped out onto the quayside in great heaps, graded by size and type. In Goa these were further divided into four groups: one part for the king; one part for the captain and soldiers; one part for the Jesuits who had a 'cloyster' nearby; and the final part for the divers. The shells were left to bake and open naturally in the sun. Then the locals removed the pulpy rotting flesh, crushing and rubbing it between their hands

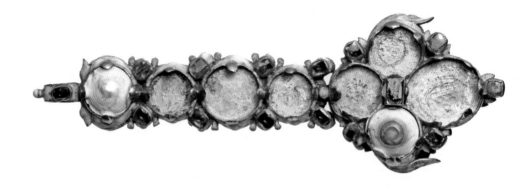

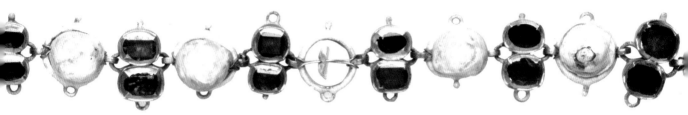

to 'find out ye pearls'. Oysters yielding the smallest pearls, called 'Alyossax', were found on the sea bed; as Gamon notes, these could yield four and sometimes as many as 2,000 grains each, which were 'soulde chepe to physicians & Apothecaries for medisen'. The largest oysters, which 'swyme alofte', produced 'thynne & whyte' material (mother-of-pearl), which the Indians call Cheripo' for 'spoones and cuppes'.

The pearls, sold to Venetian and Portuguese dealers, were priced and graded by means of seven or eight sieves, 'one bigger then another', made from latten (a brass alloy), pierced with holes of varying size and in 'price in proportion accordinglye'. The very best pearls were those in all 'partes ... perfect, bothe of water, glosse, and Bewtye, without Knobbes or spottes, of forme verie rownde, or like a pease'. In India, the surface lustre was often improved by rubbing the pearls with a mixture of crushed rice and a 'lyttell salte … to make them have a glosse'. Oriental pearls were generally worth considerably more than the duller, darker pearls from the Spanish Indies because they 'were clearer & fayrer', yet, as Gamon notes, occasionally pearls of equally good quality were found in the 'portingale Indies that are nothinge inferior to the oriental perles'.

For the buyer and retailer, Gamon offers a few words of caution. First, care should be taken to ensure that the pearls are without blemish, since any imperfections will have an impact on their saleability and price. Second, when there is a whole string of pearls, it is important to check each one, 'for where ther are manye, they are not all alike'. The best pearls will in some measure 'beare the badness of the smale. But yf it be Contraye then the Bargaine is not good'. The overall value essentially depended on the quality of the best or the worst pearl in the set.

Londoners were evidently fussy about the quality of their pearls. The jeweller Arnold Lulls, for instance, was obliged to return a 'fine pearl' to his brother in Antwerp, which 'being not of good colour I have been unable to sell here'.[98]

fan holder/aigrette A14160; chains A14204, A14071; loose pearl A14356

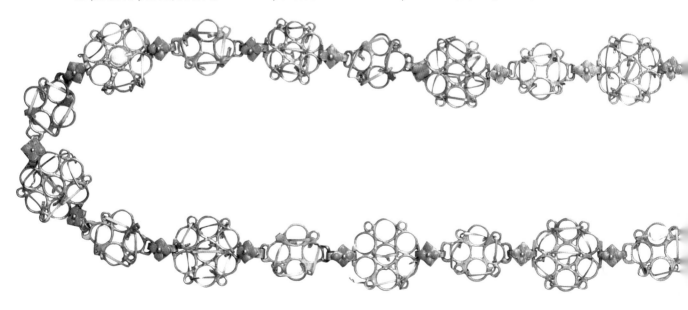

Addams spent the next few minutes on their hands and knees scrabbling to pick them up and then, satisfied that they had retrieved the lot, the pearls were weighed and valued at nine shillings the ounce. The bag of cut and polished coloured stones, some 'longer and broader then frenche beanes', were sold for 50 shillings. The pedlar spent a total of £30.[99]

A month or so later, Lindsey's agents tracked Addams down and advised him to make a settlement. Addams finally agreed to hand over the jewels on the understanding that the earl 'use him gentlye' and would grant him a part-share of the proceeds. Some sort of sealed bond was made to this effect, and in good faith Addams handed over 'one greene roughe stone or Emerodd aboute three ynches longe and three ynches in compass' with some bolts of gold and silver cloth and promised more of the same. Two of the agents returned to London and the other two went to Addams's home in Bashley. The following day, Addams retrieved one of the boxes from the haystack and in the presence of his cousin and the agents took out of it a small casket containing cut and polished precious stones of various colours, sizes and cuts, with some rings, one bag of yellow stones all about the 'bigness of ffrenche beans fairelye cut and polished to the quantity of a quarte', two or three other bags of precious stones, and several strings of beads and button beads. The whole lot was deposited in a great bag, which the agents took away, but Addams retained the key, promising to bring it to London in three weeks' time, so that the box could be opened in the earl's presence.[100]

At the appointed time, Addams arrived at the earl's house in Millbank. The box was set on a table covered with carpet, and the various jewels and beads were decanted to form a small pile. Among the stones was a silver ring with a dark-coloured stone the size of a hazelnut. As soon as the Earl saw the ring he announced that it was not fit for the likes of Addams to have and that 'he shoulde never see the same anye more' because the stone in the silver ring had 'suche a virtue

that if he that shoulde weare the saied ringe did decaye in the healthe of his bodye it woulde appeare by the stone in the said ringe and if the wearer thereof was a recovering his healthe yt woulde likewise be made manifest and appeare by the saied stone'. Lindsey said that, apart from this piece, the jewels were not worth a 'triffle'. When he asked Addams if he had anything else, Addams kept silent, and so was committed to prison in the Gatehouse in Westminster, where he remained close prisoner for nine weeks. During his imprisonment, Addams was repeatedly questioned as to whether he had any more of Pulman's jewels. He finally confessed that under the stairs in Hockley in the Hole, among 'olde shooes', was a green transparent stone seven inches in length and two to three inches in diameter, which he 'conceived to be an emerald'. This stone was the very one that Addams and the crew had noticed lying in Pulman's trunk with his tools.[101]

A couple of agents were despatched to Susan Bradaye's house in Hockley in the Hole. After a thorough search, they discovered a rhinoceros horn and some small pictures wrapped in paper, and, hidden as Addams had said under a pile of old shoes, a massive rough emerald.[102] The goods were taken to the Earl of Lindsey's house in Westminster.

After his release from jail, Addams was given a gelding worth £15 in consideration of the loss of his own horse, which the earl's servants had killed during his period of imprisonment. For the first fortnight he was required to report to Lindsey every day, but after that he was free to return to Hampshire on condition that he came up to London at the Feast of St George for further examination. Addams still had a large quantity of jewels hidden away. During his time in prision he mentioned to a fellow inmate that Pulman's belt was safely buried in the country and that he planned to go to France to sell the stones set in it because they were 'of such extraordinary value that woulde not be bought here in England and that the earl would get to hear of it'.[103]

In the meantime, many other sailors from the *Discovery* and the *Reformation* found themselves in jail. George Newell ended up in the Poultry Compter for selling pearls.[104] John Phillipps, who had sold diamonds and precious stones to John Nowell and others, was imprisoned in the Gatehouse, Westminster, then in Bridewell, Clerkenwell, and various other places.[105] Several officers were also rounded up and imprisoned, and jewels and gemstones were retrieved from the hands of their relatives and associates. Mistress Pettyes (the widow of the purser) gave up 'six or seven pretious stones twoe whereof were sett in ringes'; John Hedd's wife handed over the 'Rewbye or red stone' which Addams had given her for her husband's hat;[106] the pearl dealer, Mrs Waterhouse of the Mineries near the Tower of London, brought two great pearls to Lindsey, which she valued at six or seven hundred pounds apiece;[107] and the pedlar to whom Addams had sold a parcel of pearls and coloured stones handed over the items for the 'money that he had paid for them'.[108] The sailors were not the only group to profit from Pulman's treasure; Addams heard afterwards that one of Lindsey's agents had been bettered in his estate by upwards of £1,000,[109] a claim supported by a goldsmith in the Strand who had purchased several small stones from the agent for 25 or 30 shillings.[110]

Goldsmith jewellers in London

As information about the extent of Pulman's treasure began to spread among the community of goldsmith jewellers in London, some of them started to play a clever game. James Sympson, who had already purchased some of the jewels from the sailors on board the *Discovery*, made an appointment to see the Earl of Lindsey, offering his services as a jeweller and appraiser for Pulman's stock. He was duly invited to the Custom House, where he was shown a large chest, which contained 'nothing save working tooles belonging to a gouldesmyth or jeweller to value of 3 or 4 pounds', and various bags containing chalcedonies and

rubies

Some lapidary texts suggested that rubies gave the wearer special powers of foresight, turning a darker or lighter shade depending on the 'greater or lesser misfortune' to come. Stones of the right size, colour and clarity were rare, since they invariably had 'some faults … or spottes'. Rubies from Pegu in Burma were particularly prized.

There are a number of fine cut and polished rubies in the Cheapside Hoard. The largest (A14264), at 32.58 carats, has a slightly dull appearance, which is in part due to its twinned lamellar crystal structure, a characteristic feature of rubies from Mysore in India.

from left: A14264, 12778/119, 12778/120, 12778/121, all shown twice actual size

turquoise

The best turquoise came from Persia and was traded from the Island of Ormuz. Stones were tested for quality with a dash of diluted quick lime and if they 'appeared coullored [they were] adjudged perfect and good'.[111]

The Hoard contains a few turquoise set jewels, some cut and polished stones and a small pile of crushed turquoise 'drosse' mixed with tiny coloured gems, pieces of enamel, fragments of rock, wood and a small fish vetebra.

gems from left: 12778/103b, 12778/103e A14333, A14336, A14334, all shown twice actual size; matrix A14068

beads

Thousands of beads were imported into London in the early seventeenth century. Some were strung onto long knotted cords, but most came loose in bags, baskets and barrels. Jewellers made up bead chains and bracelets to suit their customers' wishes, but it was also possible to buy loose beads for stringing at home. White and pale-blue chalcedonies were imported from India, Africa, Brazil and Argentina. According to one text, if they were 'bored throwe with a hole and hanged about the necke' they helped to prevent 'phatasticall illusions arisinge from Melancholye',[112] and were useful talismans in any kind of legal dispute. Most of the dark red cornelians, 'of the coullor of fleshe … almost the coullor of vermelion', which the Cheapside goldsmith Hannibal Gamon said were 'well known among Juellers' for seals and intaglios, were mined in Germany, but the orange-red stones used for beads mostly came from India and Persia.

In 1630, an East India Company factor reported that he had unexpectedly acquired 216,550 red cornelians of a 'reasonably good sort' of just the kind required but rarely available without a 'years time for provision'.[113] He went on to say that the Portuguese and Dutch purchased vast quantities, though, unlike the English, they were much less concerned about the quality. Long red beads were despatched to the pursers of every East India Company fleet for the purposes of bartering, and in 1632 the Company allowed the officers to buy a certain number of agate and cornelian beads (and other items) on their own account. The demand for cornelian beads was such that when one East India Company ship brought in 4,784 'long red cornelian beads' in 1634, the gem merchants complained that the Indian craftsmen 'were so miserably decayed' that they could not fulfil their orders.[114]

There are a large number of beads in the Hoard, including long orange-red cornelians, banded agates, bloodstones and white and pale blue chalcedonies. The stones have been drilled from both ends and the majority were cut and polished at source.

anticlockwise from top: A14308, A14284, A14307, A14292, A14309, A14285, A14293, A14304, A14282, A14302, A14286, A14294, A14280, A14303, A14311, all shown twice actual size

topaz and amethysts mixed together, 2,000 heliotrope and jasper beads and a similar number of cornelian beads 'red and white together cut polished and shining'. There were a couple of handfuls of blue chalcedonies; eight to ten strings of agate, cornelian and jasper beads and 60 strings of jacinth beads. In addition there was a parcel with 100 'greate foule rubyes'; a small purse with about half a pint of emeralds; four great rough emeralds each 'the bigness of a greate walnut'; and finally three large bags of turquoise.

Sympson struggled to value the chalcedonies but thought they were worth £6 or so. They were subsequently sold to three lapidaries – Peter Tise and John Blunt, in Silver Street, Southwark, and John Critchlowe, in Shovel Alley, near Great Woodstreet in the City – for an unrecorded sum. The garnet beads were valued at £5 and the rest of the beads at £3. The four great emeralds were valued in excess of £200.[115] Sympson made a separate deal for the large bags of turquoise: some, about 40–50 lb, went to the Earl of Lindsey's tailor,[116] but the bulk was acquired by Sympson's relatives: the brothers Francis and John Sympson, jewellers in Friday Street on the corner of Cheapside, who were also invited to appraise Pulman's stock. The brothers purchased the turquoise, which had 'some drosse mixt with them as theye were taken oute of the earthe', for the price of a £12 diamond ring, which they 'conceaveth to be of the valewe of the saied turkeys and noe more.'[117]

At the same time, the Earl of Lindsey showed Francis and John Sympson the rest of the stock; they saw two or three handfuls of blue chalcedonies, and eight or ten strings of agate, cornelian and jasper beads, about 30 small emeralds all cut and polished, three dozen (perhaps more) jacinths [hessonite garnets] and a quart or more of loose topaz, all of which they valued at one hundred marks (£69).[118]

John Nowell also retained his interest in Pulman's treasure. His apprentice, Benjamin Griffith, said his master had purchased many precious stones and 'divers diamonds' from

John Phillipps and other 'seafaring men to the value of five hundred powndes'. He had also obtained six or seven ounces of pearls from Price, a pedlar, for 30 shillings the ounce, and, most useful of all, had somehow acquired Pulman's catalogue listing his stock and their prices and values.[119]

Stone cutting

While the thieves were being pursued and parts of the treasure recovered, the Earl of Lindsey removed the remaining boxes and caskets from the Customs House to his Westminster home for safekeeping. As more and more of Pulman's treasures came to light, he began to employ 'divers stone cutters and lapidaryes for cutting of Rubies and other precious stones'. Among the group assembled in his house were Robert Russell of Aldersgate Street, John Blunt of Silver Street, John Critchlowe of Great Wood Street, Leonard Renatus of Blackfriars, Herman Marshall of St Giles Cripplegate, and one Boonpas, a Frenchman.[120] The cutters were encouraged to work in Lindsey's home, and specialists were engaged at different times for particular tasks. The lapidary Robert Russell 'wrought certayne smalle Emerodds and Amatists in the house of the Earle during the space of a moneth … at certayne hours in the day', though he was obliged to use tools which a French cutter, who had previously undertaken work for the earl, had left behind.[121] Russell said that the stones were not worth more than £10 or £12.

The most challenging task was given to Robert Evetts, in the parish of St Anne's Aldersgate, and Leonard Renatus from Blackfriars. Evetts was employed by Lord Willoughby, the eldest son of the Earl of Lindsey, to 'saw asunder a great Emerodd whose proportion was two ynches or thereaboutes in lengthe and three ynches or thereaboutes in compasse'. Out of this great stone, Evetts cut two large stones with table-cut bezels, each of the tables being three-quarters of an inch square, which he estimated were worth £40–50 apiece. From

the remaining part he cut 22 smaller stones.[122] Another piece, possibly also from the same rough, was passed to Leonard Renatus, a 'French jeweller or lapidarye', who cut two 'rounde ringes'. These were passed to Robert Russell for faceting. The work of mounting and setting was undertaken by the jeweller Giles Bishoppe in Friday Street, near Cheapside, and then the completed rings were handed over to the Earl of Lindsey.[123]

Renatus claimed that the emerald was 'the biggest that he ever sawe'; however, soon larger emeralds appeared, some so large that even the jewellers and cutters were astonished. One of the earl's agents remembered seeing over twenty large emeralds, 'faire and brighte most of them cut and polished'. The lapidary John Critchlowe was shown one two inches in length and three inches in diameter, though he did not know how 'to value yt for that he never sawe anye of that bigness'.[124] Herman Marshall valued one of these great stones at £500.[125] Then an even larger emerald appeared: this was initially assessed as being worth £1,500, but after closer inspection 'in the lighte' its value was slightly reduced. Two joint rings were made from the 'fowle parte' of this stone: one was presented to the Queen by the earl and the residue was made into a fair stone cut and polished.[126] A 'ring of one entire emerald'[127] was included in the inventory of Henrietta Maria's jewels after her death in 1669, and it is possible that this was the very same ring which had been given to her by Lindsey in 1631/32.

The lapidary Thomas Parker of St Andrews Holborn, who saw some of the emeralds in the earl's house, remembered seeing one which had been valued by Renatus at £1,000, which he 'crediblye heard' had been pawned to a linen draper in Newgate Market for £300.[128] The three inch emerald which Addams had removed from his cousin's house in Arnewood was subsequently pawned in Cheapside.[129]

Over the course of the next few years, more of the stones were sold on the open market. In 1635, two cut and polished emeralds were offered to the Dutch jeweller Master Duehart

emeralds

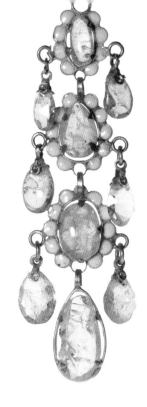
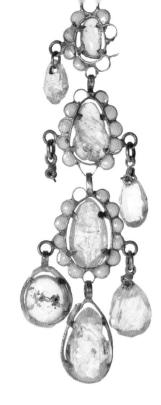

All of the Cheapside Hoard emeralds come from the mountainous district of Chivor (Somondoco) and the lower-lying province of Los Muzos, 65 miles to the north-west of Bogotá, Colombia.[130] The rich emerald deposits in this region attracted the attention of the Conquistadors, but it was not until the 1560s that the Spanish had a secure footing in the area and extensive mining interests in the Somondoco and Muzo districts.

The emeralds were recovered from shallow open-cast mines and the stones were graded according to size, colour and quality. The largest were likened to the joints of the finger or thumb; middle-sized stones to hazelnuts or almonds; and the smallest to grains of corn or breadcrumbs.[131] Stones with a cloudy aspect and multiple inclusions were called *relampagos* (lightning); the lighter, brighter coloured material was known as *verde alegre* (happy green); while the greatly prized, intense bluish green stones were branded *verde negro* (green-black). Emeralds were also categorized into three main groups or *suerte* (literally 'fortune'): a specific term used to denote gem quality. Roughs of *primera suerte* could have a cloudy or even 'dirty' aspect as long as they had a transparent 'heart'. The largest gem-quality prisms, known as *canutos* (spikes) and *piedras to cuenta* 'stones of account', were exceptionally rare. Some went to a specially convened court in Bogotá and thence to the king of Spain, but the majority were either smuggled or traded secretly by an international network of gem merchants operating from Cartagena, from the eastern ports

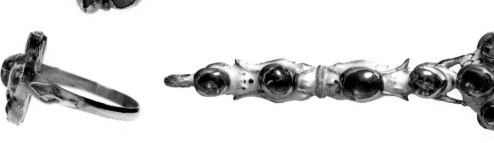

the parrot cameo

Parrots or 'popinjays' were considered to be excessively lecherous birds, and as such were regarded as a symbol of erotic rather than sentimental love. According to lapidary lore, the colour green signified new love and so the choice of gemstone may be significant. The parrot has been drilled for setting.

A14273 actual size and enlarged

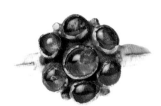

of Goa and Cairo and from the European cities of Seville, Lisbon, Venice, Antwerp, Amsterdam and London.

The Cheapside Hoard emeralds are of fine quality and most have been cut *en cabochon* (the upper face domed and the underside flat or slightly recessed). Irregular-sized stones have been foiled and used for rings and chains. More intensely coloured emeralds have been set in a brooch to form the sinuous outline of a salamander (p. 220) or drilled to form a bead.

from top left: pendants A14192, A14193; chain A14101; bead A14098; aigrette A14169; rings (from top) A14220, A14224, A14214, A14210; all twice actual size

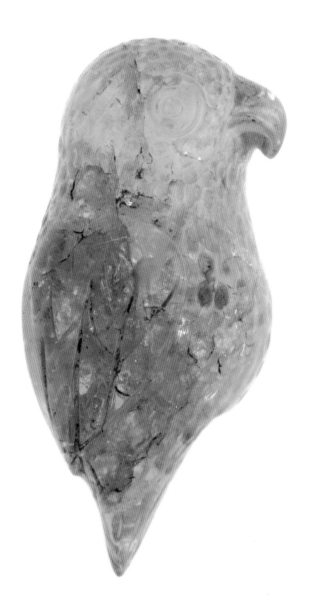

The emerald-cased watch is one of the most spectacular items in the Cheapside Hoard and one of the most remarkable jewels in the world. The cutter has followed the natural prismatic structure of the crystal, and the angles of the facets help to maximize the play of light within the stone.

inclusions[133] or differences in the homogeneity of the matrix. The lapidary work probably caused stress fractures and it is quite likely that internal fissures were exposed when the stone was cut and drilled. It is also possible that moisture seeped through

the emerald-cased watch

It is possible that the lid and case were cut from the same hexagonal rough or from two prisms of matching size, colour and translucency. The small stones in the pendant and finial were probably cut from material removed from the centre of the case, which was hollowed out to take the movement. The translucent cover has lighter colour zoning in the centre so the dial could be read when the lid was closed.[132]

The dial, with *basse-taille* translucent dark-green *champlevé* enamel, has a circular chapter ring with Roman hour numerals I–XII, interspersed with dots to indicate the half-hours. The hand is missing and there is a winding hole at the eight o'clock position. A catch-pin at the base of the dial slots into a corresponding gold tube in the lid. The dial plate is secured to the movement with iron rivets and the mechanism is attached to the case with threaded pins behind the pendant and finial. The movement is corroded, but sterographic X-rays show a

fusee-driven three-wheel going train with a verge escapement. The watch is unsigned.

The patches of corrosion in the movement are mirrored by a band of orange-brown discolouration in the emerald. The corrosion and staining have occurred because moisture has worked its way through the iron components and the partially dissolved ferrous salts have permeated into the fissures of the emerald, effectively sealing the mechanism within the case. The iron-staining suggests that the watch was tilted backwards or lay on its side during its long sojourn underground, but why it has spread in the way that it has is not entirely clear. It may have something to do with the crystallographic properties of the stone such as the ratio of solid to fluid-filled

the pendant drill hole – the enamelled gold collar does not form a tight-fitting seal and was probably added to disguise the rough edges of the perforation. There is no iron-staining on the lid, which suggests that either it has no surface-reaching fissures or was slightly ajar when the watch was buried.

The emeralds used to form the case and lid come from Muzo and were almost certainly designated 'stones of account', but how, when and where they were cut remain a mystery. Was the watch complete when it arrived in London? Were the components made in different places? Were the stones part of a pirate's booty or did they arrive in London through well-established, legitimate trade networks?

Emeralds of this size and quality were probably acquired to order and it is quite possible that they were directly sourced by an emerald dealer in South America for a specific client. It is also conceivable that they were acquired in Asia because thousands of Colombian emeralds

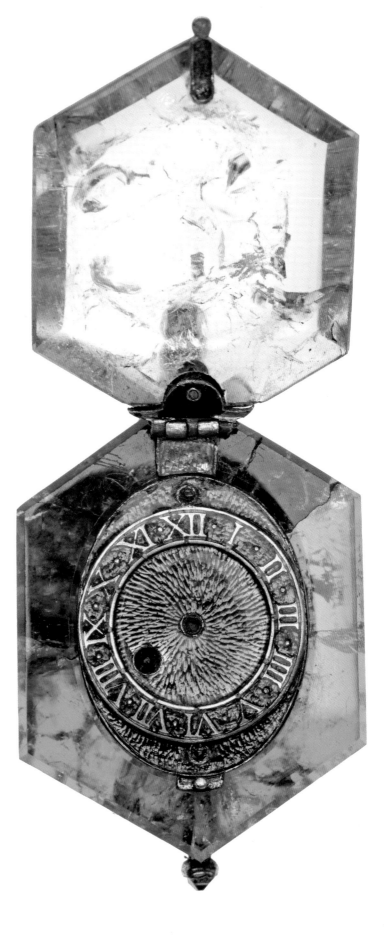

were supplied to India and Burma to satisfy local demand. The Burmese were so keen to obtain emeralds that they bartered rubies for South American stones,[134] and in Goa in the 1580s emeralds were valued 'as muche as a Dyamond and somewhat more'.[135] European dealers were also keen to buy emeralds in eastern markets so that they could be labelled 'oriental' stones, because orient stones fetched a premium price in the Low Countries, France, Germany and England.

It is possible that the watch emeralds were cut in a lapidary workshop in Seville or Lisbon or conveyed by some other route to Geneva, a city renowned for the skill of its watch and hardstone case makers. It is certainly conceivable that the stones were cut in London. What is not in doubt is that the lapidary skills of the case maker are of the highest order, demonstrating a technical mastery of the material.

There are many examples of watch cases in transparent and smoky-grey rock-crystal, amethyst and other hardstones,[136] but so far as is known the Cheapside Hoard timepiece with its emerald case is unique. Documentary evidence for gem-set cases of this quality is also rare, though Susanna Edmonds née Lulls (p. 169) left two watches in her will to her sister Margaret, one with 'two plates of gold being enamelled in a silver case' and the other a 'Watch case of Topaz being in another Silver Case'.[137]

A14162 actual size and enlarged

for £200: one was an inch or so square and the other slightly smaller.[138] But not all of the stones were of such quality and value. When the earl asked the jeweller Peter Handale, in St Margaret's Lothbury, to sell a 'foule roughe Emerodd of the bigness of a small olive' valued at £10, Handale could not find a buyer, and had to return it to the earl a short time later.[139] A number of small, low-value emeralds were appraised by John Critchlowe at £6 a piece, all about the size of a man's thumbnail with table-cut bezels and 'rounde underneath'.[140] Stephen Chapman, goldsmith, was also shown some inferior-quality stones, including a small box with tiny topaz, small emeralds, rubies and garnets, which he dismissed as 'being of little value and good for nothinge but to be sould by the ownce to an apothecarye for phisicke'.[141]

A large team of jewellers, cutters and lapidaries began to work on Pulman's treasure. Some worked for the earl, while others were employed by his friends and relations. Lady Franck, in Westminster, engaged the lapidary John Critchlowe to cut turquoise, rubies, spinels and a small emerald which she had purchased from Lindsey, but unfortunately he 'receaved of her Ladye for cutting of the saied stones … not worth muche more than their cuttinge cost'. He was then asked to cut into two one of the faceted stones in an emerald ring, but was warned to take special care in the cutting since it had already cost her £10.[142]

While some jewellers, such as Steven Clarke and one Nulle-bye, were directly employed by the earl and worked in his house, there was so much material that the work was subcon-tracted and divided up among the trade. Stones and pearls were distributed to specialists across London. Peter Handale, an expert pearl piercer, was given the task of drilling 100 round pearls weighing twelve penny weights and two grains, which he valued at £5; 198 'button' pearls worth £2; 18 'greate pendant pearles' worth 18 shillings; 34 'lesser pendant pearles' worth 40 shillings; 230 'internale pearles for stringes' worth £6, and 390 of a smaller sort valued at £10.[143] Many of the setters, mounters and

pearl piercers were blissfully unaware that they were handling stolen, or at best misappropriated, goods, so when Humphrey Goddard of Saffron Hill was commissioned to make a hatband for the Earl of Lindsey to be 'sett over with Garnetts of severall bigness', he only discovered the truth when the garnets were delivered to his workshop by Robert Russell, who had cut them. The jeweller John Arson saw this hatband in Goddard's shop and then a few months later recognized the same piece, with 'an open Emerodd crosse garnished with goulde' valued at £12, in the hands of one Mountague, a dancer, who provided entertainments for the Earl of Lindsey.[144]

Lindsey was convinced that the great diamond which Pulman had 'lost' in Mauritius had been found by one of the crew, and that this stone and many of the valuable gems stripped from Pulman's belt or removed from the chests on the ship had been spirited away and offered for sale in London. He also knew exactly what to look for because he had retrieved Pulman's inventory from Nowell. Agents scurried from workshop to workshop, interviewing, watching, listening and waiting; all the time hopeful that someone, somewhere, would make a mistake or an incriminating remark. But the tight-knit community of gem dealers and brokers, jewellers and lapidaries, was not about to give up its secrets without a struggle. The trade was necessarily clandestine and stones passed quietly from hand to hand and shop to shop. There were many whispers and rumours, but whenever Lindsey's agents thought they had a lead the jewels and stones, and sometimes the craftsmen handling them, disappeared. Even when the agents thought they had caught someone red-handed, they were greeted with blandishments and protestations of innocence and it was virtually impossible to prove that the items were stolen and part of Pulman's goods. When the gem merchant Robert Opwick in the parish of St Olaves, Hart Street, was examined in 1641 'concerning certayne pearls' that he had sold for £1,800, he flatly denied that they had anything to do with Pulman's treasure, but the agents were still

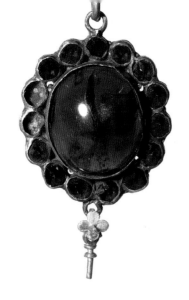
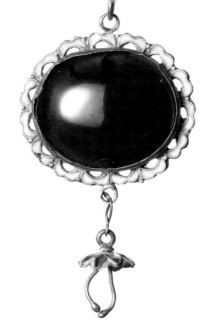
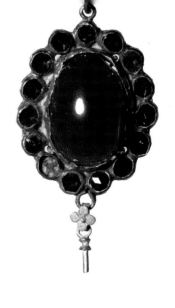

garnets

Garnets constitute the largest group of unset gems in the Hoard. The majority are cut *en cabochon* (with domed upper faces, flat and hollowed on the underside) and these include several massive almandine and pyrope garnets, or 'carbuncles' as they were known in the seventeenth century. Regarded as a symbol of constancy and used to promote wealth, garnets were also fastened to the forehead with a strip of cloth to cure watery eyes. They were valued as a heart stimulant, though some cautioned that overuse could produce a fit of apoplexy, and were commonly worn around the neck to 'drive away childish fears, overcome sorrow, and … repress troublesome dreams'.[145]

Garnets were found in Bohemia and Ethopia, but the finest came from Sri Lanka and India. According to one text, these were often set 'into a fire for the space of certaine houres' to intensify their colour. The heat-treated stones were 'greatly estemed' and cost twice as much. Garnets were also prized in Europe, and those with star inclusions (white radial flashes), of which there are several in the Hoard, were particularly valued.[146]

The orange-coloured hessonite garnet from Sri Lanka was known to the jeweller as a 'jacinth' or 'hyacinth'. Some were a rich red but most were of a 'safron couller … like waxe'. Some of the hessonites in the Hoard are faceted and show signs of wear.

pendants A14016, A14015, A14017; almandine garnet in form of eye-bath A14084; almandine and hessonite garnets, clockwise from top right A14086, A14057, A14048, A14085, A14106, A14107, A14044; all shown twice actual size

suspicious, and so he was asked if he had ever handled a large diamond of some 30 carats or so. Opwick said that he had had a diamond of 40 carats but this rough had been purchased in Spain seven or eight years ago and had since been sold.[147]

Meanwhile Addams was still at liberty, though under discreet surveillance from Lindsey's agents. He had retained a vast collection of jewels and precious stones, but it was no easy task to dispose of them, and he had not learnt to keep quiet. Every now and then he brought out special items to show to friends and relations. On one occasion he boasted that he had a jewel worth thousands, which in the 'darkest tyme of the nighte (the candles being oute) the saied jewell being layed upon a table … woulde cast such a light that a man might thereby reade with till morning or put on or off his clothes as well as by the light of a candle'. This stone was kept in a small box which Addams kept in his pocket, and one of his friends claimed that one very dark night in a country lane Addams had used the stone to light up their path.[148]

Two years later, Addams was retained as a master carpenter on a ship called the *Margaret* which was bound for Muscovy. While the ship was at Blackwall he was arrested by the earl's pursuivants and again imprisoned in the Gatehouse in Westminster, where he remained for seventeen weeks. He was charged with possessing jewels worth £52,000. He was then moved to the King's Bench Prison in Southwark for a further term of two years. On release he was forced to serve as the earl's servant for two more years, after which he was discharged to return to his house in Hampshire.

The jeweller

As the search for the treasure continued, Pulman's relatives began to make their own enquiries, and John Higenius, a physician, was appointed administrator on their behalf. An appeal for justice was promptly issued and on 28 April 1637 'articles or

interrogatories' were submitted to Parliament against the East India Company; the Earl of Lindsey; Nicholas Pope, goldsmith, and Rachael, his wife, in Fleet Street; George Nowell, goldsmith on Holborn Bridge; and Christopher Addams, shipwright. Higenius also asserted that Gerrard Pulman, gem merchant, had been poisoned on the *Discovery* by Abraham Porter, surgeon, and that his goods, 'a large collection of gems and precious stones, collected during the previous thirty years were divided among the crew of the ship'.[149]

The petition was read to the House, and a commission of enquiry under the Great Seal was established. On 1 August 1641, Henry Morgan, Lewes Morgan, Tambervile Morgan and Hugh Lewes of Gray's Inn were given three months to track down and examine 'more than threescore' witnesses in London and several counties in England. But with rebellion in Ireland and political disturbance, and 'many other distractions', the task was both difficult and hazardous. Though they 'excelled themselves to the utmost', travelling night and day to the great neglect of their own affairs, for which they were only partly paid, they were not able to complete the commission in time.

Dr Higenius met and interviewed many of the witnesses himself. Although the Earl of Lindsey gave the appearance of aiding his quest, even going so far as to provide him with a house on the edge of his Lincolnshire estate to serve as a base for the operation,[150] Lindsey had absolutely no intention of relinquishing his own claim to Pulman's treasure; so, when Addams was pursued by Dr Higenius and Pulman's relatives, the earl was anxious to keep them apart, and told Addams to 'goe out of the waye' to his son-in-law's house in Norfolk.

The commissioners tried to discover more about Pulman's background and his contacts in London. To this end they interviewed the 70-year-old goldsmith Nicasius Russell (also known as Nicholas Russell), a native of Bar-en-Lisle in Northern France, who had a shop in the parish of St Anne's Blackfriars. An eminent goldsmith, who sold jewels and plate

to Anne of Denmark, Russell had an interesting story to tell because it transpired that, thirty years before, Gerard Pulman had spent two years working for him as his journeyman in London. According to Russell's testimony, Pulman left his service for France. After a gap of ten years, Russell received a letter 'oute of Barberye where Polman then was … asking him what diamonds of such and such waightes woulde yeald here in England and to send him answere thereof [because] he had a great store of diamonds'. What Russell wrote in reply is unknown, and he did not hear from Pulman again.[151]

The commissioners were still compiling witness statements when Dr Higenius died. Thereafter his attorney, John Guile, a fellow Dutchman, pursued the action on behalf of Pulman's son and heir, and his guardians, the Tribunal of the County of Zutphen in Westphalia – a secret society who had probably provided some of the funds to support Pulman's expedition to Persia. Fearing a miscarriage of justice and concerned about the 'distractions of the time', the Tribunal asked Guile to extract the reports and associated papers from the commissioners to 'carry beyond the seas for a time'. But the papers were never sent. What happened to the rest of Pulman's treasure is unknown, but a good deal of it passed through the hands of London jewellers and goldsmiths, and at least one of the very large cut and polished emeralds ended up in Cheapside.

Buried treasure

THE REAL WORTH of the Cheapside Hoard lies not in its overall value, which is considerable, nor in its most exquisitely wrought, rare and unique items, but rather in its sheer size and range. It includes jewels of unparalleled design and form, complete and partly worked items, items of variable date and production, a huge number of cut and polished stones, and assorted hardstone vessels. The material content, manufacturing processes and techniques are extremely diverse and the skills of the stone cutters, enamellers and jewellers are remarkable. Most of the items are in excellent condition and only the vulnerable pearls, the base-metal components of the watches and some of the enamels show signs of burial and exposure to the soil. As a time capsule of the Elizabethan and Stuart jewellers' trade it is unsurpassed. Yet how can it be classified? Does it reflect the stock of one jeweller or several? Is it representative or is it in a class of its own? Were the items fashioned just before the Hoard was buried or had they been in stock for some time? Does it include part of a private collection which was broken up, pawned or sold? Could it be a burglar's swag? Why and when was it buried? To whom did it belong? Such questions are difficult to answer, for the clues, to quote the sixteenth-century writer Richard Barckley, are rather like 'a chaine rent in peeces, whose links are many lost and broken, and the rest so slightly fastened as they will hardly hang together'.[1]

The Hoard seems to constitute the stock-in-trade of a working goldsmith, because it contains finished and unfinished

articles, loose gems and a large number of pieces of the same design. Its discovery in Goldsmith's Row certainly lends credence to this view. The very fact that there were so many goldsmiths trading in the same area presumably necessitated a degree of specialization, and most probably sold a basic range of fashionable pieces to maintain business and custom, as well as special items to attract the casual shopper and the interest of the serious collector. The diversity of jewels and other items in the Hoard certainly supports this supposition. In addition to what could be called 'general stock', there are many articles of great rarity, value and quality that would have made very acceptable royal and courtly gifts.

Many writers have surmised that the contents of the Hoard were primarily suited to the tastes and pockets of the merchant classes because of the relative lack of very valuable 'court quality jewels'. But this interpretation not only belies the cultural mores of the merchant community but also fails to recognize that these citizens were among the most affluent in the land. Research shows that the merchants were not only able to afford but actually bought the best. Their trade contacts and networks provided them with unrivalled opportunities to introduce the latest fashions from Continental Europe, and their considerable purchasing power helped to stimulate demand for the exotic and the new. London merchants' inventories are full of the most expensive and fashionable jewels. In the light of this evidence the importance, relative value and market potential of the Hoard should be reconsidered.

Since next to nothing is known about the circumstances of the Hoard's burial, and theories concerning its concealment are at best conjectural, much rests on the items themselves. Yet this is by no means a straightforward task, because jewels were constantly adapted or reworked to suit contemporary taste and fashion, and jewellers retained old stock for recycling. There are no hard and fast rules. How is it possible to distinguish whether a jewel was made abroad or by immigrant artisans in

the squirrel pendant

This pendant, carved from cornelian, is a faithful representation of the Eurasian red squirrel, the only squirrel native to the British Isles. Red squirrels were a familiar sight in the parks and gardens of London, and the naturalist Edward Topsell observed in 1609 that they were 'exceeding tame … [if] taken when they are young … [and] will often times sit upon [men's hands or] creepe into their pockets for Nutts'.[2] But squirrels appeared in other guises too. Their pelts were used to line and trim gowns, their bushy tails made a serviceable brush, and they were even hunted for food, though their flesh was 'not very wholesome'.[3] They were represented in carved and painted form as tavern and shop signs; they were depicted on coats of arms, heraldic badges and seals; and they were even given iconographic status in art and literature.[4] When James I

made his 'royall and magnificent entertainment' through the city on the eve of his coronation in 1603, for instance, he was greeted by the spectacle of Prothymia, or Promptitude, with a squirrel in her right hand 'as being the creature most full of life and quickness'.[5] And it was perhaps this aspect of the squirrel's nature which most fascinated contemporaries, for, as Richard Brathwaite put it in 1634, the squirrel 'is that nimble Reveller of the Forest who is always set upon a merrie pin … He keeps Holiday everie day, and is never without his pumps on, to be readie to dance. For he will daunce you beyond measure.' To better observe this 'dance', squirrels were sometimes taken from the wild and set in cages, like a 'foure-footed bird', with a 'chime of lettle Bels' around their neck and ankles.[6] Topsell observed that 'such sweet-sportful creatures' could make enchanting pets, though they had a tendency to run amok and 'eat al manner of woollen garments'.[7]

For Renaissance philosophers seeking some kind of correspondence between man's condition and the natural world, the squirrel's agility and resourcefulness were particularly noteworthy. As Wolfgang Franzius argued, beasts possess 'shadows of vertues [and] faculties analogously as they are in man',[8] so the squirrel's reputed ability to ford a stream on a raft

fashioned from a piece of bark with its tail held aloft like a sail was commonly cited as a moral exemplar of ingenuity and skill. As one poet put it, 'that which the Body proves unfit, Must often be acquired by … Wit'.[9] The squirrel's acquisitive and assiduous efforts to garner seeds and nuts for winter were also given emblematic significance, with accompanying mottoes on the theme of *Tu ne l'auras qu'avec peine* (Thou shalt not have it without pains) or *Latet abdita* (It lies concealed, or May concealment keep it safe).[10] So it is perhaps no coincidence that Edmund Courtnall, a Cheapside goldsmith, chose a painted squirrel for his shop sign in the 1560s.[11]

Some depictions of squirrels were amatory, even erotic, in intent. In *Emblemata amatoria*, for example, Pieter Cornelisz shows a cherub gazing at a squirrel in a wheel with the supporting motto *More rotam inclusi volvo atque revolvo sciuri. Fine carens captum circulus urget: amo* (Like a caged squirrel I turn the wheel and turn it again. A circle without end pushes me on, trapped: I am in love).[12]

Although squirrels were represented on seals, badges and occasionally rings, so far as is known the Cheapside pendant is an exceptional survival. The lapidary has selected a stone with an appropriate orange-red hue and has carved the piece with skill, delineating the tufted

ears and bifurcated hairs of the tail, which has been drilled for suspension. The colour has particular significance since only red-coated members of *Sciurus vulgaris* are found in Britain, which suggests that the pendant was either carved here or was made specifically for the English market.[13]

The pendant's significance for contemporaries is difficult to assess. We neither know, nor are likely to discover, if it had particular meaning as a heraldic, amatory or symbolic jewel. Nor can we tell if it was part of some general stock or a commissioned piece. It is impossible to date and we have no way of knowing if it was new or old when it was buried. It is conceivable that it had some significance as an armorial device and it is also possible that the flat base was left plain so that it could be personalized with a monogram in the form of a seal. It is not possible to assign the piece to a particular individual or family since squirrels were used as a cognizance on many arms and the number of options is simply too great. Perhaps the most plausible explanation is the simplest: that it was made for its charm and broad-based appeal, for though tiny it would have made an enchanting gift or favour.

A14272 shown actual size and enlarged

London, or indeed by English jewellers who had either worked for immigrants or adopted their techniques and designs? Was there such a thing as a distinct national style? To what extent were the jewellers or their customers and patrons arbiters of taste?

A matter of record

Part of the problem in tackling these questions is that there is hardly any extant jewellery of similar type and date to the Hoard. Although portraits and documentary sources provide invaluable evidence, they can be difficult to interpret and seldom provide enough detail to make direct and accurate comparisons possible. After all, the value of an inventory depends on the knowledge and expertise of the appraiser, the amount of time allocated to its compilation and the purpose for which it was intended. If an inventory was compiled for an insolvent estate, for instance, the appropriate commissioners for the bankruptcy generally appointed accredited appraisers who could assess the household and shop contents without recourse to a specialist adviser. Inventories compiled for the purposes of a dispute or court case tend to be based on the 'expert' opinions of the parties involved, although occasionally independent witnesses and valuers were brought in to validate or refute their testimonies. Probate inventories were usually drawn up by the executors – family members or business partners and associates who did not always have the skills to describe the salient qualities of a jewel or provide an accurate valuation.

There are other pitfalls too. Inventories were usually compiled in difficult circumstances. They only provide a record of someone's property on a particular day, and it cannot be assumed that they give a true or complete picture since items might have been deliberately omitted or poorly described to conceal or disguise the real asset value from creditors and other interested parties. It is not always clear how much money was

Two irregular shaped rubies, set to form pendant drops.

A14069a, A14069b, both shown six times actual size

tied up in the stock, and valuations are not always supplied. It is unlikely that consistent stock levels were maintained over the lifetime of the business and there is usually no way of knowing if the type of stock listed is exceptional or usual. Does the stock reflect the latest trends or had it been sitting around for a while? How much had been manufactured on site? How much had been outsourced and bought in for resale? Did the stock include items that belonged to others, such as specimen stones supplied by a client, pawned items or items bought in for repair or alteration? Was the jeweller working independently or as part of a consortium?

Inventories of the late sixteenth and early seventeenth centuries are often quite sketchy. What for instance, are we to make of the singularly unhelpful reference to 'stones' in William Wheeler's inventory, or the mystifying description 'one turtle dove' in the stock of the jeweller Gregory Barker?[14] Inventories are not consistent in their level of detail, and even in the same document the amount of information can vary from item to item. Most of the jewels sold for her 'majesties benefit' in November 1600, for instance, are summarily described in one-line entries with the name of the item, followed by its material and weight, but the final page listing jewels and stones sold to John de Granade, who seems to have had a particular interest in buying sapphires, spinels and rubies, is quite different. Here reference is made to the colour, type and condition of the gemstones, with detailed descriptions of their flaws and inclusions. The ballas rubies (spinels) are described as 'full of eyes fowle', dim and 'full of clouds like an Amatiste' (amethyst). The sapphires, dark or pale blue, were drilled, without good 'proportions', full of 'clouds' and 'flashes' (presumably star inclusions) and were cut in the form of a heart and oval, with or without facets.[15]

Sometimes a jewel or gemstone is described at length because it was particularly valuable or the subject of a dispute, such as 'one Jewell of gold with the picture of a woman

therein sett with one great fowle diamond cut with lozinges, one nayle diamond seaven triangle dyamondes whereof three are pendant, and 26 table dyamondes great and small the said Jewell and dyamondes beinge appraised at £120'.[16] But even here it is not clear whether the 26 table diamonds were part of the jewel of gold or a separate group of unset stones, the whole lot valued together.

Nomenclature also presents a number of challenges: it is not always obvious what the appraiser meant; nor is it always certain if the term had been correctly applied. Spellings were not standardized and there was a certain amount of specialist jargon. French and English stone cutters used the term 'cerse', perhaps a slice or a particular type of cut,[17] and Dutch and English diamond cutters used the word 'bourde' for a specific kind of diamond polishing material (see p 164). Terminological confusion was rife. One inventory mentions 'a stone called a ballys garnished with gold' and 'a stone called a spinnel garnished with gold'. Spinel and ballys (a diminutive for ballas rubies) are in fact one and the same, so either the appraiser was using two terms interchangeably for one type of stone, or one stone was a genuine ruby (not a balas ruby) and the other a spinel.[18] Equally ambiguous is the repeated used of the term 'rock ruby'. For the most part the term 'rock' simply meant an unpolished stone left in its rough natural state, such as the 'one thousand four hundred and seventy four *rock rubies* at £46' in a schedule for debt between the merchants William Blackett and Oliver Westland.[19] When rock rubies are mentioned with reference to a jewel, however, the term 'rock' must have had a slightly different shade of meaning. A natural ruby rough has no play of light or lustre, so it seems inconceivable that genuine 'roughs' were set in lavishly enamelled jewels. Perhaps in such a context 'rock' ruby meant a cut and polished stone of irregular or 'natural' form, though it might also have been an alternative term for a spinel or ballas ruby (see previous page).

chains from left to right: A14074 amethysts and diamonds; A14006 amethysts; A14200 enamel and diamonds; overleaf, A14252 hessonite garnets; A14072 enamel; A14194 almandine garnets

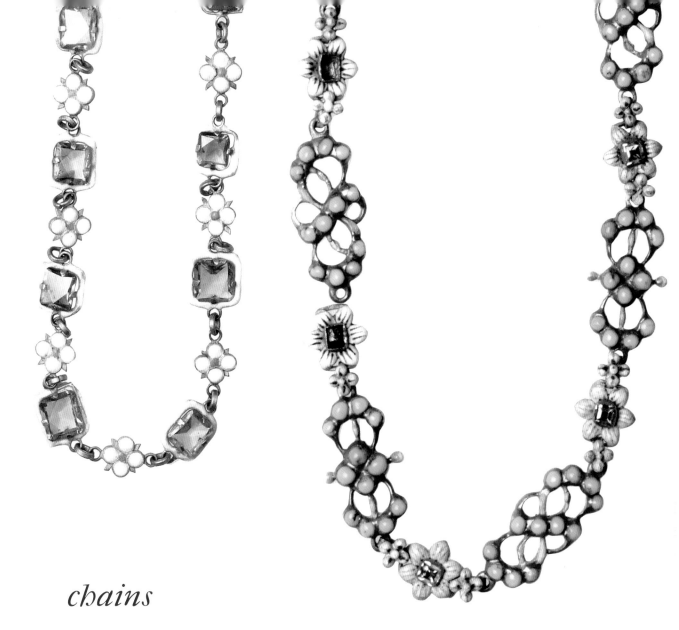

chains

Worn in cascading loops of ever-increasing length to the waist, necklaces were so beloved that one seventeenth-century wit remarked that people would rather wear a base-metal counterfeit worth eight pence than remain unchained.[20] The thirty chains in the Cheapside Hoard vary greatly in length. Some form a continuous loop; others have come apart; and some have been reassembled to form shorter or longer strands. It is possible that some of the shorter lengths served as bracelets, 'carcanets' (a jewelled band for the hair) or 'borders' (a decorative trimming). Most consist of delicate knots, stars, scrolls, foliate and floral links with the details picked out in white and coloured enamels. Others include cabochon or faceted stones and pearls. Some of the designs repeat, but each necklace is unique with different colour combinations of enamel or gemstones to provide subtle variation and choice.

Necklaces of this sort are often depicted in contemporary portraits, but they were evidently susceptible to chipping and damage, as Adriana points out in Shakespeare's *Comedy of Errors*, 'I see the jewel best enamelled /

Will lose his beauty.'[21] This remark must have had particular resonance with the theatre audience at the time. Indeed it is possible that the fashion for enamelled necklaces began to wane in the early seventeenth century because of this inherent problem. The Hoard necklaces are the only examples of their type to have survived.

In his diatribe on Jacobean fripperies and fashions, the playwright Thomas Tomkis noted that 'a ship is sooner rigged by far than a gentlewoman made ready'.[22] The elaborate ruffs, puffs and stuff worn by the style-conscious were matched by their love of jewels, each piece having to be laboriously tied, pinned or stitched into place. Necklaces presented the greatest challenge: the links were inclined to twist and snag, and because they were worn in long lengths, reaching almost to the waist, they had to be looped and entwined around the neck and bodice.

Portrait of an unknown woman, formerly known as Mary, Queen of Scots. c. 1570.

Artist unknown, oil on panel, transferred to canvas, National Portrait Gallery, NPG 96

The unidentified sitter is here festooned with chains, but she also wears an enamelled Venus and Cupid pendant at her neck. The matching pendants fastened to her breast and girdle depict a classical column set against a wheel of fortune, emblematic of fortitude during the trials of life.

Some terms were used concurrently or interchangeably. Some had currency for a short period while others changed their meaning and usage over time. The word 'carcanet' for example was usually used to describe a collar or necklace, but was also applied to any jewelled band or ornament worn in the hair. Gemstones presented a particular challenge because by no means all jewellers had sufficient expertise to identify correctly the material or even distinguish the true from the false. And because appraisers were aware of the risks of making a mistake they often exercised caution with vague phrases like 'a stone called' such and such, or they would give up altogether and limit their remarks to shape and colour: a 'pendant with Blew and white stones' or simply a 'coloured stone'.[23] Hannibal Gamon, described as a 'great doer' in all matters connected with gemstones, wisely cautions that the colour of a stone cannot not be plainly described 'as discerned by sight' since some are transparent, some opaque, and some 'a mixte between bothe'. As a rule of thumb, he continues, the more perfect and intense the colour, the less 'luciditye is in it', and so he suggests that stones of whatever type and degree should be assessed according to four criteria: colour, brightness, hardness and vertues.[24]

Occasionally attributions were given for precious stones and jewels to reinforce their importance and boost their value, such as a 'German opall' and a 'diamond with scotch pearle hanging at it'.[25] Elizabeth I had thirteen chains of 'Paris work', part amber, part bugle (glass), part agate, part mother of pearl, and part marble,[26] and 'dyvers dutch Agats' (agates), though whether this meant that the stones were sourced and/or cut in the Low Countries is uncertain.[27] Gold chains of 'Spanish worke enamelled black' and others of 'divers colours', especially green and red, are mentioned in Anne of Denmark's jewel inventories.[28] A gold chain of 'Spanish work' valued at £10 was stolen from Sir Robert Filmor's house in 1620. Another gold chain of 'Spanish worke' enamelled red,

mystery objects

There are several items in the Cheapside Hoard which are difficult to classify because their purpose is unknown. These include fine gold wire ornaments with inset plaques of mother of pearl set back-to-back (now mostly lost). Each lobe is individually fashioned from profiled setting wire and the lower frame is suspended from a tiny quatrefoil overlain in white and pale blue enamel. The pendant loop is set at right angles to the main axis of the piece, which suggests that it was designed to hang in a certain orientation. The choice of material and the shape of the lobes resemble the transluscent seed pods of the plant *Lunaria*, which was regarded as a symbol of honesty and appreciated for its healing properties.

Mother of pearl, often engraved with delicate patterns, was used for decorative inlays on all sorts of objects, particularly caskets, pen cases, knife handles, dagger hilts and cups and bowls. There were 'five devices of mother of pearl as fishes &c' listed among Elizabeth I's jewels, and '64 fishes of mother of pearle valued at 6s 8d among a jeweller's stock in 1607,[29] but whether these were gaming counters or jewels of some kind is unclear. Specific references to jewels of mother of pearl are rare and it is by no means certain that the ornaments in the Hoard were designed for wear.

A14075, A14076, NN12469, shown one-and-a-half times actual size

blue and white and made in the fashion of 'Esses and loopes' weighing five and three-quarter ounces, was listed among Margery Smith's goods in 1630; this was priced at £18.[30]

Much less straightforward was the term 'orient', which was occasionally applied to amethysts, emeralds, topaz, garnets and pearls. Although this sometimes meant that the stone had been mined in the East, because oriental gems were considered superior to their occidental counterparts, and had greater cachet on the European market, the term was also applied as a signifier of quality rather than provenance. To make matters worse, gems with similar attributes to an oriental stone were also called 'orient' even if the gem material was quite different. So the 'great amatist orientall' in one of Anne of Denmark's bodkins in 1606/7[31] and the three 'orientall amethysts' listed among Queen Henrietta Maria's jewels in 1669 might have been genuine 'oriental' amethysts, or violet-coloured sapphires, or some other purple stone.[32]

The demand for 'oriental' gems was such that stones from the New World were re-exported to eastern gem markets so that they could be marketed in Europe with an 'orient' attribution. Many of these stones ended up in the Low Countries. When the merchant financier Thomas Gresham was working in Antwerp in 1560, he acquired an emerald worth £266 13s 4d, a table diamond valued at £200 and a point diamond worth £50, on the understanding that they were 'oryent' stones to sell in London. The stones were despatched with 1,000 ells of black damask. Gresham wrote to his London contact to say that he had signed a contract with the supplier which meant that he had either to pay for them or return them within twenty days of receipt.[33] It is quite possible that the emerald was a New World stone re-marketed as an orient gem, but it is also conceivable that it was a green spinel or some other green stone.

Portrait of Elisabeth van der Aa, 1628, by Thomas de Keyser (1596/7–1667). The handle of the feather fan is similar to jewels in the Hoard (*shown overleaf*).

Musée de l'Hôtel Sandelin, Saint-Omer, France, inv. no. XIR 212580

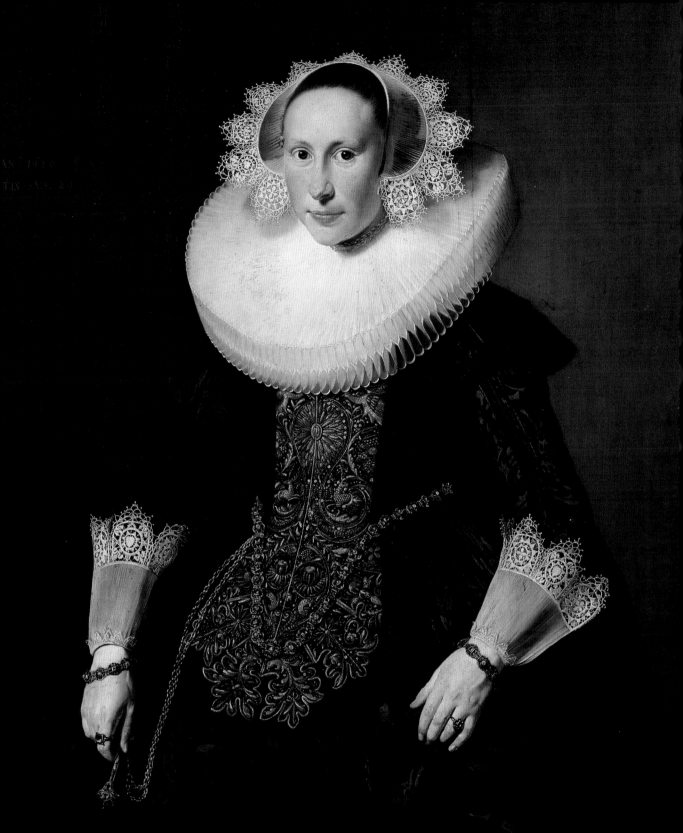

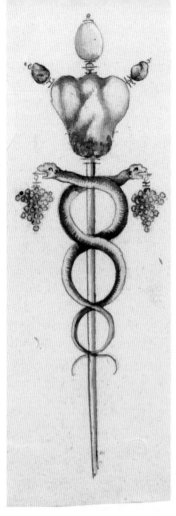

fan handles or aigrettes

These gold enamelled and gem-set jewels, ranging in length from 55 to 68 mm, have a short shank, flared socketed head and suspension loop. Set with different stones in various combinations, including star-cut garnets and amethysts, rose-cut white sapphires and diamonds, table-cut amethysts, pearls and cabochon (domed) emeralds and garnets, they are the only known examples of their kind.

The designs include lotus flowers in white, green and blue enamel, conjoined wings and winged caduceus. The caduceus, an emblem of eloquence, the intellect and fertility, was the heraldic wand of the Greek deity Hermes and his Roman counterpart Mercury, the divine messenger and patron protector of travellers, merchants, gamblers, liars and thieves. The album of jewellery designs attributed to the merchant jeweller Arnold Lulls (active in London from *c.*1584 to 1642) includes a caduceus pin surmounted by a pearl (*left*).

Victoria and Albert Museum, D.6:1–25–1896

'When Mercury did take his powerful wand,
His charming caduceus in his hand…'

Francis Beaumont, *Salamacis and Hermaphroditus*, 1602[34]

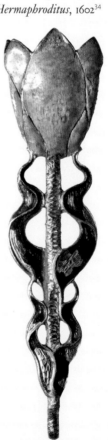
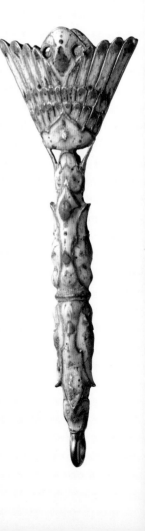

Elizabeth I had a 'fanne of white feathers with a handle of golde havinge twoe snakes wyndinge about it, garnished with a ball of diamondes in the ende and a Crowne on each side within a paire of winges'.[35]

One jewel (A14168), which might have been given as a love token, set with garnets on one side and pearls on the other, has a single, orange hessonite garnet in the centre of the shank (the rest are darker red almandine garnets) with a corresponding heart-shaped pearl on the reverse.

Although the exact purpose of these jewels remains a mystery, the slender, socketed heads probably held plumes of feathers. The shapes are reminiscent of aigrette and fan-holder designs of the late sixteenth and early seventeenth centuries. A feather fan handle of similar size and shape hangs from Elisabeth van der Aa's girdle.

from left: A14166, A14159, A14117, A14167, A14168 (front and back), A14165, A14115

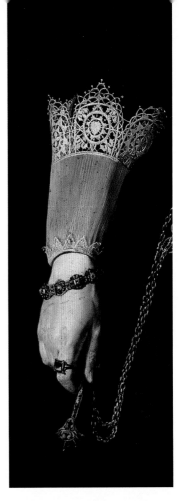

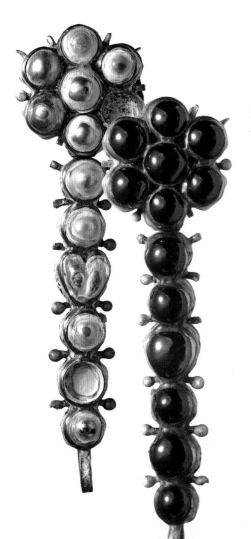

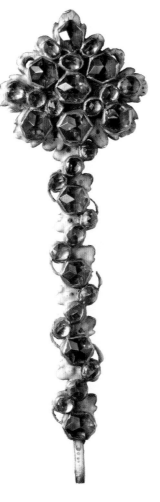

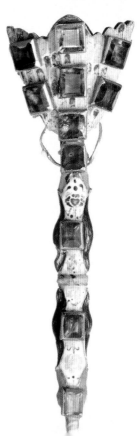

Cut and polished stones

The extent to which stones were cut and polished at source or imported in rough condition for cutting in London is unknown. In all likelihood a certain amount of preliminary cutting and polishing was done to remove any flaws and extraneous matter for the purposes of assessment and sale, though how far that process went must have depended on the type, amount and quality of the gem material, the purpose for which it was intended, and the availability of local knowledge and expertise. Some of the Cheapside Hoard gems were cut and polished in their country of origin: most of the agate beads and garnets, for example, and probably also the large spinels. It is possible that the spinels and cornelians were heat-treated to enhance or alter their colour.

The innate beauty of a gem was enhanced by splitting the stone along natural lines of cleavage to create a series of angles or facets. Each facet was precisely aligned to remove impurities, reflect the light and bring out the inherent quality and brilliance of the gem. Since gem cutters only sought to remove areas with cracks and inclusions, the shape of the rough determined the final outline of the polished stone. As a result, gems often have an irregular and asymmetrical form because the cutter was striving for the maximum size possible. Accounts describe triangular, lozenge, round, square, 'peare fashion' and 'heartwise' stones, but the shape of the stone was of secondary importance to its quality and cut. The most fashionable cuts were the point, triangle, table and rose; diamonds cut 'ridgewise'[36] are also occasionally mentioned. The catch-all term 'facet' or 'faceted stone' was commonly used when the cuts were either too complex to classify accurately or when the person describing them had insufficient knowledge.

The most valuable and desirable cut was the table-cut, with a small lower surface – cullet – obtained by slightly grinding the point, and a larger flat upper surface or table, square or

rectangular depending on the general shape of the rough. Flat and 'half rounde' table-cut stones are also mentioned.[37] Thin table stones were particularly prized and, according to some accounts, were 'worth more than they weigh', though contemporary commentators, like Hannibal Gamon in Cheapside, were quick to point out that a cut and polished stone should be 'neither too thick or too thynne' in order to reflect as much light as possible lest it appear lifeless and dull. Thin table-cut stones, especially diamonds, could be 'set on velvett' to make them appear bigger; but the best diamonds, 'being kinge of all praetious stones', had to be cut in certain proportions so that the side facets were equal to the overall area of the top of the stone, and the

> under part be no broader, then that 3 of the bredthes thereof will make the bredth of the upper parts. And in depth according to the same proportion. And the squares called Bizals, must stand close with the edge of the ring or collets where in it is sett, being of hole depth, so some what longer then square, and yet not more then that it may be gessed which is the length and bredth thereof.[38]

Stones imported in their natural unpolished state were variously described as 'rocks', 'roughs', 'brute', 'coarse', 'fowle' and even 'nasty'. Most of the diamonds arriving in London in the late sixteenth century were supplied by Portuguese gem merchants, who had a virtual monopoly on the trade. In 1594 Hannibal Gamon purchased two packets from his local dealer, the first containing 114 stones, comprising 41 'brute' diamonds of various carat weights, 9 'poynte' diamonds, 15 'rock' stones, also of varying weights, 24 'thynne stones', 13 stones for 'nayles' and 12 more for 'tryangles'. The cutting cost per carat was 10 shillings and the whole parcel cost £27 10s. The second packet, purchased at the same time, contained a further 50 brute and nayle diamonds at £3 per carat at a total cost of £29 12s 6d. In 1592 Gamon went down to the West Country to buy rough stones from the Portuguese prize ship *Madre de Dios*, which, he noted

This unmounted table-cut citrine is beautifully proportioned. A stone of this size, which shows no sign of wear, could have been set in a jewel or possibly mounted on a vessel or dagger hilt.

A19312, shown twice actual size

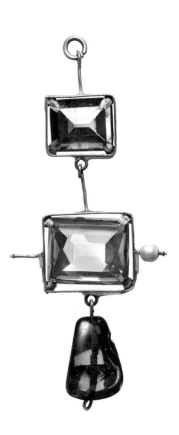

This pendant is set with Sri Lankan stones. The sapphires are of exceptional quality, with deep colour saturation and even colour dispersion, the facets are extremely precise and the lapidary skills of the European cutter are of the highest order. The spinel drop, however, corresponding in outline to an octahedral rough, was almost certainly cut at source. This stone has been drilled from both ends in a five-stage process using two drills of different diameter to correct the misalignment. One of the drill holes has a stepped profile, which presumably helped to prevent the drill tip from wandering during the early stage of perforation.

A14104 shown actual size and enlarged

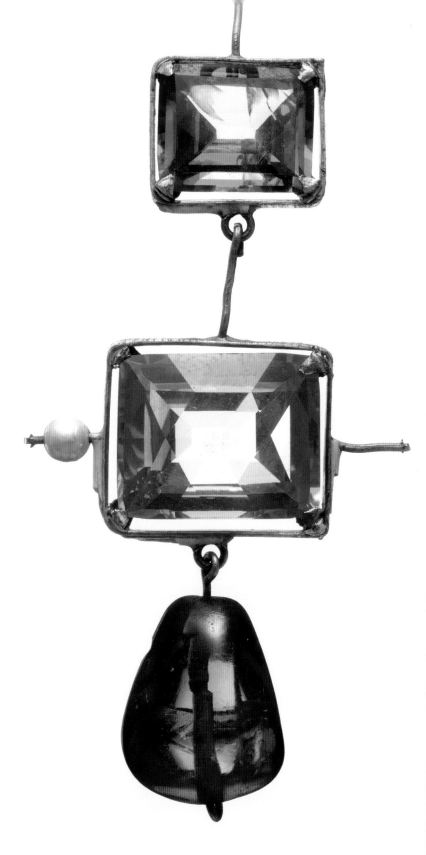

with some pleasure, he was able to secure at a much lower rate than he had hitherto managed to get from the merchants in London.[39] He was not alone. Robert Brocke in Lombard Street, a dealer called Scote in Fenchurch Street and two of Gamon's neighbours in Goldsmith's Row, John Tirrie (Tirrey) at the sign of the Black Lion and Richard Howe at the sign of the Griffin, also bought stones from the ship. Robert Howe bought so many 'below the price' that he feared for his safety, and it was subsequently reported that he had 'shut up shop' and had gone to ground. He was later spotted around town paying calls to various stranger jewellers, and then rumours began to spread that Dutch and French jewellers had purchased a large number of the stones (diamonds and rubies) in secret, many of which were apparently designated for buyers in Frankfurt and Venice.[40]

Some diamonds were sourced from Borneo, but the majority came from the Deccan area of India, especially the region of Golconda, where there were 23 active mines in the early to mid-seventeenth century. Most were found fairly close to the surface at a maximum depth of 18 feet and, according to contemporary accounts, each mining district was renowned for stones of particular colour and quality.[41] Some were well formed like 'two pyramids whose bases are not in the middle'; some were shaped like the 'great end of a razor blade', thin on one side and thick on the other; and some 'lookt like ordinary Peble stones or very great Gravell without regular shape'. The colours ranged from 'very white' to browns inclining to a greenish tinge, reddish yellow and yellows.[42] But the very best diamonds, as Hannibal Gamon noted, 'must be withoute anye faultes, bothe in corners and sydes, … cleane cutt without any Naystnes, and of a good water christalline, and shyning cleare, not yellowe, Blewishe, or Blackyshe or browne, but cleare, and cleane in all perfection'.[43]

Gamon stressed that diamonds could only be cut with other diamonds or diamond powder, although sometimes London

diamond cutters, wanting suitable material, had to resort to using 'bourde', a material black in colour like iron, and 'called in Latin Syderites', from Cyprus (probably some sort of iron carbonate from a meteorite), which 'could be easily broken and crushed in a steel mortar'. This material was commonly sold to both diamond and agate cutters for 4 shillings the carat, unless the supply was limited, in which case the price was adjusted to reflect market demand.[44]

Some jewellers were diamond specialists. One had over 1,000 diamond-set jewels, mostly crosses, pendants, bracelets, rings and chains, as well as loose stones in assorted boxes and packets graded according to type, quality and size. The 101 rough diamonds were split between two boxes, 14 valued at £60 and the rest at £210; the 'little' diamonds were likewise divided into two groups, with 300 valued at £35 and 60 at £15. References to the colours, shapes and weights of the stones are few, though one unspecified 'jewel' in the list was set with 56 brown diamonds worth £20 and there was a box of 'fowle' diamonds valued at £2 10s.[45]

Most of the stones in the Cheapside Hoard are table-cut, but there are also star-cuts and many rose-cut stones with 6, 12, 18 or more triangular facets. It is difficult to be certain when the rose-cut was introduced, though it is specifically mentioned in documentary accounts from c.1600 onwards. In 1612, for example, James I purchased a 'fair rose diamond set in a ring of gold' from the goldsmith John Harris for £400.[46] In 1657 the jeweller John Crompton had all sorts of diamond-set jewels, with large table-cut stones, thin table-cut stones, a ring with a 'single rose diamond' and a locket with 16 rose diamonds and a blue sapphire in the middle.[47] Rings and other jewels in the 'form of a rose' – in other words, rosette shaped – were also fashionable, such as the two small 'roses of diamonds set in golde' among Elizabeth I's jewels in 1600,[48] the brooch of gold in the 'forme of a Rose garnished with sparkes of Diamonds and Rubies' among Anne of Denmark's jewels,[49] and the 'jewell of gold in the

Portrait of Anne of Denmark (1574-1619), Queen consort of James VI and I, oil on canvas, c.1617 after Paul van Somer, (c.1576–1621). The diamond jewels worn by the Queen have devotional, emblematic and personal significance. The crowned monogram jewels fastened on her ruff underline the Queen's affection for her family and dynastic connections: the *S* for her mother Queen Sophie of Mecklenburg and the *C4* for her brother Christian IV of Denmark. Anne's piety and Catholic faith are expressed by the pendant cross and Sacred Monogram IHS jewel. The large crossbow shaped bodkin in her hair was a symbol of brainpower over brute strength.

National Portrait Gallery, NPG 127

diamonds

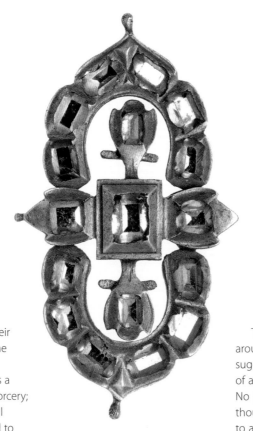

Diamonds were prized for their sparkle, lustre and adamantine qualities but also for their supposed magical powers 'as a defence against the arts of sorcery; to disperse vain fears; to quell quarrels and contentions and to help lunatics and those troubled with phatasms and nightmares'.[50] Diamonds worn on the left arm were believed to 'give victory over enemies' and, according to one text, those who wear them 'will be bold and daring' in their transactions.[51] They were regarded as emblems of constancy, innocence and fortitude, and were especially valued for their reputed ability to 'frustrate all the maligne contagious powers of poisons': a view which gathered force during the Renaissance with the publication and reworking of classical texts.[52] Diamonds worn close to the heart, on the finger and next to the skin were considered particularly efficacious.

Though by no means the most valuable of gemstones, diamonds were certainly the most popular. Of the jewels specifically listed in the Exchequer records of the

Jewel House during the later part of Elizabeth's reign, for instance, approximately three-quarters were diamond-set; though, as this excerpt suggests, the size and quality of the stones were variable: 'Item, 8 rings of gold set with 8 fair diamonds, £400; 12 rings of gold set with 12 lesser diamonds, £200; 24 rings of gold set with mean diamonds and counterfeit diamonds, £188.'[53]

Diamonds were set into jewels of every conceivable type: in large brooch pendants worn on the breast, sleeve or hat; in chains and borders; in earrings, buttons and pins. Most of the diamonds in the Cheapside Hoard are used in conjunction with coloured stones. The two exceptions are a mount of symmetrical openwork and an enamelled gold ring.

The location pins or tabs around the edge of the mount suggest that it formed part of a multi-component jewel. No precise parallel is known, though it is stylistically similar to a diamond-set monogram pendant in the collections of the Muzeum Narodowe w Szczecinie, Poland, attributed to Jacob Mores the Elder (c. 1540–before 1612). In this jewel, the Roman letters *IHS*, representing the Holy Name (from the Greek ΙΗΣΟΥΣ, Jesus),[54] are intertwined and superimposed.

Whether the Cheapside mount was made to represent the letter *S* in a devotional jewel of this type or comprised part of a secular ornament is unknown. The table-cut stones have been foiled and the quality of the diamond cutting and setting is of a very high order. Elizabeth I had several 'sipher' jewels, and there are a couple of jewels of gold, 'being the Sipher of Jesus in Diamonds', and other diamond-set monogram jewels in the 1606–07 inventory of Anne of Denmark.[55]

the form of a rose

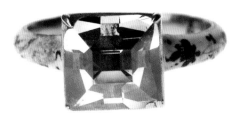

Almost half of the rings in the Hoard have rosette settings of emeralds and garnets (in one case sapphires) around a larger, slightly raised central stone or pearl. Calyx-like cusps with pellets of white enamel (now mostly lost) enhance the flower-like aspect of the design. The clustered arrangement had an impressive impact and made good use of smaller stones, which, although cheaper and easier to obtain, must have been much more costly to mount and set.

from top: A14233, A14222, A14237, all at four times actual size

'Julia, I bring
To thee this ring,
Made for thy finger fit;
To show by this
That our love is,
Or sho'd be, like to it.'
 (Robert Herrick, 1591–1674)

The ring is set with a large solitaire table-cut diamond of superb quality. The outer facets have been slightly chipped with a scorper (a type of chisel or graver), which occurred when the stone was set.[56] This ring is the only one in the Hoard that has enamel all the way round the hoop, so it must have been made for a specific customer (a young woman or girl with slender fingers) or possibly as a set piece for retail since it could not be resized.

 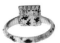

mount (left) A14096 four times actual size; ring A14244 four times actual size and below actual size

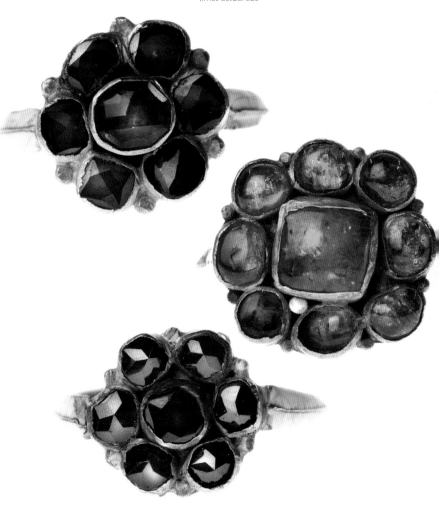

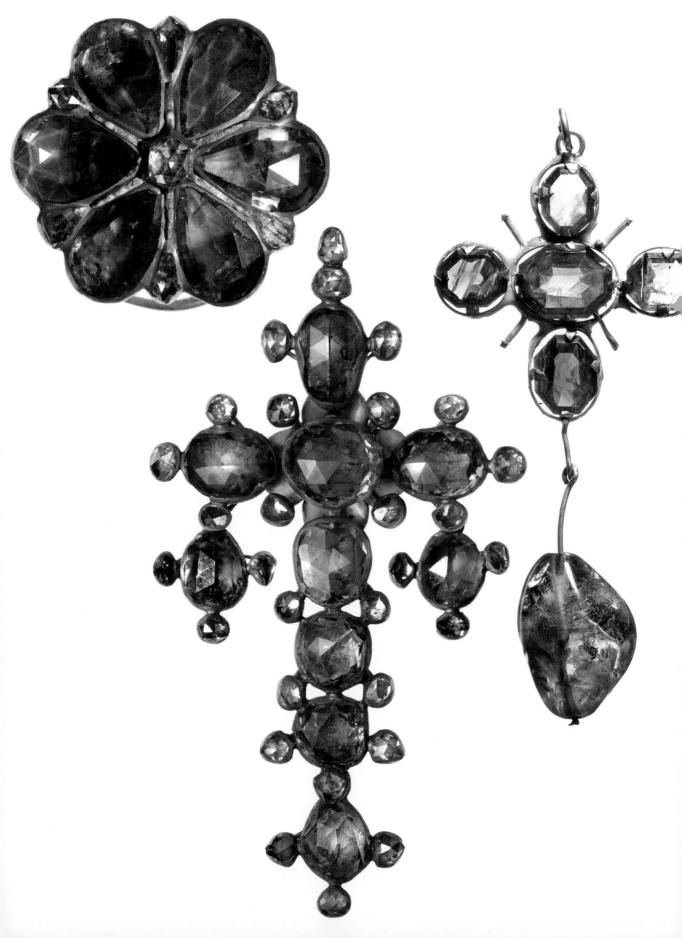

fashion of a rose sett with 24 diamonds' which was the subject of a dispute between the London goldsmiths Richard Eman and Richard Harwood in 1609.[57] Occasionally, however, the use of the term 'rose' is ambiguous. In 1600, for example, the gem merchant John de Granade purchased some of Elizabeth I's old jewels, which included 'one ballace [spinel] like a rose dymme and fowle with a worde in it'. Was the stone rose-coloured, shaped like a rose or cut with rose facets?[58] Perhaps all three. Equally confusing is the bequest of a 'gold ring with a Rose' to Christian, the daughter of the jeweller Fabian Simpson, in 1650.[59] Did it have a rose-cut solitaire, a rosette-shaped bezel or both combined?

The Hoard contains a large number of pendant jewels of considerable charm and elegance. These include tiered clusters of faceted amethysts, emeralds and garnets; enamelled gold and pearl wirework cages (see p. 81); and vine branches laden with bunches of grapes exquisitely carved from emeralds and amethysts. Jewels with pendant amethyst grapes feature in a pattern book attributed to the Dutch jeweller Arnold Lulls, who was active in London from *c.*1584 to 1642. When his daughter, Susanna Edmonds, drafted her will in 1646 she left bequests to her niece Mary Blackwell of 'my two Redd Amathist grape pendants – hanging att two hands five small rubies above each hand' and to her daughter-in-law Martha Wood 'my greene Emrald Grape Pendant hanging att a hand and one each side a diamond in the middle of two leaves' (see p. 174).[60]

Other pendants comprise gem-set and enamelled crosses, such as top right (A14105), with violet-blue iolites and an orange-pink spinel and bottom left (A14110), with diamonds and pink sapphires (see also p. 199).

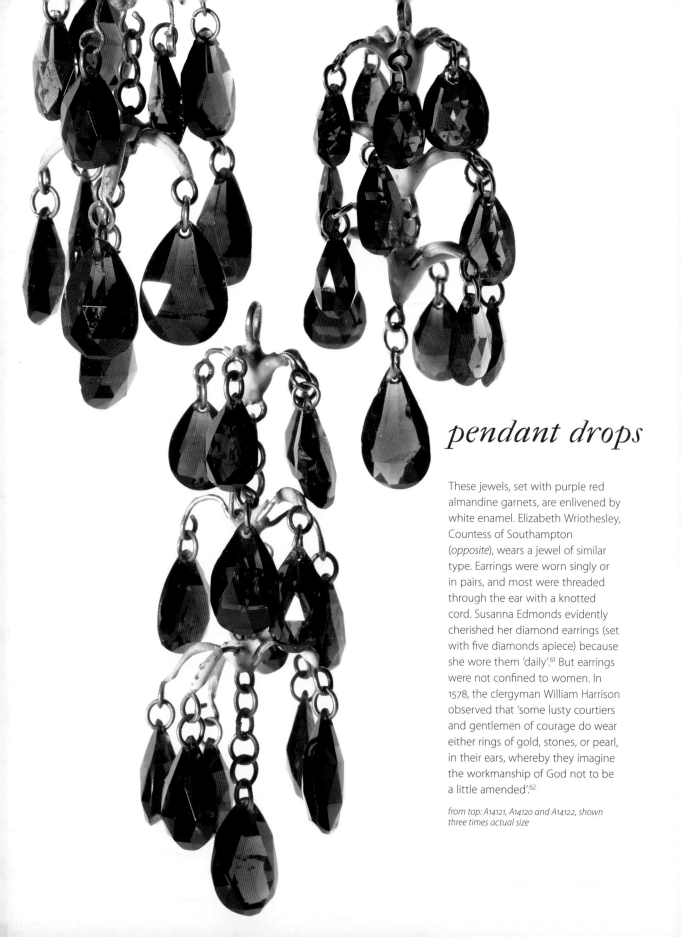

pendant drops

These jewels, set with purple red almandine garnets, are enlivened by white enamel. Elizabeth Wriothesley, Countess of Southampton (*opposite*), wears a jewel of similar type. Earrings were worn singly or in pairs, and most were threaded through the ear with a knotted cord. Susanna Edmonds evidently cherished her diamond earrings (set with five diamonds apiece) because she wore them 'daily'.[61] But earrings were not confined to women. In 1578, the clergyman William Harrison observed that 'some lusty courtiers and gentlemen of courage do wear either rings of gold, stones, or pearl, in their ears, whereby they imagine the workmanship of God not to be a little amended'.[62]

from top: A14121, A14120 and A14122, shown three times actual size

Portrait of Elizabeth Wriothesley (née Vernon), Countess of Southampton (detail). Artist unknown, oil on panel, c. 1620.

National Portrait Gallery, NPG 570

Elizabeth Vernon, maid of honour to Elizabeth I, married Henry Wriothesley, 3rd Earl of Southampton, in 1598. A patron of Shakespeare and a colonial pioneer of some distinction, Southampton was known for his flamboyant dress, flowing auburn locks and beguiling appearance, 'bright and shining, beautiful from top to toe'.[63]

Elizabeth is shown here elegantly attired in black and red. Her lace coif is adorned with pearls and she wears a tiered ruby or garnet earring, similar to three jewels in the Cheapside Hoard. The diamond-set letter *S* on her chain presumably stands for 'Southampton' and her hand rests on a miniature locket, which probably contained a portrait of her husband.

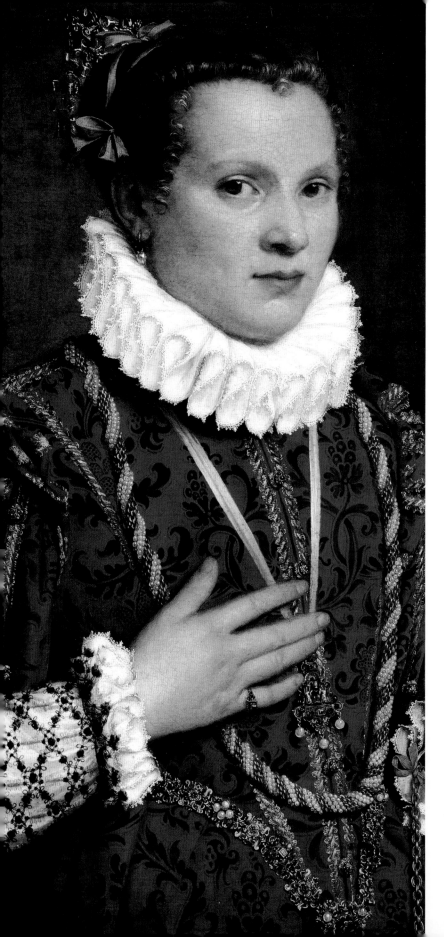

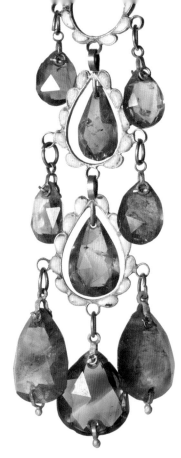

Portrait of a Young Woman with a Fan, *c.*1570 (detail). Giovanni Batista Moroni, oil on canvas.

Rijksmuseum, SK-A-3036

The sitter is splendidly attired, befitting her status as an Italian noblewoman. She wears an elaborate 'attire' of gold spangles and pendant gems which was designed to shimmer with the slightest movement. Londoners were especially fond of hair ornaments, and in 1583 Philip Stubbes bemoaned the fashion, complaining that women strove to outdo each other with 'curled, frisled and crisped [hair] laid out in wreaths and borders from one ear to another … hanged with bugles, gewgawes and trinkets besides'.

clockwise from top left: A14181, A14182, A14192, A14119, A14193, A14178, shown three times actual size

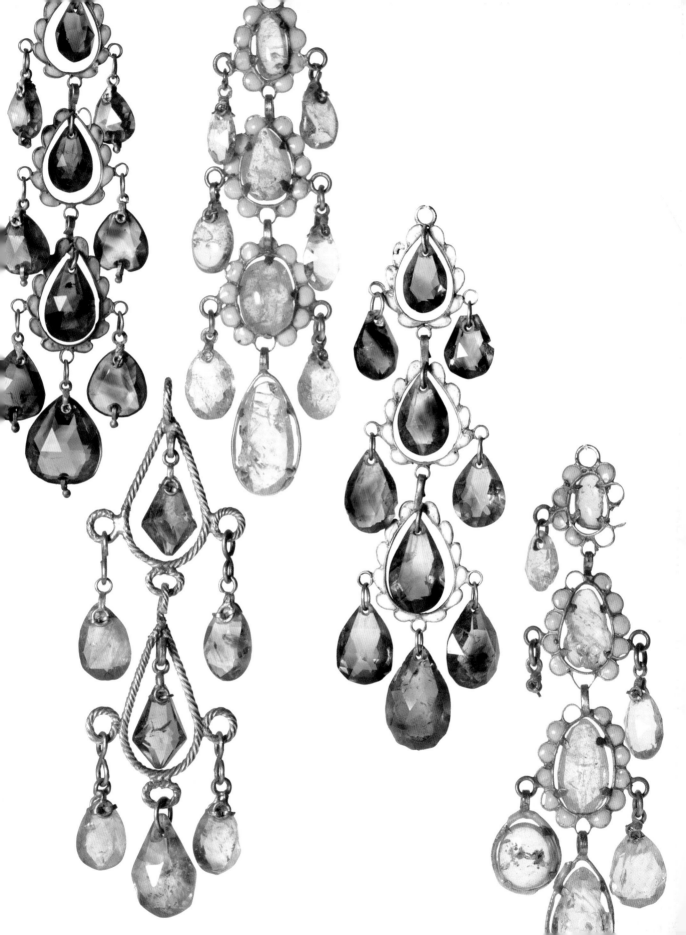

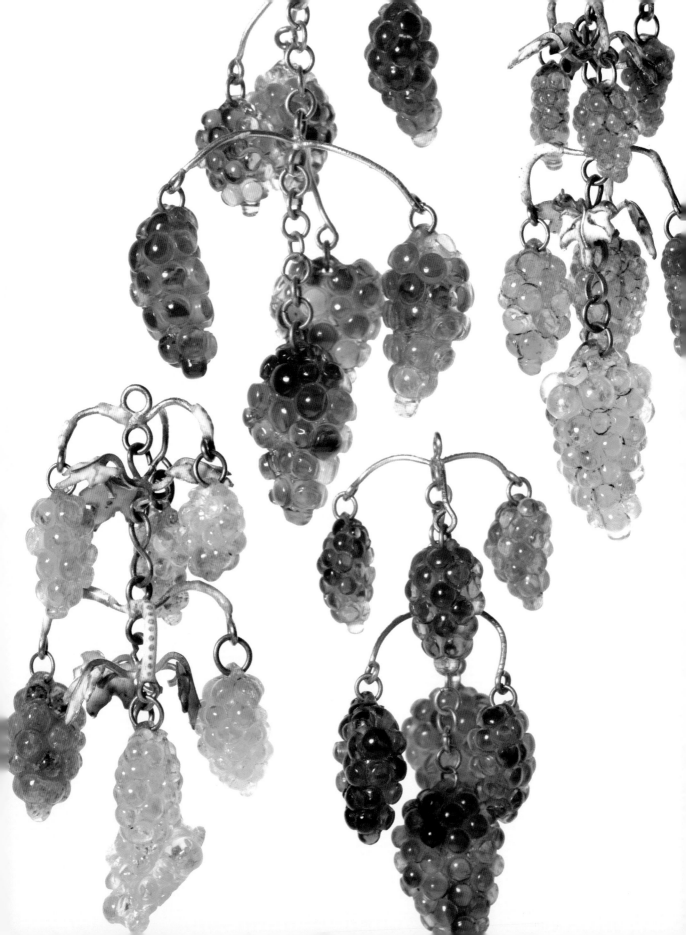

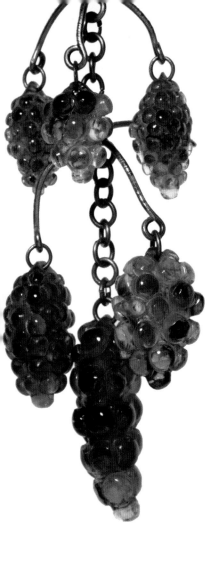

clockwise from top left: A14187, A14112, A14063*, A14064, A14111, all at three times actual size.

right: detail from Lulls Album, Victoria & Albert Museum, D.6:1-25-1895

a strawberry leaf

According to the herbalist John Gerard, 'divers sorts of Strawberries, one red, another white a third sort green' were cultivated in London gardens at the end of the sixteenth century.[64] The fruits were eaten fresh in season and conserved in succades, cordials and syrups, while the leaves and roots were appreciated for their curative properties. Physicians specifically recommended the plant for its 'singularly good healing of many ills', and in an age of sympathetic medicine, when analogies were drawn between the physical appearance of a drug and its resemblance to the part of the body on which it was supposed to work, the red heart-shaped fruits were advised for those of 'cholericke and sanguine temperature' suffering from blood disorders and cardiovascular complaints.[65] Concoctions of strawberry juice, white wine, powdered pearls and the shells of crayfish 'exquisitely beaten' were advised for cooling the stomach,

liver and blood, while infusions of the roots and leaves helped to control 'cardiacall passions [to] make the heart merry'.[66] Strawberry leaves were also 'boyled and applied in the manner of a pultis' to reduce inflamation, and distilled strawberry water was used to soothe sore throats and eyes and as an embrocation to 'scoure the face … to make [it] faire'.[67]

The strawberry plant's culinary and therapeutic qualities were matched by its significance as a secular and sacred symbol. Flowering under the astrological sign of Venus, with heart-shaped red fruits, it was a recognized emblem of love. But it was also used in Renaissance iconography to symbolize innocence, for though the plant 'creepe low by the Earth, and … venemous things creepe over the Hearbes [it was] in no manner infected with any venemous contagion'. This idea was developed by Geoffrey Whitney in his *Choice of Emblemes* of 1586 where a strawberry plant

is depicted with a snake entwined around the stem under the motto *Latet anguis in herba,* accompanied by the verse:

> Of flattringe speeche, with
> sugred wordes beware,
> Suspect the harte, whose face
> doth fawne, and smile,
> With trusting theise, the worlde
> is clog'de with care,
> And fewe there bee can scape
> theise vipers vile:
> With pleasinge speeche they
> promise, and protest
> When hatefull hartes lie hidd
> within their brest.[68]

The strawberry was also used in religious art and moralistic literature to symbolize the main tenets of Christian faith. The white flowers were regarded as a symbol of purity, the ternate leaves were used as a metaphor for the Holy Trinity, and the pendant berries signified the redemptive blood of Christ and the humility of the righteous.

It is highly significant that the pendant has been carved from

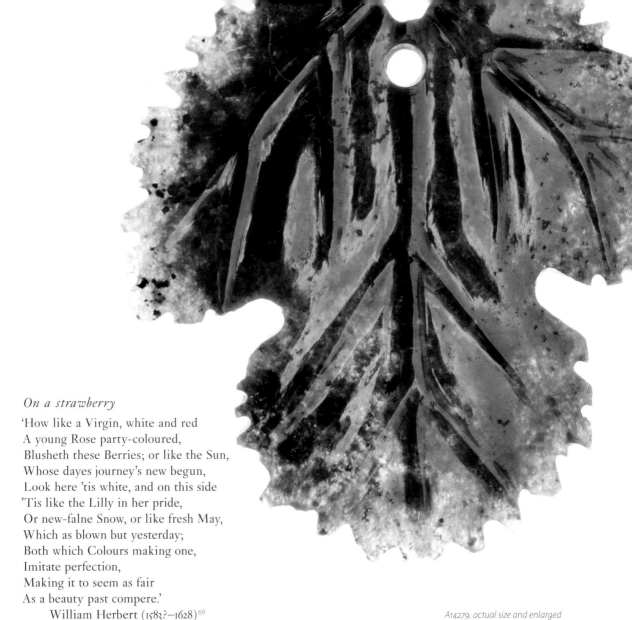

On a strawberry

'How like a Virgin, white and red
A young Rose party-coloured,
Blusheth these Berries; or like the Sun,
Whose dayes journey's new begun,
Look here 'tis white, and on this side
'Tis like the Lilly in her pride,
Or new-falne Snow, or like fresh May,
Which as blown but yesterday;
Both which Colours making one,
Imitate perfection,
Making it to seem as fair
As a beauty past compere.'
 William Herbert (1583?–1628)[69]

A14279, actual size and enlarged

bloodstone, because the stone was held to have therapeutic benefits and mystical properties. The red inclusions were likened to spots of blood and so bloodstone was also used as an internal and external medicament for blood disorders of various kinds. The Italian painter Vasari was given a bloodstone amulet to hang around his neck because he suffered so greatly from nose-bleeds that he 'was often left half dead'.[70] Patients suffering from the bloody flux were encouraged to drink powdered bloodstone with the juice of the milfoil; calcined bloodstone was used to treat plague victims; and the Strasburg surgeon Hieronymus Brunschwig applied a paste of the pulverized mineral to a cut, arguing that no physician should be without it 'to lay … upon ye wonde and vaynes'.[71] And because the mineral was held to possess 'more virtue than all the others' for staunching bleeding, hundreds of rings, seals and beads of Indian and Sri Lankan bloodstone were made for the European market.[72]

The Cheapside strawberry leaf pendant seems to have had dual significance as an amatory and devotional jewel and, so far as is known, is the only one of its kind.

Curiosities and 'Anticke' gems

> The valewe of your Aggatt is now Lyttle, but of old tyme of great valewe, not that his vertue is less nowe then it was in olde tyme, but that they are more plentifull now then in those days…. This stone is not sold by weight as other transparent stones be, But onely carieth a valewe If the coullors lye soe well in it that therein maye be engraven the Image or picture of a prince or noble man.[73]

The Elizabethan passion for antiquities and natural rarities attracted the attentions of unscrupulous dealers as well as lampoons and waspish remarks from London wits. As the writer Thomas Nashe put it: 'a thousand guegaws and toyes have they in their chambers, which they heape up together, with infinite expence, and are made to beleeve of them that sell them, that they are rare and pretious thinges, when they have gathered them upon some dunghill.'[74] Antique gems were avidly collected and were especially prized for their aesthetic qualities, technical virtuosity, subject matter and supposed magical properties. Some were displayed in magnificent cabinets of the sort owned by John Mathewe in 1667 housing 'several small Agatts Cornelions, Hilitrope and Jasper stones with some natural shells to the number of two hundred'.[75]

This late-sixteenth- or early-seventeenth-century gem of highly polished banded agate is engraved with a vase of flowers or foliage (possibly a branch of rosemary). The overall shape, bevelled edge and angle of the engraving suggest that it was designed as an inlay for a casket, and it was possibly set with others of corresponding shape and design. A little chest of silver gilt garnished with gold and 'cameo stones' was listed among Elizabeth's jewels in 1600.[76]
A14062 at four times actual size

Special stones were mounted on vessels or caskets, and gems with portraits and allegorical and mythological subjects were enclosed in bejwelled settings. John Mabbe the Younger had 'one little Jewell with a Camewe' set with five rubies, five emeralds and a pearl, and many other carved agate jewels depicting Hercules, Julius Caesar, the head of Christ, a phoenix, the 'storye of Vulcanus' and 'a woman cutt on it like a More'. These were set in elaborate enamelled gold mounts with pearls and other gems.[77] Elizabeth I had dozens of cameos, including a 'brooche of Golde wherin is set an Antique hedd of Agathe' [agate] with rubies and very small emeralds, which was described in 1600 as 'of little worth'; small buttons 'with faces of Aggatt [or camewes],[78] gold rings set with 'camewes' and a

A14271, A14158, A14113

crucifix of gold set with a 'kamewe'.[79] The jeweller Nicholas Herrick had 60 'smale camewes' at 20 shillings and 9 large cameos valued at 13*s* 4*d*'. No other details are supplied. In 1607 the London goldsmith Gregory Barker had 'an anticke sett in plane gold', which was valued at four shillings,[80] and in the same year Edward Fawkner, a founder, had an intaglio 'ringe with an aggat with a head graven in it' valued at twenty shillings. Elizabeth Springwell's jewels inventoried in 1661 included 'one onixe [onyx] stone with an Emperors head valued at £5'.[81]

The Cheapside Hoard includes 20 carved gemstones or glyptics, mostly in the form of unset cameos (carved in relief) or intaglios (incised). The oldest, carved from sardonyx and attributed to the Alexandrian workshops of the second or first centuries BC, depicts the profile head of a Ptolemaic queen with a vulture headdress cut from the upper brown layer of the stone. The identity of the queen is uncertain, but on stylistic grounds, principally the sloping forehead and small chin, there are two likely candidates: Berenike II (d. 222 BC) or Cleopatra VI (d. 30 BC) in the guise of the goddess Isis. For Roman and later collectors, the portrait was probably identified as Cleopatra, who attracted something of a cult following.[82]

Equally important are two Byzantine cameos. The largest and finest is a reverse-set white sapphire depicting the Incredulity of St Thomas, possibly dating to the third century AD, in a late-sixteenth to early-seventeenth-century mount of enamelled gold surmounted by a pearl. The stone has been recut so that the Greek inscriptions for Jesus Christ and St Thomas, IC X /ΛΑΨΗ at the top, to the right ΘΗC ICTO, and between the figures ΧΘѠMA, are mutilated. The second Byzantine gem is an amethyst cameo carved in high relief with two saints, each with an incised halo and an inscription: to the left ΑΓO ΔΕ ΗΗ Ο[...] (Saint Demetrios) and top right ΑΓO ΓΕѠΡΓΙΟC (Saint Georgios). The carving was probably done in the sixth century but the inscription was added later, perhaps in the ninth century. Byzantine cameos were valued

as diplomatic and religious gifts, and of the three hundred or so gems that are currently known, the two gems in the Hoard are considered the finest. The sapphire cameo is of such quality that it was probably made for an emperor.[83]

The Roman gems include a cornelian intaglio of perhaps the early first century BC, depicting Silenus (the companion and tutor of the wine god Dionysus) draped in a mantle with a thyrsus (a staff of fennel entwined with ivy leaves) in his right hand, with a boy satyr (a god of the woodlands), holding a wine cup and a curved staff (A14267). Another Roman gem dating to the late second or early third century AD is engraved with an eagle with a wreath in its beak and wings displayed. The eagle was the attribute of Jupiter, the supreme deity of the Roman pantheon and a symbol of the Roman Empire. Wreaths of laurel, oak, myrtle and other plants were regarded as tokens of power and conquest.[84]

The market for antique gems stimulated demand for contemporary copies, of which there are a number of examples in the Hoard. The amethyst (A14257) has a laureate head of an emperor, probably Domitian, with the letters VIIX cut in front, while the cornelian (A14270) depicts a generic 'classical' figure. The onyx cameo (A14263) celebrates the union of Mars, the god of war and agriculture, with Venus the goddess of love and beauty, and it is possible that the sardonyx cameo (A14022) was conceived as a personification of sight. Representations of the five senses were plentiful in Renaissance art, and popular prints were published with emblematic inscriptions to 'use your senses in God's honour; he who does otherwise falls into ignominy'.[85]

The Hoard also includes a small group of late-sixteenth-century devotional glyptics, including a double cameo of St George and the Dragon with a penitent saint on the reverse (A14256); an Italian or north European moonstone intaglio of the Annuciation (A14255); a fine cameo head of Christ (A14261); and a splendid reliquary pendant of diptych form with three

from top: A14267, A14021, A14257,
A14270, A14263, A14022

Diana surprised by Actaeon

The story of Diana and Actaeon from Ovid's *Metamorphoses* III was one of the most popular mythological subjects for Renaissance artists, yet their dramatic encounter is rarely depicted in glyptic form. This onyx cameo captures the moment when the huntsman Actaeon stumbles upon the goddess Diana and her nymphs bathing in a sacred pool. The outraged goddess flings some water into the young man's face and in an instant he turns into a stag, whereupon he is pursued to his death by his own hounds. Ovid attributes Actaeon's tragic end to 'fortune's fault and not in any crime of his', a sentiment shared and expounded during the Renaissance with the translation of Aristole's *Poetics* in 1549 and other classical texts.

A14276, enlarged

ape or monkey

This tiny gem of Mexican chrysoberyl awaits a setting. Monkeys and apes were believed to be full of 'plaguy tricks' and the very worst of human vices, and yet, as one writer noted, though 'the body of an Ape is Ridulous by reason of an indecent likeness and imitation of man … they are kept in rich mens houses to sport withal'.[86]

A14260; actual size 9 mm high

cameo of Elizabeth I

Many hardstone cameo portraits of Queen Elizabeth I have survived in European public and private collections. The smallest were set into rings or elaborately jewelled frames. This example, in agate, was probably made by a specialist workshop towards the latter part of the queen's life or in the years immediately following her death.

> 'The *Phœnix* of her age, whose worth did bind
> All worthy minds so long as they have breath,
> In linkes of Admiration, love, and zeale
> To that deare Mother of our Common-weale.'
>
> Aemilia Lanyer (1569–1645),
> 'To the Lady *Elizabeths* Grace')

ceremony, though sometimes presents were offered in private. Chief among the valuable presents which Queen Elizabeth bestowed on her favourites were portraits in miniature of herself. The portraits varied in size, quality and distinction, but even the most humble had splendid jewelled settings.

right Sir Christopher Hatton (1540–1591), Lord Chancellor, *c.*1589

Artist unknown, oil on panel, National Portrait Gallery, NPG 2162

Sir Christopher Hatton, described as of 'comely tallness of body and of modest sweetness of condition', was a particular favourite of the Queen and they were devoted companions throughout their lives. In this portrait, Hatton wears a jewelled hatband, white feather and hat jewel, triangular gold buttons and, most prominent of all, a cameo of Elizabeth at the end of a lavishly bejewelled chain, to express his loyalty and affection.

The jeweller Arnold Lulls had an agate cameo 'with the picture of Queen Elizabeth', which he left to his daughter Susanna. This was stored in a box wrapped up in a paper with a hand appearing in the clouds 'distinguishing the good from the badd' and a ragged yellow pearl.[87] Elizabeth's fame endured: the diarist John Evelyn noticed that Jerome Lanier, who had been appointed court musician in 1599, was still wearing a ring with her cameo portrait in 1654.

Gift-giving was a well-regulated process in Tudor and Stuart society. On New Year's Day it was customary for all members of the court and royal servants to give presents to the sovereign. The gift exchange took place in a public

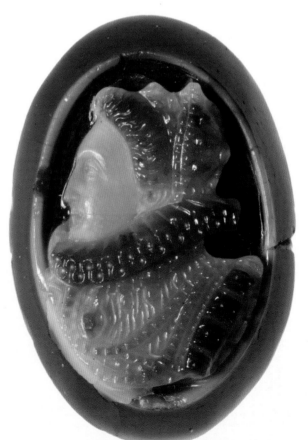

A14063 enlarged
and actual size

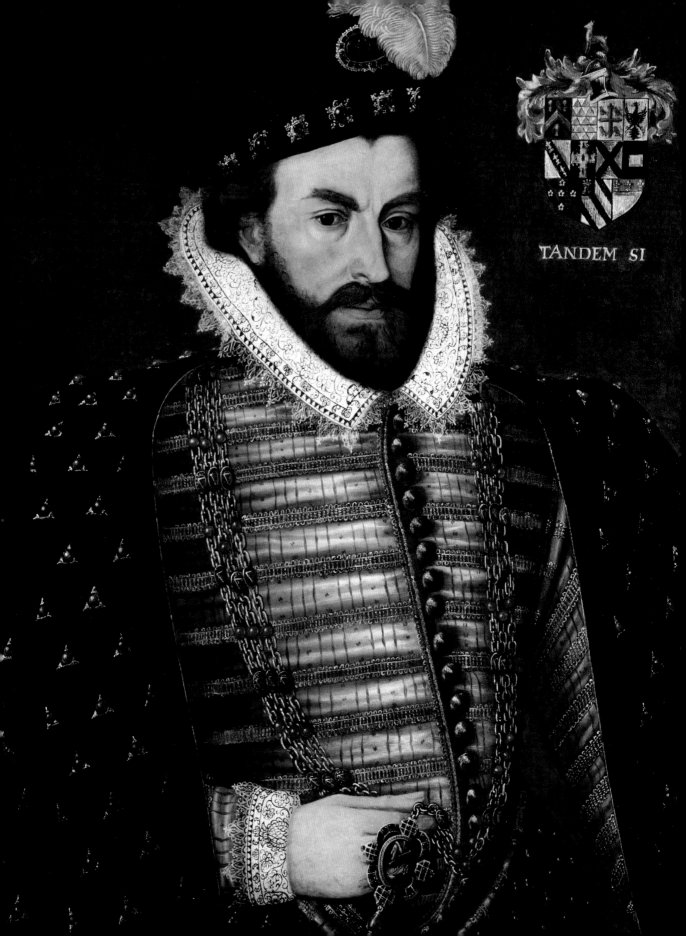

TANDEM SI

commesso portrait

The *commesso* was a highly specialized form of cameo portraiture, in which carved gems, mostly hardstones, were combined to form a likeness. Most were set pendant-fashion in enamelled and bejewelled armatures of gold. The technique was developed and perfected in Florence, where in 1588 the Medici Duke Ferdinando I set up a dedicated workshop to produce *commessi* and other works in hardstone (Opificio delle Pietre Dure). Most of the *commessi* portraits depict figures from classical mythology, members of the Medici family and, following Marie de' Medici's marriage to Henri IV in 1600, members of the French court and nobility. Surviving examples are exceedingly rare. The Cheapside *commesso* depicts a woman's head in agate. The back of the head is slightly recessed to hold another coloured stone for the hair or headdress and other stones would have been placed below to construct the torso. The portrait is too individualistic to be anything other than a portrait, but whom it depicts is unknown. Marie de' Medici, who spent some time in London between 1638 and 1641, is a possibility. When she made her triumphal procession along Cheapside on 31 October 1638 (see p. 30) she was 'accorded all the honours due to the dowger queen of France and the mother of Henrietta Maria', but she was not universally welcomed. Bishop Laud made the following diary entry:

> [I] have great apprehensions on this business. The English people hate or suspect her, for the sake of her church, her country, and her daughter, and having shifted her residence in other countries, upon calamitie and troubles which still pursue her, they think it her fate to carry misfortune with her, and so dread her as an ill-boding meteor.[88]

A14019

A14262, A41255, A41261

interlocking gold hoops, the outer pair set with uniface cameo portraits of the head of Christ and the Virgin in bloodstone, inscribed EGO·SVM·VIA·VERITAS·ET·VITA (I am the Way, the Truth and the Life) and MATER·IESV·CHRISTI (Mother of Jesus Christ). The central band is decorated with the Instruments of the Passion in white and black enamel. The head of Christ cameos are stylistically similar to medallic prototypes attributed to Antonio Abondio (1538–1591) and to other bloodstone cameos executed by the brothers Ottavio (c.1567–1624) and Alessandro Miseroni (1573–1648) for Rudolf II in Vienna and Prague.[89]

Of equal interest is a supremely important group of cameo plaquettes in cast blue and purple glass. Two, showing the head of Christ (now broken) and the Ecce Homo, are identical in size and detail to lead and bronze medals cast by Antonio Abondio for Rudolf II in c.1587, and to a variant of similar date by the German medallist Valentin Maler (1540–1603).[90] Whether the Cheapside plaquettes were cast from the same matrix used to cast the medals is unknown. The other two blue glass plaquettes, depicting busts of St Mark and St John the Evangelist, with their symbols, a lion and eagle, seem to have been derived from prints executed by the Dutch artist Jacob de Gheyn in 1588.[91] Similar plaquettes in lead, part of a series depicting the Four Evangelists, were made in Augsburg.

The glass has been chemically analysed and the results have proved rather interesting. Three of the blue glasses (A14254, A14277 and A14278) are compositionally similar, with roughly equal amounts of alkali ingredients (soda and potash) and between 60–70 per cent silica. The blue colour is derived from various colouring agents, principally cobalt in the region of 0.3 per cent but also significant amounts of manganese and iron. The St John plaquette (A14258) is quite distinct, with low levels of soda and potash as well as significant amounts of lead, perhaps 30–50 per cent. The lime levels are low and this piece is significantly coloured with cobalt at around 1 per cent with

cameo locket

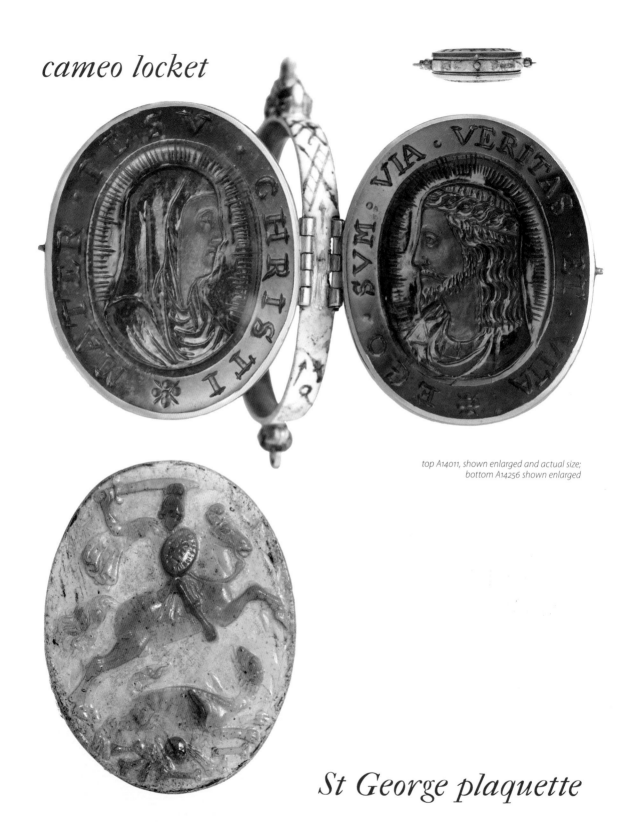

*top A14011, shown enlarged and actual size;
bottom A14256 shown enlarged*

St George plaquette

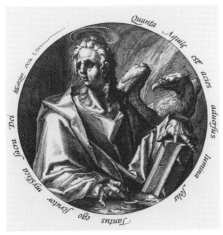

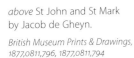

above St John and St Mark
by Jacob de Gheyn.

*British Museum Prints & Drawings,
1877,0811,796, 1877,0811,794*

*clockwise from top right: A14278, A14254,
A14277, A14258 actual size, and enlargement
of A14278*

blue glass plaquettes

equally high levels of phosphorus, manganese and iron. The compositional difference suggests that this glass was made either at a different time or in another workshop. All four glasses were made in northern Europe. The small plaquette with St George and the Dragon (A14256) is rather different in style and composition, with high levels of soda, lower amounts of potash, 4 per cent lime and no lead. The colouring element is manganese with small, almost trace, amounts of iron, so this glass was made either in one of the other workshops to a different recipe or in a different place entirely.[92] It is possible that they were collected for their medallic interest and displayed on a casket, vessel or cabinet, but it is also conceivable that they were used as a devotional aid, possibly foiled or back-lit for a monstrance, cross or reliquary. No other glass plaquettes of similar date and type are known; their presence in the Hoard is a mystery.

Mounts and foils

'The gem is clear, and hath nor needs no foil'[93]

The early seventeenth century saw a marked change in jewellery design. The settings were reduced and the gemstone took pride of place. The new fashions required specialist skills and the lapidaries were keen to try out different cutting techniques. Some established a reputation for cutting certain types of stone: John Critchlowe of Great Wood Street specialized in garnets and amethysts; John Blunt of Silver Street cut turquoise and rubies; and Robert Russell and Leonard Renatus were renowned for their skill in cutting emeralds.

Many of the Cheapside Hoard jewels have delicate, almost skeletal, frames celebrating the natural beauty of the gemstones and the technical skills of the stone cutter. The highly polished pale-yellow citrines (shown here) are lightly held in pale-blue enamelled settings and the stones have very complex, composite rose, star and step-cut faceting. There are tiny holes in the

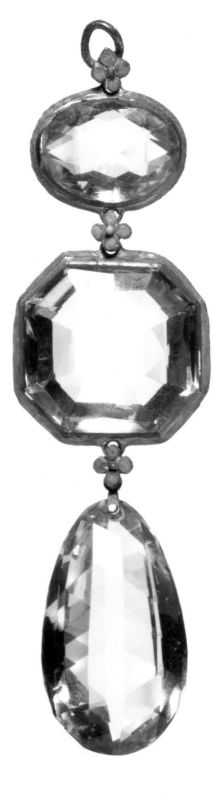

citrine pendant A16551, shown three times actual size

The pink and white sapphires in these
jewels have bright green copper foils,
which have begun to break down.

A14109, A14018, shown four times actual size

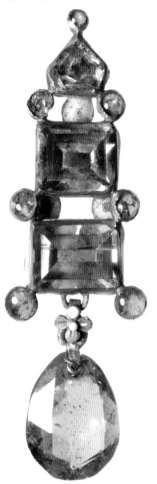

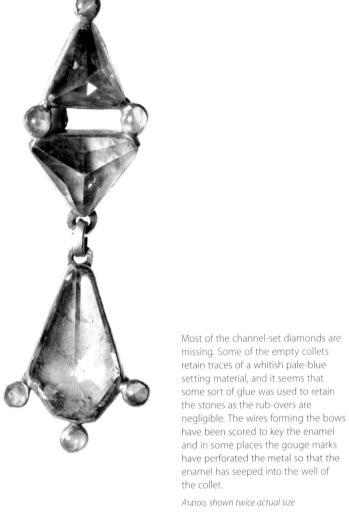

Most of the channel-set diamonds are
missing. Some of the empty collets
retain traces of a whitish pale-blue
setting material, and it seems that
some sort of glue was used to retain
the stones as the rub-overs are
negligible. The wires forming the bows
have been scored to key the enamel
and in some places the gouge marks
have perforated the metal so that the
enamel has seeped into the well of
the collet.

A14100, shown twice actual size

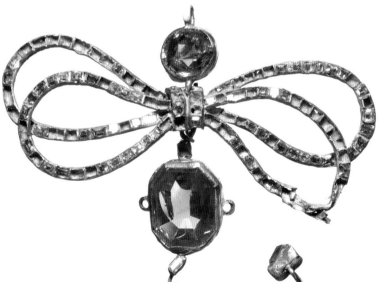

angles of the octagonal setting, which suggests that the gold rub-overs (setting strips) were cut into short lengths, each slightly overlapping its neighbour to make a neat seal around the stone in the manner of an envelope. A high-carat gold was used, which must have helped to minimize damage to the enamel and cushion the stones.

Although documentary sources suggest that the quality of the gemstones and the skills of the cutter were important, some jewellers took short cuts. Among the stones purchased by de Granade in 1600, for example, were four ballas rubies, 'being ragged haveinge holes in them and one of them a peece glewed'. Stones were commonly patched up to disguise imperfections and some were set in such a way to give the appearance that they were larger and more magnificent than they really were. One striking example of this practice is illustrated in Van Dyck's dynastic portrait celebrating the betrothal of William II, Prince of Orange, to Mary, Princess Royal of England, in 1641. Mary wears a diamond pendant with a very large stone in the centre. But all is not what it seems, as the gem dealer and jeweller Gaspar Duarte noted in a private letter to his compatriot Christian Huygens. The 'solitaire' diamond was in fact a composite of four diamonds 'glued together' so that they looked like one diamond worth 1 million florins at a cost of 'a mere 80,000 florins'.[94]

Mounts were artfully constructed so that irregular and uneven-sized stones appear to be well matched. Metallic, mineral- and organic-based foils were used to artificially enhance or alter the colour of a stone or to disguise any ir-regularities in the colour zoning. An interesting reference to the use of foil occurs in the inventory of Anne of Denmark, when a box of 17 unset diamonds of 'divers formes and valewes' set in wax with assorted 'square peeces of beade and two ruby roughs' could not be weighed because the foils were still adhering to the backs of the stones.[95] Composite stones known as doublets, made up from two stones cemented together or a stone and

glass combination, were also common. There are no doublets in the Hoard but many of the stones are foiled and sometimes extra setting material has been used to raise a small stone in its mount so that it appears larger than it really is.

Old and broken trash

Jewel inventories invariably include old and broken items, such as the 'three gold ringes old and broken gold' in William Wheeler's stock in 1601 and the 'one broken jewel sett with a dublet and two white stones' among Gregory Barker's impressive collection of amethyst, garnet, diamond, emerald and opal pendants, 22 silver-gilt gimmel rings and pearls.[96] Although some of this 'old stuff' probably constituted items brought in for repair or alteration, most of the 'broken' stock must have represented scrap for recycling. There were 'divers parcels of broken golde' and many damaged articles among Elizabeth I's 'old jewels' in 1600, and the 1593 inventory of the Cheapside goldsmith Nicholas Herrick included several items of 'broken gowlde being several peeces set with base stones and counter-fettes and great peeces of Amell (enamel)' weighing just over 27 ounces and valued at £64 6s 7d. Diamonds had been 'taken owte' of a set of nine enamelled gold buttons (no valuations are supplied) and he had other pieces of broken gold with various pieces of enamel 'sett with bad stones not worth their waighte in goulde', valued at £14 12s 6d; two old watches made from latten (a brass alloy) in crystal cases, valued at 20s; as well as bits of enamel beaten out from jewels, various lumps of broken gold, damaged jewels and 'other trash'.[97] Whether Nicholas actually purchased old jewels from his clients and other jewellers for recycling purposes is unknown, but his younger brother William was certainly engaged in this activity: over a period of three months, from August to November 1594, he spent the colossal sum of £1,000 buying up broken gold chains and other jewels from his fellow goldsmiths.[98] Broken jewels and

pieces of 'olde makinge' also feature prominently in Anne of Denmark's inventories; the gemstones were removed to make up new jewels but most of the gold settings were consigned to the melting pot.

There are several 'broken jewels' in the Cheapside Hoard. Many stones have been prised from their settings (see A14093, A14094 and A14095, pp. 59 and 199), and there are a number of cracked and broken gemstones, hardstone vessels, knife handles and spoon bowls.

Rock crystal, prized for its brilliancy and purity as a 'stone to the touch [and yet] like water to the eye', was carved into all sorts of vessels and fantastical forms. It was found in Cyprus, Spain and Germany, and on the Swiss/Italian border, where some of the best crystals were found. Some of the finest carving was done in Milan and Prague.[99] Many of the Cheapside Hoard rock crystals have been drilled for mounts and most show signs of wear, which suggests that the metal components had already been stripped off for recycling. The silver-gilt mounts on the Cheapside Hoard tankards and what might be a converted 'reliquary-salt' (A14005) are English. Herrick's inventory includes a 'fair gilte salte with a christall', some gold mounts for a 'pott', as well as a censer chain and jewels of 'Church worke' set with rubies, diamonds and a cluster of pearls (which was presumably taken from a reliquary or statute). Some of the rock-crystal items in the Hoard had a devotional purpose; these include the top or transverse limb of a cross (A14023), three tubes (possibly from a reliquary) (A14207 A14208 and A14209), and a skilfully carved intertwining branch with buds or thorns – perhaps part of a crown of thorns for a reliquary bust or statue of Christ (A14077), which might have been acquired as a consequence of the Dissolution of the Monasteries and the subsequent destruction of chantry chapels between 1536 and 1553.

from left: A14209, A14005, A14023, A14077

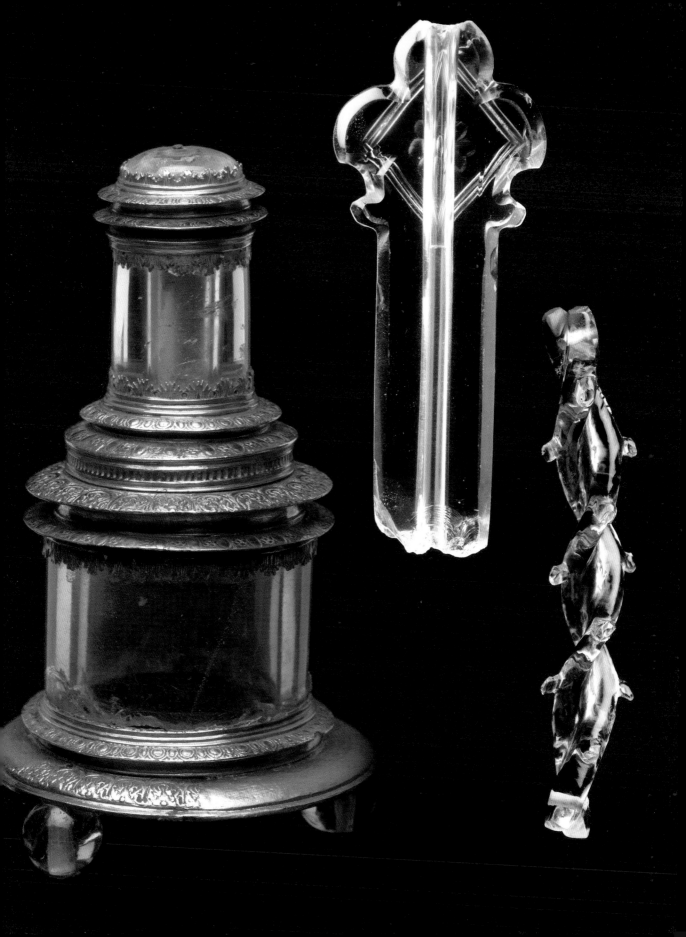

On account

Buttons feature prominently in Herrick's inventory. He had 72 enamelled gold buttons set with pearls; 60 gold buttons without enamel; 180 buttons of a smaller size with a pearl apiece; and, perhaps most fascinating of all, 'eighte buttons upon the which there was lent the some [sum] of 22s'. This last and singular entry could imply that pawning jewels was simply a sideline for Herrick; but in common with many other goldsmiths, money-lending seems to have been an important and lucrative strand of his business, and jewels or gemstones were commonly offered as security for a loan. Although goldsmiths were certainly not the only ones engaged in the trade of usury, which a statute of James I in 1604 argued had 'grown of late to many hundreds within the citie of London',[100] the link between the goldsmiths' trade and the business of moneylending was well established and there was a great deal of sharp practice. Jewellers bartered to buy expensive stones and set up consortiums to raise the cash. All sorts of complicated deals were struck, and bonds, agreements and bargains were brokered.

Occasionally things went wrong, as Robert Howe and Bartholomew Gilbert discovered to their cost when they tried to raise some money to buy a large uncut diamond of 26½ carats in 1594. They approached their fellow goldsmith Robert Brook [Brock], who agreed to lend them £1,000 for three months on condition that they paid £25 interest. Howe and Gilbert hoped to sell the stone before the expiry of the loan term and they asked Brook to test the market to see how much it would sell for. So Brook decided to redeem the stone by taking out a large loan from his neighbour Giles Simpson, a goldsmith in Lombard Street at the sign of the White Bear, topped up with money of his own. He then proceeded to tout the stone around London. Several jewellers offered to buy it for £1,200–£1,300 on the understanding that they could spread their payments over a year. Having discovered its market value, Brook decided to

clockwise from top: A14126, A14130, A14133, A14128, A14127, A14139, A14009, A14007, A14010 (front, back and side); all at twice actual size

Buttons of many shapes, sizes and materials were used as decorative trimmings and to fasten tight-fitting garments. Most were made in two halves, soldered around the circumference, with a simple loop at the back. The fronts were plain or decorated with a variety of geometric and foliate motifs, and occasionally with some kind of whimsical device of particular significance to the owner.

for jerkins' in stock.[101] Most of the buttons listed in the Royal Wardrobe Accounts were made from precious metals, bejewelled and enamelled with pansies, pea pods, half-moons and other devices. Some were embellished with half-pearls, mother-of-pearl and hardstones, while others of acorn shape formed miniature receptacles for musk and ambergris perfume balls.

Just one diamond survives, but the missing stones have left an imprint in the setting material which suggests that they were also table-cut.

Buttons with diamonds and rubies were popular. When burglars broke into Margery Smith's house in Westminster in the middle of the night on 11 February 1630, they made off with 24 buttons of gold, set with 'foure

 buttons

Buttons were given to members of the court and royal household as New Year's gifts; they feature prominently in goldsmiths' and haberdashers' stock and in household inventories. In 1576, the Cheapside goldsmith John Mabbe had 2,037 'buttons of gold for Gowns and capes', 347 gold buttons set with agates and 96 'buttons

Among the 'Old Jewels' of Elizabeth I appraised by the royal jewellers Leonard Bushe and John Spillman in 1600 were 'buttons of gold like Roses with small sparkes of Rubies and one sparke of a diamonde in the middest'.[102] The stones were removed and recycled. Similar buttons, with green, blue, white and black enamel, are included in the Hoard.

rubies and one table diamond in the middle' valued at £48.[103]

The Hoard also includes a handful of decorative buttons or mounts of the sort commonly stitched to a garment or hat. (A14007, A14009, A14010). These have green, blue and white enamel (now mostly lost) and the centres are wired to take a bead or pearl.

buy out Gilbert and Howe, giving them an 'extra £100'. But on receipt of the £100, Howe and Gilbert went to Brook's shop arguing that the stone was theirs, and 'they would warrant it against all the world, that they had bought and paid for it and therefore they might make the better warranty of it'.[104]

Sir Arthur Gorges tried to get around the problem of dealing directly with jewellers by appealing to the Earl of Salisbury. In May 1607 he wrote a rather pitiful letter explaining that he had come upon hard times and was now living in a little cottage in Kew and had 'been enforced to impawn some good jewels, that in former times, when my estate was better, I had gathered together'. But, he continued, 'not being able to redeem them, and less able to continue interest, I must sell them outright, wherefore, being fair and perfect, I did the rather presume you might like of them'. The jewels comprised a fair table diamond 'very perfect in all his corners' valued at £250, a string of 100 'orient round pearls' at £5 apiece and another 40 pearls at £10 each, all 'safely strung and fast sealed'. Gorges said they were all worth above £1,100, 'for on such pawns the goldsmiths will not lend half their value'. Cecil could have the jewels 'in far better sort than at any jeweller's hands in the world'.[105]

Perhaps Gorges was wise to be cautious, because in 1637 when the jeweller Richard Forster had pawned some precious stones with the goldsmith Drew Lovett he received counterfeits in return. Lovett tried to pin the blame on his apprentice Thomas Naudike, but both were found guilty.[106] Were some of the Cheapside Hoard jewels and stones pawned? It is no longer possible to find out.

Enamelled jewels

Enamels were used to add weight and substance to a jewel, to enhance and enliven the design and to provide a counterbalance to the gold and the brilliance of a gem. As the physician

Charles I pawned many 'Roiall and Princely Ornaments and Jewells' to raise funds for his military campaigns on the Continent, and for powder, carbines and other equipment during the English Civil Wars. The pawned jewels included the large diamond set in gold known as the Mirror of Great Britain; a lozenge-shaped diamond called the 'lettre H of Scotlande' and The Three Brothers, a jewel of great magnificence comprising three large table-cut ballas rubies (spinels), a great pointed diamond and four pearls.

This document records a series of payments to two London merchants who were employed in his 'Majesties secrett service', as well as £1374 13s 4d to the Dutch moneylender Philipp Calandrin 'to defraye the interest of his Majesties Jewells pawned att Amsterdam'.

46.78/657

Phillip
Burlama
chi

Whereas I understand by Mr Phillipp Burlmiathi his desire for his
Ma:ties service to be certified from mee what somes of money the said
Phillipp Burlmiathi hath receivd att the Receipt of his Ma:tie
Exchequ since his last gen[er]all charge delivered the 3 day of ffebruary
1634. I have therefore made search and hereafter have sett downe
such somes of money as have bene since issued att the Receipt which
I conceive may concerne him:

Viz:

xj & xij Martij 1634	To Phillipp Burlmiathi Merchant for his Ma:ties secrett service and to bee disposed of as his Ma:tie by direction under his signe manuall shall appoint part of 12000 w[i]th Cent Acompt Imprest &c By Privie Seale dated 25 October 1634 — 7145	£ 12000
xj October 1635	More to him in full of the saide some of 12000 for his Ma:ties secrett service by the said Privie Seale — 4855	
	To Job Harby of London Marchant to bee by him imployed in such overseas of his Ma:ties service as he shall receive direction for by his Ma:ties L[ett]res under his signe manuall By Privie Seale dated 13 August 1636 —	£ 12000

Summa £ — 24000 . 0 . 0

Memorand: that there was in Michmas Terme 1635 there was the some
of £ 1374 . 13 . 4 paid att the said Receipt to Phillipp Calandrin of Amsterdam
Merchant or to his Assignee to defraye the interest of his Ma:ties Jewells
pawned att Amsterdam. By Privie Seale dated 9 October 1635 &
uppon search of the Teller I finde that the money was paid to Peter
Shortrey by vertue of a Procuration from the saide Phillipp Calandrin

x:mo ffebr: 1636

Ex:p me Roberd Pye

Christopher Merret wrote in 1662, enamelling 'is a fair and pleasing thing and in itself not only laborious, but necessary, since ... metals adorned with Enamels of many colours make a fair and noble shew, enticing beyond measure the eyes of the beholder'.[107] Enamelled jewels were certainly fashionable in Elizabethan and early Stuart London and they are a conspicuous and distinctive feature of the Cheapside Hoard. Virtually every jewel is enamelled to a greater or lesser extent, and there is a wide variety of enamelling techniques. The methods used include *champlevé* (incised 'fields' or recesses in the metal base); *cloisonné* (cells created from soldered strips of metal to create the design); *basse taille* (translucent enamel over a patterned metal ground); *ronde-boss* (where the metal surface is partly or completely covered) and a form of *plique-à-jour*, (enamels suspended within open-backed *cloisons* or cells).[108] Some jewels combine several processes.

All of the chains have enamelled floral links, either as the predominant design feature or in the form of a small quatrefoil or sexfoil component. The roseate link is especially prevalent because, as the London herbalist John Gerrard remarked, 'the Rose doth deserve the most principall place among all floures ... for its beautie, vertues, fragrant and odoriferous smell; but also because it is the honour and ornament of our English Scepter, as by the conjunction appeareth in the uniting of those two royall houses of Lancaster and Yorke.'[109] The longest chains, some almost two metres in length, are entirely composed of floral and foliate enamelled gold links. The floral links represent two kinds of species rose of the semi-double bloom variety: half with white petals around a central spray of translucent amber enamel, and the rest with translucent amber petals with white enamel centres. The backs are identically detailed with calyx-shaped *cloisons* (cells) filled with opaque light-green enamel.

Many of the jewels are decorated with a 'ground' of opaque white enamel embellished with dots, dashes, sprigs and veins in a contrasting colour, usually black, but occasionally with

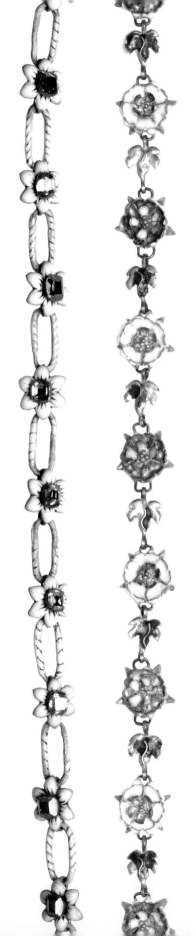

enamel

The chain on the right is particularly complex. The larger 'floral' links have a turquoise enamel centre and the lobes are filled with black enamel with an applied sprig of gold (some missing). The little white pellets on the wire sprays should be perfect spheres but most are slightly irregular because they have been over-fired. It is possible that the missing pellets have dropped off simply because they were fired at a lower, correct, temperature.

chains from left: A14069, A14073, A14195; pendants from top A14158, A14093, A14157; rings from left A14240, A14214, A14246; brooch A14082; overleaf: chain A14196 front and back

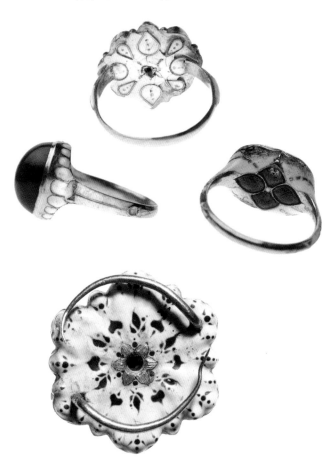

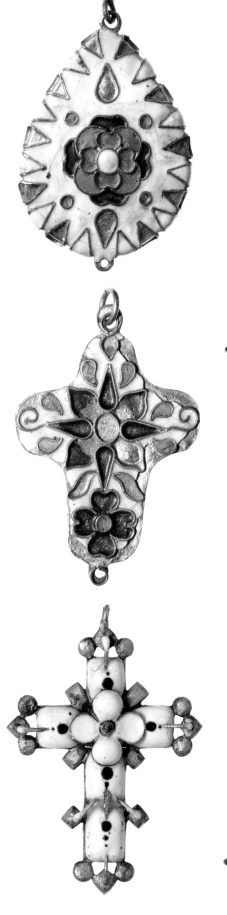

reddish browns or blues. How these contrasting colours were applied is not entirely understood. In some cases the colours have been painted directly onto the surface but in others the white ground seems to be slightly depressed (caused by a rapid melting of the oxides which has exposed irregularities on the surface, or possibly by a deliberate scoring so that selected areas could be filled with the colourant in the manner of an inlay).

Although it is possible that some of the small enamelled components (the leaves, quatrefoils and sexfoil links) were outsourced to specialist workshops, most of the enamelling and setting must have been done under the same roof. It has not proved possible to ascribe particular jewels to specific workshops, though in terms of both production technique and style a few tentative groupings can be made. The Byzantine sapphire cameo mount and three of the enamelled crosses, for example, were probably made in the same workshop. The crosses are not counter-enamelled, which might go some way to explain why the enamel appears to have contracted slightly around the edge. It is also likely that the rings were made by the same jeweller enameller. The enamels themselves, from a tiny analysed sample, seem to have consistent compositions: the white enamels are opacified with tin oxides in a lead-rich glass matrix, and the only real difference between the white and blue is the addition of copper, iron and cobalt oxides.[110] In all likelihood, the jewellers obtained frit (ready-made blocks of enamel) from the local glasshouses, which could be pulverized into powders as and when required.

Burglar's swag

'Certes there is no greater mischief done in England than by robberies'[111]

Londoners were extremely security-conscious, and with good reason. There were many thieves on the prowl, carrying 'dyvers Counterfeit keys and certyeen pycklocks'.[112] While

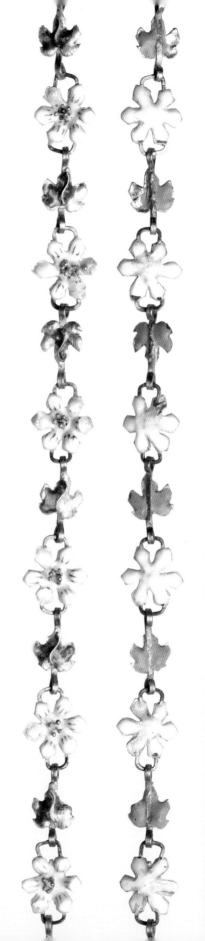

jewellers did their best to protect their stock in strong boxes with concealed or 'blind' keyholes and sophisticated locking mechanisms, these precautions were not always enough to deter a determined thief. The goldsmith George Agard discovered this to his cost when a group of labourers broke into his house in Covent Garden and 'bore away one iron chest worth twenty shillings, containing twelve plain gold rings worth six pounds, one gold ring sett with five diamonds worth three pounds and ten shillings, one gold ring set with six small rubies with a table diamond in the middle worth forty shillings' as well as a grey cloak and ten pounds in cash.[113] The best and only secure way to protect valuables in a domestic or commercial context was to hide them away from prying eyes in a garret, under the stairs, under the floorboards, behind a piece of wainscot panelling, in a privy or in a hole underground. Above all it was important to keep the location hush-hush, with as few people as possible in the know.

Does the Hoard constitute a burglar's swag? There are several well-documented accounts in the Goldsmiths' Company archives of pilfering, larceny and embezzlement of plate and jewels, but these offences mostly took place in back-alley premises, well outside Goldsmith's Row. The contents of the Hoard do not suggest loot because there are so many partially worked items. It stretches credulity to suppose that a thief would deliberately bury stolen property in a street full of goldsmiths' shops and tenements; nevertheless the jewellery trade was highly secretive, as some of the records in this book show, and there was all sorts of covert and furtive activity, some of it entirely legitimate but some of it highly suspect if not downright illegal.

Some of the most informative and detailed descriptions of the Elizabethan and Stuart jewellery trade are contained in legal records. These show that jewellery was usually fenced within twenty-four hours and nearly always in the area close to the original theft. Stolen goods were generally transported

by the burglar on foot and the ill-gotten gains stashed away in upper rooms, cellars, closets, garrets, barns, stables, storerooms and in all sorts of extraordinary containers. A large amount of jewellery was stolen by pickpockets. One of the most infamous pickpockets was Moll Cutpurse (seen here in a contemporary broadside), who was finally apprehended in 1612, and of whom the letter writer John Chamberlain wrote:

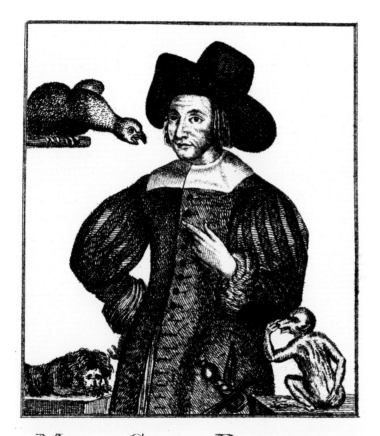

MOLL CUT = PURSE.

See here the Prefideffe o'th pilfring Trade
Mercuryes fecond Venus's onely May'd
Doublet and breeches in a Un'form dreffe
The female Humurrift a Kickfhaw meffe
Here no attraction that your fancy greets
But if her FEATURES pleafe not read her FEATS

> [T]his last Sunday Moll Cut-purse, a notorious baggage (that
> used to go in man's apparel and challenged the field of diverse
> gallants) was brought to Paul's Cross, where she wept bitterly
> and seemed very penitent, but it is since doubted she was
> maudlin drunk, being discovered to have tippled off three
> quarts of sack before she came to her penance.[114]

After a short spell in Newgate Prison, Moll resumed her career
as a jewellery fence, which she pursued until her death from
dropsy in 1659.

One of the most interesting cases of jewellery robbery took
place on 26 March 1589. On this occasion, John Tannett and
William Sendye, both described as late of London gentlemen,
mugged Roland Bredeford, the 'servant of Nicholas Herrick
goldsmith' on the highway at Islington. Tannett and Sendye
drew swords and daggers, beating and mistreating Bredeford
and stealing a quantity of jewels worth £524, as follows:

> a jewel of gold with divers precious stones set therein, worth
> one hundred pounds; another jewel of gold with divers precious
> stones namely an agget [agate] and divers dyamonds and rubyes
> fixed therein, worth ninety pounds; another jewel of gold with
> divers precious stones worth one hundred and thirty pounds;
> a gold chain worth fifty-four pounds; two gold rings with
> diamonds set in them, worth one hundred pounds; and another
> chain of gold and pearls worth fifty pounds.

The highwaymen pleaded guilty and both were sentenced to
be hanged. Then there was an interesting turn of events: after
almost a year in Newgate Prison, Sendye produced the Queen's
pardon under the Great Seal, and in this document there is
an intriguing reference to one Richard Clark, late of London
goldsmith, who was held to be an accomplice in the felony
before its commission. It was further claimed that Clark had
put Tennett and Sendye up to the job. Clark was apprehended,
pleaded guilty and was sentenced to be hanged.[115]

In a further twist, recognizances (or bonds) of £10 were
taken from George Hodges in the parish of St Bride's and
from Arthur Beedell of Walthamstow, and £20 from Robert
Coppyn of Hoxton, to ensure that they appeared at the next

rings

Rings were given by both men and women to express their loyalty and devotion. They were exchanged as material proof of contract, and were customarily bequeathed to relatives, friends and colleagues as a lasting token of remembrance, gratitude and affection. Londoners often left specific bequests in their wills for different qualities of memorial ring that were graded according to the recipients' relationship with the deceased.

Jeweller goldsmiths sold more rings than any other item, and rings feature more prominently than any other jewel in contemporary accounts. There were plain rings, enamelled rings (mostly black but occasionally of 'divers colours'), rings with 'pictures' (presumably glyptics of some sort or perhaps painted miniatures), seal rings, gimmel (folding) rings, embossed rings, parcel-gilt rings, simple gold and silver rings, hollow or puff rings, hoop rings, claw rings and rings set with a variety of stones.

Diamond rings are mentioned more frequently than any other

type of gem-set ring. There were cluster settings in the form of a rose, with doublets and with other stones, usually rubies or emeralds. Ruby rings seem to have been marginally more popular than emerald-set rings and those set with 'turkey stones' (turquoise). Rings set with amethysts, sapphires, cornelian, garnet, jacinth (hessonite garnet), toadstones and pearls are far less common. All of the rings in the Cheapside Hoard are gem-set and most are enamelled. Herrick's inventory includes two claw rings set with five table-cut diamonds; the ring with the larger setting was valued at £15 and the smaller at £5.

Rings were often secured with black cords or ribbons entwined around the fingers and fastened at the wrist, but they were also stitched onto sleeves and hats, threaded on to chains and girdles, and attached to ruffs and cuffs as a declaration of love, friendship and allegiance. The placement of rings on items of clothing gave them a greater prominence and significance than they might otherwise have had.

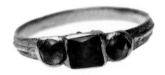

A14230 garnet; A14232 ruby and garnet; A14228 and 12,778/13 amethyst, all at twice actual size

Portrait of Margaret Cotton, *c.* 1620–30.

artist unknown, oil on panel, Guildhall Art Gallery, 1496

Margarett
Cotton

session, because Robert Coppyn was suspected 'of beinge one of theym that robbed Mr Herrickes man the Goldsmith in Cheape syde of £500 in cheanes precious stones and other juels in the Highway towardes Islington'.[116] Unfortunately, we do not know what happened to Coppyn, but it seems that Herrick had been specifically targeted. The case is intriguing for several reasons. First, the felons knew what Bredeford was carrying, where he was going and that he was travelling alone. Second, there was evidently a network of felons who not only had inside information but were prepared to use force to get what they wanted. Third, precious items of this sort were evidently sent out on the open road with seemingly little in the way of security. Were the jewels on their way to a buyer or dealer? Had they been commissioned? These questions will probably remain unanswered. Nevertheless the whole incident is interesting for the particular light it sheds on the jewellery trade in London at this time, and on one of the capital's wealthiest jewellers. Four years later Herrick fell to his death from the upper window of his house at the sign of the Grasshopper in Cheapside. Suicide was suspected, and he was certainly in poor health; but perhaps there were other, darker factors that contributed to his death.

Most jewellery was stolen through burglary or housebreaking – quite often when the owner was absent but occasionally when the residents were at home and asleep. On 19 August 1610, Margeret Metcalf, a spinster of London, stole property from Richard Durgan, a gentleman, at Whitechapel, including 'three gold ringes with three diamonds set in them worth one hundred pounds, a gold ring 'with a turkey' set in it worth forty shillings, and a gold hoope ringe worth twenty shillings'. She confessed to the crime. In an attempt to avoid the death sentence she pleaded pregnancy.[117] On another occasion, in 1613, two ladies in the household of Sir Thomas Vachell in St Martin-in-the-Fields were 'put to fright' by the sudden appearance of John Vaughan, alias Parry, and Gratius Johnson, who took clothing, including a dress with buttons of goldsmiths' work, sheets, bolts of cloth,

toadstones

Toadstones – so-called from their supposed resemblance to the bulbous excrescences on the back of the toad, are in fact rounded teeth from the fossil fish *Lepidotus maximus*.[118] The teeth, used for crushing molluscs and crustacea, vary in size and profile; the larger specimens with a gently domed crown were ideally suited for setting in rings.

'Sweet are the uses of adversity,
Which, like the toad, ugly and venomous,
Wears yet a precious jewel in his head.'
Shakespeare, *As You Like It*, II, I.

Toads were thought to be poisonous, and so toadstone rings, open-backed so that the stone had direct contact with the skin, were used to guard against contagions, to detect the presence of poison, and to heal 'all manner of grypings and paines of the guttes'.[119] Whether the Cheapside Hoard specimens were found together or acquired individually is unknown, but isolated teeth have been found among the Solnhofen limestones in Germany and, nearer to home, in Oxfordshire, Dorset and Surrey.

toadstones A14025, A14026, A14028, A14030, A14037 at twice actual size

a couple of bolsters, a feather fan, a diamond ring and a heap of diamonds, rubies and pearls.[120]

Less common were the all-female crime brigades. One of the most infamous was a gang that was active in the late sixteenth century and that were finally brought to book in 1590. Three women, Elizabeth Arnold, Elizabeth Hawtrey and Elizabeth Jonson, committed a number of offences. Elizabeth Arnold was the front woman, while the other two 'feloniously received and comforted the said Arnold'. Arnold was rather busy. She helped herself to an 'imbossed ring' and a round hollow ring with a whistle, worth 40 shillings each; a ring with a turquoise stone and another set with pearl worth 20 shillings, a 'folding ringe' worth 13s 4d; and a 'blacke enameld ringe' worth 6s 8d; with some clothing from a property in Turmylstrete (possibly Turnmill Street in Islington). This cache went to Elizabeth Hawtrey in Limehouse. A few days later Arnold set off again and raided another property nearby, this time making off with silver whistles, rings set with rubies and emeralds, various pieces of jewellery and some silver spoons. These items were taken to Elizabeth Jonson, in Westminster. Shortly afterwards the women were apprehended. They were all found guilty and hanged.[121]

Goldsmiths were often targeted. In 1640, the Goldsmiths' Company gave Arthur Denton a 'present' of £20 because his shop in Goldsmith's Row had been burgled and goods to the value of £500 had been taken.[122] It is not clear whether Denton was present or absent when the crime took place. Goldsmiths suffered from other forms of criminal activity too. In 1678, Mary Read of Holloway was finally brought to book for shoplifting a gold ring valued at seven shillings. It seems that she had been a frequent customer at the goldsmith Stephen Higgins's shop. In his statement to the court, Higgins said that she had come into his shop dressed like a country woman with a high crowned hat with a large basket perched on top and had asked to look at rings of a specific value. Though she visited the shop almost every week for a year, she purchased only two rings, and yet

Higgins lost 'a great many'. It seems to have slowly dawned on Higgins that Read was a thief and so he resolved to trap her. The trial notes read: '[S]he came in and asked for a Ring of such a value, and he reached down a Box, in which there were Rings upon every Pin, and laid it before her. She chose one, and when it was weighed said it was too heavy.' Higgins, by this stage wise to her deception, deliberately turned his back, whereupon Read, true to form, took the ring and popped it down her bodice. But this sleight of hand was observed by a gentlewoman witness. When Read was challenged, she 'offering to undress herself' was taken into the kitchen. Once there, 'opening her bosom' the ring clattered to the floor. Higgins then accused her of stealing other rings. The accused, with a great deal of whining, 'denied the thing, and [claimed] that it was but a Trick of the Goldsmith to make her pay for Rings he had lost'. She was found guilty.[123]

Sometimes jewels were taken by forcible entry, 'the lock being pickt', and sometimes through brazen cunning, as in the case of John Delamot and Edward Leepman, who 'did deceive and defraud one Nathaniel Green, Goldsmith of the sum of £60'. The defendants turned up at Green's shop with a box containing four gold rings set with diamonds and one pearl necklace with a 'Crociate of Diamonds' and asked him to lend them £60. Green put them off, 'it being a Fast Day', but they returned the following morning, with yet another box, this time stuffed with paper, two farthings and three lumps of lead. Before Green handed over the money, the defendants 'desired to have the box sealed', and while his back was turned to pick up a candle the felons switched the box of rings for the dud one full of rubbish.[124]

A question of value

It is difficult to gauge the comparative cost of goods both at a given date and in relation to articles of a similar kind, largely

because the statistical sample is too small, the information supplied is meagre and patchy, and the material itself is so variable. Some items held their value over time, while other articles of the same broad type have a wide range of valuations reflecting their weight and the quality of the craftsmanship and materials. When, for instance, a vast cache of 4,870 pearls was stolen by Francis Hill and John Newporte from Henry Batten in St Clement's Danes in 1613, the pearls were grouped as follows: '120 gems called pearles worth 2s 6d each, 230 score pearles worth 6 pence each, and 150 gems called pearles worth 3 pence each'.[125] Apart from making the obvious point that the pearls were of varying quality, which is reflected in their price, and that there were almost as many of the most expensive pearls as the cheapest, it is difficult to draw any other conclusions. The laws of supply and demand also affect valuation figures. In a saturated market a perfect stone will still hold its price, though it may be difficult to sell, while poorer quality material might have to be sold at a loss.

In legal cases it is not always clear who provided the valuations. It is possible that the owner had receipts or had noted down or even remembered the purchase price, or perhaps they approached the goldsmith from whom they had acquired the pieces, or simply told a goldsmith what sort of things they had lost and obtained an estimate of value based on their verbal description. The diarist John Evelyn makes an interesting comment in this regard. On 11 June 1652 he suffered at the hands of a couple of highway robbers near Bromley in Kent. 'What they got', he said, 'was not considerable, but they took two rings, the one an emerald with diamonds, the other an onyx, and a pair of buckles set with rubies and diamonds, which were of value.' Although the robbers threatened to cut his throat if he made a noise, he complained bitterly, so they cocked their guns and told him to keep quiet because they were waiting for someone else. Evelyn then 'begged for my onyx, and told them it being engraved with my arms would

betray them; but nothing prevailed'. The robbers left and Evelyn was tormented with flies, ants and the sun. After two hours he managed to struggle free and claimed his horse, although the saddle had been taken. The robbers had left it tied to a tree as, Evelyn supposed, the animal was too well known on the road. Then, with the help of two countrymen, Evelyn rejoined the highway and immediately reported the crime to the local JP. The next day, despite sore wrists, he rode on to London, where he got '500 tickets printed and dispersed by an officer of Goldsmiths' Hall, and within two days had tidings of all I had lost, except my sword which had a silver hilt and some trifles'. The rogues had pawned one ring 'for a trifle to a goldsmith's servant' before a ticket reached the shop, and the other was bought by a victualler, who took it to a goldsmith. He was not so lucky, because by this time the goldsmith had seen the ticket and the victualler was arrested. Evelyn interviewed him, and then discharged him on his protestation of innocence.[126]

Signed and sealed

Although the date and circumstances of the Hoard's burial are shrouded in mystery, there are two items in the collection which offer some particularly helpful clues. The first, an enamelled gilt-brass clock-watch with alarm and calendar indications, bearing the signature 'G Ferlite' on the back of the movement, has the distinction of being the only item in the Hoard that can be directly linked to its maker. Gaultier Ferlite (sometimes rendered Ferlitte or Ferlito) was of Swiss Italian extraction and the son of Hieronimus Ferlito, a native of Palermo in Sicily, who was the minister of the Italian Protestant Church in London from 1565 until his death in 1570. Hieronimus was living in Coleman Street in the City with his wife Laure (née Canale), a boy (possibly Gaultier) and a maidservant in 1568.[127] After his death, his widow married Lorenzo Anfosso,

the Ferlite watch

This watch by Gaultier Ferlite is
the only item in the Hoard to bear
a maker's mark. It was probably
made in Geneva between 1610
and 1620.

*A14092 shown actual size (below left),
enlarged, and detail of the back of the
movement (below right)*

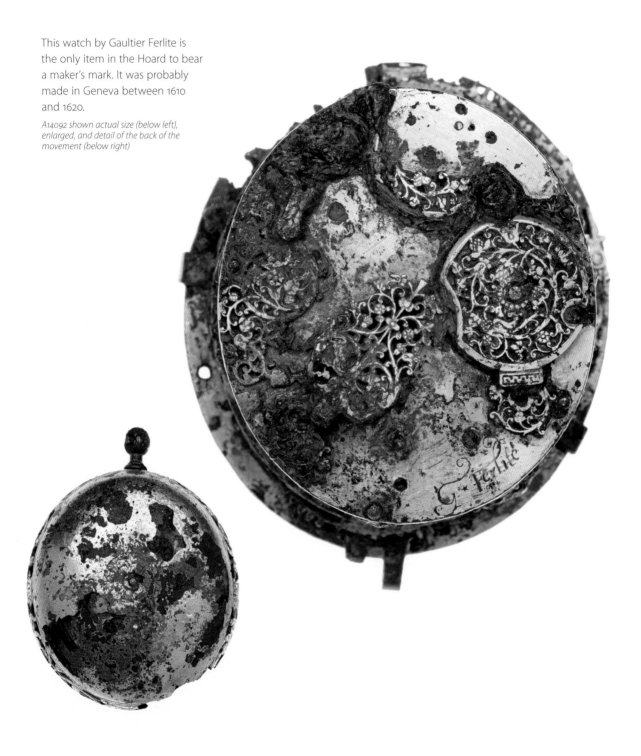

'[I]t strikes! One, two,
Three, four, five, six. Enough, enough, dear watch,
Thy pulse hath beat enough. Now sleep and rest;
Would thou could'st make the time to do so too;
I'll wind thee up no more.'
 Ben Jonson, *Staple of News*, London, 1625, (I.1)

leaving England for Geneva, where other members of the family were living.

By 1590 Gaultier had married and established himself as a clock and watch-maker in Geneva. As a result of his bravery in defending the City against the Duke of Savoy, he was granted honorary 'bourgeoisie' status, or citizenship, in 1599. He was held in such high regard that when the watch and clockmakers' guild was formed in 1601 he was asked to serve as its *juré* (master). Yet, despite his official standing, Ferlite had a rather chequered career. In 1599 he was commissioned to make a watch as a present for the Duc de Sully, minister to the French King Henri IV, which he sold to the City Syndics for 80 ecus. Sully, however, returned the watch, claiming that it was not of sufficient value, because when he had shown it to Parisian watchmakers they said that it was not worth more than 20–30 ecus. In some embarrassment, the City officers asked Ferlite to take his watch back and demanded restitution of the 80 ecus; but Ferlite refused to accept that the watch had been overpriced. The dispute rumbled on for 17 years. After endless discussions, Ferlite finally took possession of his watch, giving the City a mere 50 ecus in return.

In 1614, Gaultier was accused of espionage. He was able to prove, however, that the foreigner with whom he had been associating was an honest but well-travelled watchmaker from Graz, who had worked in Paris, Orléans, La Rochelle, Montpellier and Lyons. His fortunes improved in 1621 when he was appointed Lieutenant of the Banner for one of the City companies. Yet four years later he ran into trouble again when he kept his head covered inside the church of St Pierre during Holy Communion. By 1633 he had evidently redeemed himself, and was appointed councillor to the 'Magnificent Council of Two Hundred'.[128]

The Cheapside timepiece is the only known watch by Gaultier Ferlite to have survived. It has two unusual, perhaps unique, characteristics: the grotesques satyrs flanking the

chapter ring are inverted, and the chapter ring itself, marking the hours in Roman numerals, is reverse-set so that the 12 o'clock and 6 o'clock positions are transposed. As the watch was designed to hang from a chain or ribbon around the neck, the wearer could tell the time with a quick downward glance. As one horologist has noted, it was 'not until the twentieth century with the introduction of the type of watch commonly worn by nurses that this idea was reintroduced'.[129] Whether this attribute was common to all of Ferlite's watches or was just a particular feature of this timepiece is unknown. Although badly corroded, with much loss of enamel, it is a sophisticated instrument and would have been greatly prized when it was made *c*.1610 or perhaps a little later.

The second item that can be associated with an individual in the Hoard is a tiny cornelian seal engraved with a heraldic badge: a swan on a wreath within a lozenge surmounted by a viscount's coronet (now chipped). The blazon is a variant form of the Stafford badge which was recorded by Sir William Segar, Garter King of Arms in the early seventeenth century as follows: 'on a field per pale Sable and Gules Upon a wreath Argent and Azure a swan wings expanded Argent gorged with a coronet attached thereto a chain reflexed over the back Or'.[130]

The viscount's coronet is particularly significant because there has been only one peerage title of viscount in the name of Stafford or held by a family named Stafford: this was granted to William Howard (1612–1680), the youngest son of Thomas Howard, earl of Arundel (1585–1646), as a result of his marriage to Mary Stafford in 1637.[131] Shortly after their marriage, Mary's brother Henry Stafford (Baron Stafford), who had been a ward in the Arundel household, died. As the sole heir, Mary assumed her brother's estate and the barony was conferred upon Mary Stafford jointly with her husband by Letters Patent on 12 September 1640. William Howard's claim to the title was challenged by other peers and so the matter was referred to the Committee for Privileges, but before they could debate the

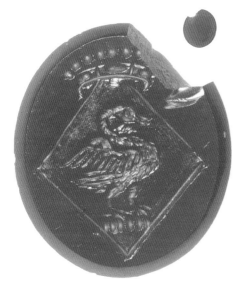

A14321, front enlarged and back shown actual size

point Charles I intervened and on 11 November, as Stafford later wrote, 'it pleased the late King of Glorious memory, the yeare 1640 to create mee a Baron and soone after a Viscount, by which I was legally intytuled unto all the rights and priviledges that belonged unto a Peere of this Realme'.[132] The intaglio gem in the Hoard was therefore presumably made for him or his wife.

Like his parents, Stafford was a passionate collector of antiquities. Like them, he spent much time abroad and like them he engaged the services of English diplomats and agents to scour markets and auctions to buy choice articles on his behalf. In 1633 he wrote to one of his father's contacts, William Petty, in Venice, 'I pray if you meet with any thing that is good … buy it for me.'[133] Stafford was also a devout Catholic, and because he thought his presence 'might rather prejudice [the king] than serve him', he left England for the Low Countries in August 1641 with his mother Aletheia née Talbot (1582–1654), who remained in exile in Amsterdam for the rest of her life. The Earl of Arundel was charged with the task of escorting the queen's mother Marie de' Medici to the Continent and in 1642 they left England for Italy. The following year, the Arundel estate was confiscated. On 7 August 'A note of my Lord Arundells Jewells and other things' was compiled, which included two branches of coral (one great and one small), 216 'rich jewels with precious stones in a browne paper sealed up', a watch case of mother-of-pearl, 'two blew stones with small pearles', a little iron chest inlayed with gold with several rings and jewels (not specified), a gilt box inlaid with coral and pearls 'with several small things in it in browne paper', 26 'cornelian and gold rings some with stones in them', 15 'stone rings' in a little green box, a silver-wire trunk, a crystal cup in a red case, and various other small articles of silver, amber and coral.[134]

Stafford remained abroad until 1646, when he was granted permission to return to England. His estate was sequestered by Parliament after the king's death, and in 1680, on the false testimony of Titus Oates and others, he was implicated in the

William Howard, 1st Viscount Stafford, artist unknown, watercolour on vellum, c. 1670.

National Portrait Gallery, NPG 2015

Popish Plot affair, found guilty of high treason and executed on 7 December. After his death his property reverted to the Crown and the Stafford title was immediately nullified. Mary retained her title until her death in 1688.

The Stafford association is intriguing and poses a number of questions. What is the seal doing in the Hoard? Was it there by chance? Does it have a deeper significance? When was it made? There are currently no firm answers, but the fact that there are three seal blanks for rings in the Hoard, two in cornelian and one in onyx, raises the possibility that the damage occurred in the workshop. It is possible, though perhaps not very likely, that the gem was damaged in wear and had been returned to the jeweller. It is also conceivable that it was one of several jewels and 'antique' gems acquired through pawn or purchase when the Stafford/Arundel collections were broken up and sold, and that the damage occurred in an attempt to prise the gem from its setting. It is perhaps no coincidence that there are a number of devotional jewels in the Hoard that suggest a Catholic recusant connection. It is also interesting that Stafford had international connections and a penchant for collecting gems and antiquities.

Whatever the truth, the fact that the Stafford gem is included in a Cheapside jeweller's stock must mean that the Hoard was buried after 1640/41, possibly during the English Civil Wars, when the goldsmiths' trade suffered, supplies of gemstones and other luxury materials were limited, and the market for jewellery was depressed. When the Goldsmiths' Company beadle tried unsuccessfully to gather quarterage payments in 1642, he was unable to do so because, he wrote, 'some are gone for soldiers; many shops are shut up, and the occupiers will not be spoken with; and the hardness of the times is such that the Goldsmiths' trade has been taken away.'[135]

Harder times followed. Many goldsmiths succumbed to plague in 1665 and then the final blow came in September 1666 when the Great Fire swept across the City.

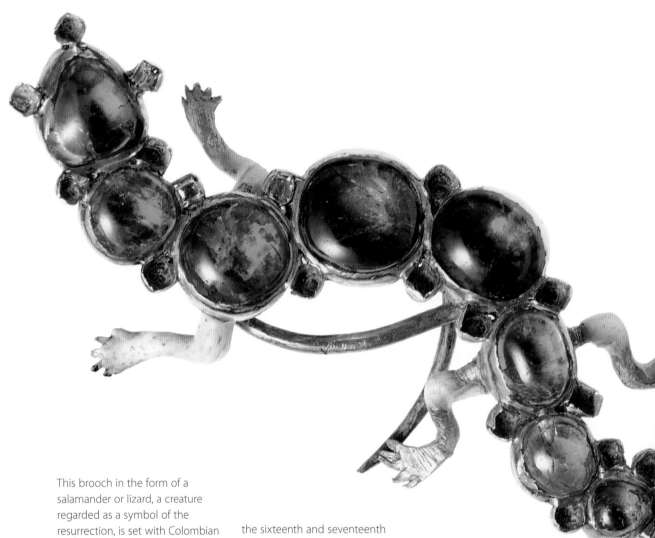

This brooch in the form of a salamander or lizard, a creature regarded as a symbol of the resurrection, is set with Colombian emeralds and Indian diamonds. The legs and underparts are covered in opaque white enamel speckled with black and brown enamel dots and flecks to represent the animal's scaly flesh. The gaping mouth is lined with white enamel and the teeth are indicated with painted black enamel dots, and the tip of the coral tongue has snapped off. There are a pair of recurving and overlapping pins on the back for attachment.

Lizards and salamanders seem to have held a special place in the visual and decorative arts of

the sixteenth and seventeenth centuries. They were considered to have prophylactic benefits and symbolic significance: their manifold virtues were described in emblem books, alchemical treatises and natural histories. Different characteristics and qualities were ascribed to each animal, but because scientific zoology was in its infancy reptiles and lizard-like amphibians were not only grouped together but were also associated with the mythological dragon and other 'crawling things'. The degree of zoological confusion is evident in Andrea Alciato's

Emblematum liber of 1531 where a 'little lizard' is identified as a 'newt bestarred';[136] and in Conrad Gesner's monumental *Historiae Animalium*, published between 1516 and 1565, the salamander is classified as a reptile. Edward Topsell continued the tradition in his *History of Four-Footed Beasts and Serpents*, the first book on natural

history in the English language, by including lizards and salamanders among 'divers sorts of Dragons, distinguished partly by their Countries, partly by their quantity and magnitude and partly by the different form of their external parts'. He prefaces his remarks on the salamander with the comment that 'I will not contrary … opinion which reckon the Salamander among the kinds of Lyzards, but leave the assertion as somewhat tollerable'.[137]

Topsell's descriptions are worth investigating in order to understand the signficance of the Cheapside jewel and how it might have been interpreted by contemporaries. He provides a lengthy description of the green lizard, which 'onely abound in Italy and … is a beast very loving and friendly to man', and suggests that it could be eaten in a sauce to prevent the 'Falling-evill'. A daily spoonful of lizard juice and wine cordial helped those 'that have disease in the lunges' or pain in the loins. Eye problems were relieved if lizard 'eys pressed out alive' were set into 'golden buttons or Bullets, & carryed about', and the heart of the green lizard 'is also very good against the exulcerations of the kings evill, if it bee but carryed about in the bottom of some small Silver vessell'.[138]

Though the lizard was considered to have many virtues, it was the amphibian salamander with its glistening black and yellow spotted skin, that attracted the most admiration because of its fabled ability both to live in and to quench fire. A paradox which Topsell notes 'on first hearing' 'doe crosse one another, for how can that either be nourished or live in the fire, which quencheth the same beeing put into it?'[139] Because of its reputed abiltiy to 'live in fire' and its proven and remarkable facility to regenerate limbs, the salamander had great emblematic significance in the sixteenth and seventeenth centuries. It was used to represent the element 'fire' in the illustration 'The "Chymic Choir" of the Seven Metals' in the alchemical treatise *Musaeum Hermeticum*, published in Frankfurt in 1625, and it was used as a metaphor for incorruptible power, resurrection and enduring faith in sermons, poems and humanistic literature. The salamander was adopted as the impresa of Federico II of Gonzaga (1500–1540) with the motto *Quod huic deest me cruciat* (What it misses torments me) and was the heraldic beast and personal emblem of François I (1494–1547) with the legend *Nutrisco et extinguo* (I nourish and extinguish).[140]

Lizard and salamander jewels were fashionable across Europe;

the number of contemporary references and surviving examples attest to their popularity. Dame Dorothy Horsey bequeathed a salamander jewel set with nine diamonds and two rubies to her daughter in 1590.[141] Elizabeth I was given a New Year's gift by the Treasurer of the Chamber, Thomas Heneage, in 1577, which comprised 'a juell of golde, being a table, thearin is a salamaunder of ophalles [opals] garnished with 18 smale dyamondes, and a pendaunte with ophales and rubyes'. She received another, from Charles Smythe, 'a small juell, being a salamaunder, a smale ruby, two smale dyamonds, and three smale perles pendaunte' in her 1578/9 New Year's gifts; it was perhaps this jewel or another similar that was listed among the inventory of Elizabeth's possessions in 1604, although one of the diamonds was missing.[142]

Salamander jewels were known across Europe, but particularly in Spain, where zoomorphic jewels were especially prized. A 'winged lizard' pendant set with rubies was recovered from the 1588 wreck of the Spanish Armada ship *La Girona*. In 1623, Signora Leonara Garibo gave a lizard jewel of gold adorned with pearls, emeralds and rubies to the Conventual Church in Malta. This was later broken up and melted down.[143]

A14125; front enlarged; back actual size

Although there are a few famous accounts of individuals who took the precaution of burying their valuables in deep pits or cellars, eyewitnesses noted that the vast majority had enough time to make good their escape, taking their possessions, ledgers and portable stock with them. Nearly two days passed before the businesses at the west end of Cheapside were engulfed, leaving ample time for the prudent jeweller to take steps to protect his goods and remove them to safety. When Samuel Pepys stepped gingerly over the still smouldering ashes of Cheapside a few days later, Goldsmith's Row had gone. All that remained was a jagged pile of brick and timber, molten lead and glass, but below, tucked away under one of the cellars, lay a great treasure awaiting discovery. Plans for rebuilding began almost at once, and in 1667 Walter Chauncey, Joan Bonner, John Davenport and others took up new leases for their properties in Cheapside. They had no idea the treasure was there.

Rather like the salamander, which contemporaries believed could be nourished by and withstand fire, the Hoard survived the fire and post-fire rebuilding. The who, what, why and when questions remain largely unanswered, and in the absence of further evidence all we say is that the mysteries surrounding the Hoard's ownership, date and burial are part of its appeal. The fact that it was never reclaimed can only mean that the owner died or was prevented in some way from returning to collect it, and his secret perished with him.

The presence of the salamander jewel in the Cheapside Hoard, with gemstones from the Old and New Worlds is perhaps a fitting symbol for the collection, and serves to underline London's position at the crossroads of the international gem and jewellery trade in one of the most dynamic periods of English history.

The Great Fire of London, 1666, after Jan Griffier the Elder, (*c.* 1645/52–1718), detail, oil on canvas, *c.* 1675.

27.142

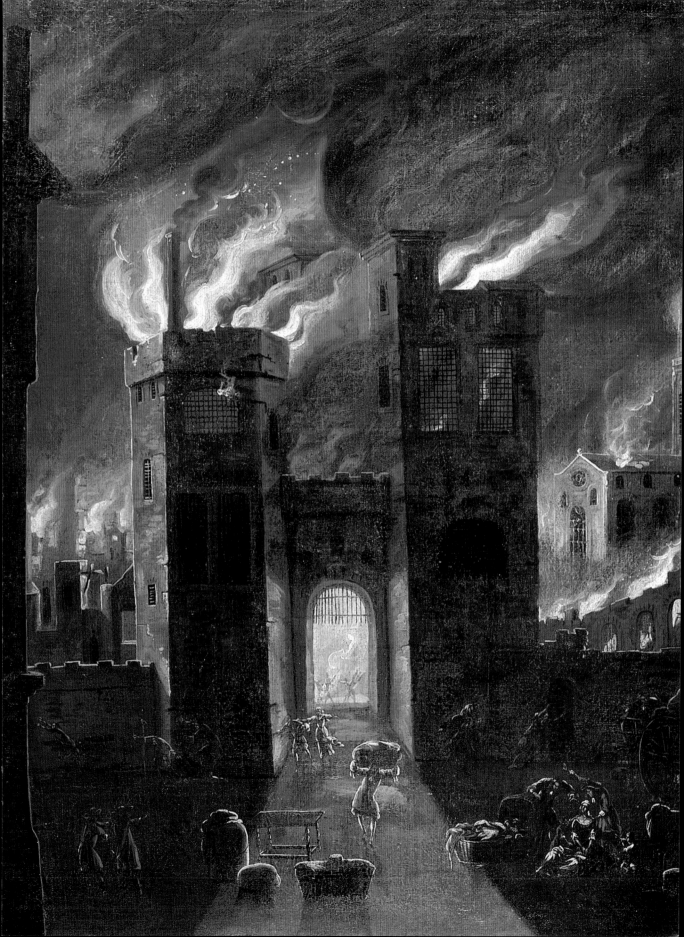

Notes

ABBREVIATIONS

BL British Library
BM British Museum
GC Goldsmiths' Company
GL Guildhall Library
LMA London Metropolitan Archives
NA National Archives
NLS National Library of Scotland
PA Parliamentary Archives
RS Royal Society
V&A Victoria & Albert Museum

A SPECTACULAR FIND

1. The Post Office of London Directory for 1910, Kelly Directories, London, 1910.
2. GC, Schedules, 29 October 1872 and March 1898.
3. GC B.IV.65, 1910–37.
4. H.V. Morton ('Stoney Jack'), 'More Fellow Men – 31', *Daily Herald*, 4 February 1937.
5. H.V. Morton, *In Search of London*, London, 1951, p. 18.
6. From Morton, 'More Fellow Men – 31'.
7. *Daily Express*, 27 June 1928.
8. Morton, *In Search of London*, p. 18.
9. Letter and invoice from G.F. Lawrence to the Victoria & Albert Museum, 2 November 1926. According to a minute in the V&A archives, Lawrence had been 'allowed to retain [this chain] (which had been exhibited by him on loan) at The London Museum for a number of years'.
10. Letter from G.F. Lawrence to the London Museum, 21 November 1927.
11. V&A, M.15–1929; M. 16–1929; M.17–1929; M.19–1929.
12. *Daily Chronicle*, 16 July 1928.
13. *The Times*, 21 March 1914.
14. *Daily Chronicle*, 16 July, 1928.
15. *Manchester Courier*, 19 March 1914.
16. Ibid.
17. V&A, Minute, 27 October, 1914.
18. Letter from L.J. Hewby, Treasury Chambers, March 1915.
19. The City Solicitors and Coroner undertook their own investigations with the aid of the City police and were entirely satisfied that the Hoard had been found on the site of 30–32 Cheapside.
20. Letter from Lewis Harcourt to Sir Homewood Crawford (legal adviser to the Corporation of London), 10 April 1916.
21. Letter from Lewis Harcourt to Mr Oates, 28 October 1920.

22. Letter from Lewis Harcourt to Guy Laking, director of the London Museum, 10 May 1916.

23. Holograph letter from the director of the London Museum, Guy Laking, to Lord Esher, 7 April 1916.

24. Letter to Lewis Harcourt from the City Solicitors, 4 May 1916.

CHEAPSIDE

1. Fynes Moryson, *An itinerary written by Fynes Moryson gent. first in the Latine tongue, and then translated by him into English: containing his ten yeeres travell through the twelve dominions of Germany, Bohmerland, Sweitzerland, Netherland, Denmarke, Poland, Jtaly, Turky, France, England, Scotland, and Ireland. Diuided into III parts*, London, 1617, p. 65.

2. Norman Egbert McClure, ed., *Letters of John Chamberlain*, 2 vols, Philadelphia, 1939, vol. II, p. 460.

3. Thomas Deloney, *Thomas of Reading, Or, The six worthy yeomen of the west*, London, 1612, ch. 6.

4. Moryson, *Itinerary*, Part III, p. 65.

5. *Tom Tell-Troath: or, a free discourse touching the Manners of the Time*, London, *c.* 1622, in J. Somers, Baron Somers, *A Collection of scarce and valuable Tracts, etc.* vol. 2. London, 1809, p. 129.

6. John Stow, *A Survey of London*, reprinted from the text of 1603, ed. Charles Lethbridge Kingsford, Oxford, 1971, pp. 345–6.

7. Andrea Trevisano, *A Relation … of the Island of England … about the year 1500*, Camden Society, London, 1847, pp. 42–3.

8. GC, Court Minutes, A, ii, fos. 100, 193, 201 *passim*, 316, 305.

9. GC, Court Minutes, L, fos. 78 and 522.

10. GC, Court Minutes, O, fo. 672 [668] Wednesday, 6 June 1610.

11. GC, Court Minutes, O, Part 2, fo. 102, 3 April 1600.

12. GC, Court Minutes, P, Part 1, fo. 224.

13. GC, Committee of Contractors for Leases, B393, 1915, fo. 54, 3 February 1651.

14. The Rent Book also refers back to leases dating to 1544 and includes a number of post-1610 annotations for lease reversions and additional terms up to 1640.

15. NA, PROB/11/273, will dated 6 July 1607.

16. NA, PROB/11/233, will dated 20 September 1653.

17. NA, PROB/11/65, fo. 607. , 15 January 1583; and PROB/11/71, fos. 70–71, 20 November 1578, proved 19 August 1587.

18. NA, PROB/11/137, will, proved 17 March 1621.

19. It is possible the 'tapestries' were painted banners of the sort executed by Ralph Treswell and other members of the Painter-Stainers' Company.

20. BM, Crace Collection 1880–11–13–3316; see also n. 12 in J. Schofield, ed., *The Surveys of Ralph Treswell*, Publication No. 135, London Topographical Society, 1987.

21. George Dalton had a tenement, two shops and a stall, which he rented from the Goldsmiths' Company for £6 per annum.

22. Parliamentary Archives, HL/PO/JO/10, Dep. 44, p. 85.

23. There is one other image of Cheapside, dating to 1598, but this simple sketch was drawn to show the market traders and does not include the goldsmiths' shops.

24. LMA, Court of Common Council and Court of Aldermen, Letter Book V, fo. 35v (Brokepotte's name is variously spelt; in the Goldsmiths' Company archives it is sometimes rendered Breakepott or Brickpott).

25. LMA, Repertories of the Court of Aldermen in the London City Record Office, Rep 16 fo. 80v.

26. LMA, Rep 17 fo. 150.

27. H.J. Hessels, *Ecclesiae Londino-Batavae archivum*, vol. III, London, 1887–88, p. 1081.

28. *The Survey of Building Sites in the City of London by Peter Mills and John Oliver*, ed. P.E. Jones and T.F. Reddaway, London Topographical Society, vol. II, 6 May 1668.

29. Ibid., vol. IV, 27 May 1669.

30. GC, Court Minutes, K, fos. 111, 261, 429.

31. GL Inventories, 1950/22/18, an unnamed goldsmith of St Giles Cripplegate [12–23/1677], and, 0017/04/02 P. Ab 225625/3 fo. 73, William Blinkarre, citizen goldsmith of St Giles Cripplegate.

32. GL Inventory, P. Ab 25625/2 fo. 48, John Winterton, citizen goldsmith of St Giles Cripplegate (4–8 February, 1669).

33. Leicester Record Office, RO, DG 9/2409, 7 and DG9/2407 (probate copy).

34. Cecil Papers, May 1596, 1–15, Calendar of the Cecil Papers in Hatfield House, Volume 6: 1596 (1895), pp. 164–83.

35. LMA, Mayor's Court Original Bills, MC1/225.179, 1633.

36. NA, PROB 11/331, 24 December 1669.

37. LMA, Mayor's Court Original Bills, MC1/62B, February 1639, 129. In 1635, when Maior was listed in the Returns of Aliens, he had one journeyman but had only been in the country for three months; see I. Scouloudi, *Returns of Strangers in the Metropolis, 1593, 1627, 1635, 1639: A Study of an Active Minority*, vol. LVII, no. 1855, Huguenot Society of London, London, 1985.

38. LMA, Mayor's Court Original Bills, 1651, MC1/72.218. Gason was apprenticed to Richard Wayman; he was free of the Goldsmiths' Company in 1635 (see Goldsmiths' Company Apprenticeship Book, AB1, fo. 334r).

39. Hannibal Gamon (variously spelt with a single or double *m*) was free of the Goldsmiths' Company in 1575. His son and namesake was born in 1582.

40. GC, Court Minutes, O, fo. 615, Friday, 5 March 1608.

41. Cited in T.F. Reddaway, 'Elizabethan London – Goldsmiths' Row in Cheapside, 1558–1645', *The Guildhall Miscellany*, vol. 11, no. 5, p. 183.

42. University of Chicago Library, Ms. Bacon 30802, June 1581.

TRADING PLACES

1. 'James 1 – volume 127: January 1622', Calendar of State Papers Domestic: James I, 1619–23 ed. M A Everett Green, London, 1858, pp 332–341; and, *Analytical index to the series of records known as the Rembrancia: 1579–1664*, ed. W.H. and H.C. Overall, London, 1878, no. VI.42 for 28 October, 1622.

2. GC, charter, Edward III, cited in W. Herbert, *The History of the Twelve Great Livery Companies of London…* , vol. 2, London, 1836, pp. 128–9.

3. GC, Court Minutes, P, fos. 636 and 637, 8 February 1622.

4. GC, Wardens Accounts and Court Minutes, P, fo. 668, 13 June 1623.

5. GC, Court Books, P, fo. 673.

6. GC, Minutes, P, Part 2, 21 Jas. 1, 1623.

7. GC, Court Minutes P, Part 2, fo. 707, 7 April 1624.

8. GC, Court Minutes, S, fo. 360, 7 March 1635/6; NA, PROB 11/273 – the will dated 6 July 1657 refers to house and shop in Cheapside and Saint Matthew's Court. Chauncey had other property in Petty France and Bedlam.

9. GC, Minutes, 30 May 1638.

10. GC, 4 November 1652, fo. 74r, 4 in B393/1930 Account of Tenants, Properties, Terms and Rents commencing between 1638 and 1697.

11. There are several William Wheelers (grandfather, father and son) in the Goldsmiths' Company records and it has thus far proved impossible to distinguish them. One was making plain hoop rings, enamel rings, gimmel rings, garter rings and knot rings in the 1650s. It is possible that other family members were also engaged in this specialist area of the trade. See Goldsmiths' Company Court Book, Y, fos. 291v and 222v. See also Company Lease Book 1913: B393/1930, fo. 66v, 1 October 1652 and fo. 74r, 4 November 1652.

12. There are two Francis Whites in the Goldsmiths' Company apprentice records: AB1.fo.26or received his freedom on 11 July 1623 and AB1.fo.336l received his freedom in 1636.

13. GC, Court Book, Y, fos. 8or and 122v; I, fos. 32r, 86r, 89v, 89r.

14. GC, Lease Book, B, 26, no. 168, and B, 393, 1–55, 20 April 1670.

15. GC, Court Book, N, fo. 87, 18 June 1596; NA, PROB 11/123, 3 March 1614.

16. GC, Court Book, L, Part 2, fo. 403.

17. GC, Court Book, R, Part 2, fo. 454, 'his trade of merchandizinge … often beyond sey', 17 April 1634. For other property holdings, see Court Book T, fos. 92r and 94v.

18. GC, Court Book, P, Part 1, fo. 118; Part 2, fos. 359 and 624.

19. GC, Rent Book 1913, B393; Court Book, P, Part 1, fos. 118, 359; Part 2, 624.

20. GC, Court Book, P, Part 1, 204, 17 March 1615.' Denny Fulkyne, goldsmythe, borne in Fraunce, a denyson; tennant to Mr Throgmorton; Barbara his wife; Dowgate Ward, City of London'.

21. GC, Court Book, O, Part 3, fo. 689 and ABl fo. 15ol, 3 August 1604. William was initially apprenticed to his brother John and was then 'turned over' to William Herrick in 1610. For reference to his shop in Cheapside, see Court Book, I, fo. 118.

22. There were two, possibly three, Thomas Sympson, goldsmiths, working in London in the late sixteenth and early seventeenth centuries. There are records for a Thomas Sympson in the parish of St Mary Woolnoth in the 1560s and again in the 1590s Without Temple Bar. The Goldsmiths' Company records suggest that one employed 'Strangers' who were not licensed to work in 1592, and the Returns of Aliens for 1568 mentions a 'Thomas Sympson, goldsmythe [with] servauntes Morrys van Myndon and Henrick van Corbus, Douchemen; and they go to the Douche churche. Douche persones, ij' [Dutch]'. One of the Thomas Sympsons received his freedom of the Goldsmiths' Company in 1604; he died in 1644. It is probably this man who lived and worked in Cheapside.

23. I am grateful to David Mitchell who supplied most of the following references to Covell from the Goldsmiths' Company archives. Court Book, L, Part 1, fos. 5 (apprenticeship, 29 July 1569), 144 (10 May 1573), and 153 (3 July 1573, water sapphire dispute). Covell is also listed in the Rent Book 1913: B393.

24. GC, Court Books, L. Part 1, fo. 427, 5 December 1578.

25. GC, Apprentice Records, AB1, fo. 258l.

26. GC, Apprentice Records, AB1, fo. 315r, 1 February 1633; ABl, fo. 365r, 8 October 1641.

27. W.B. (William Badcok), *A touchstone for gold and silver wares. Directing how to know adultereated and unlawful goldsmiths works, and the greatness of the cheat therein; and how to punish the offenders, and recover recompence to the party wronged.: Being a treatise of great use for every buyer of plate, and all buyers and wearers of silver-hilts and silver-buckles, and all other kind of goldsmiths works*, London, 1677, p 132.

28. Statute [18 Eliz. Cap. 15], 8 February 1576–20 April 1577.

29. Cited in F.J. Furnivall, ed., *Harrison's Description of England in Shakespere's Youth, Being the second and third books of his Description of Britaine and England edited from the first two editions of Holinshed's Chronicle AD 1577*, London, 1877–1908, Book 1, p. 34.

30. NLS, Adv. MS 31.1.10 (1606) fos. 196 and 192.

31. John Baret, *An Alvearie, or Triple Dictionarie, in Englyshe, Latin and French*, London, 1574 and 1580.

32. Philip Stubbes, *Anatomie of Abuses*, London, 1583, p. 67.

33. NLS, Adv. MS 31.1.10 (1609) fo. 34, 324.

34. GC, Minute Book, P, Part 2, fo. 584, 2 August 1622 (Richard Blagrave). Blagrave seems to have been a jeweller; he is mentioned on two occasions in the Company minutes, in 1621 (Court Book, P, Part 2, fo. 514, for substandard rings, thimbles, bodkins and counterfeit pearls; and then again in 1624 (Court Book,

Q, Part 1, fo. 13, for 11 gilt rings, 6 gold hoop rings and 5 enamelled rings.

35. W.S. Prideaux, *Memorials of the Goldsmiths' Company*, vol. I, London, 1896, p. 206.

36. GC, Court Minutes and Wardens Accounts, Part 3, vol. 14, 1604–1611, Saturday 24 January 1606, fo. 494/98.

37. Worshipful Company of Goldsmiths, R Part II, 13 January 1631–8 May 1634, fo. 219. Bonneville, variously spelt Boneval and Bonevale, was one of a group of jewellers in *c.* 1630 (undated) who was not paying quarterage to the Goldsmiths' Company; see Goldsmiths' Company J.V.[1]3. I am grateful to David Mitchell, pers. com. for this reference.

38. W.B. (William Badcock), *A touchstone for gold and silver wares,* pp. 98–9.

39. GC, Court Minutes, P, 142, fo. 142, 303, 593. NA PROB 11/144, 5 October 1624, parish of St Saviour's Southwark.

40. Walter Sherburne Prideaux, *Memorials of the Goldsmiths' Company: being gleanings from their records between the Years 1335 and 1815*, London, 1896, vol. 1: 5 Chas. i. – 1629.

41. GC, Court Minutes, P, fos. 481, 482, 8–22 January 1620.

42. 'Letter from Lahore, the capital city of the Grand Mogul, to Baron du Tour by Augustin Hiriart, Jeweller, 26 April 1625', Inguimbertine Library, Carpentras MS. 1777 fo. 354 in E.D. Maclagan, 'Four Letters by Austin of Bordeaux', *Journal of the Punjab University Historical Society*, vol. IV, no. 1, 1916, pp 8–9. I am grateful to Susan Stronge for this reference.

43. Later created first earl of Salisbury and lord treasurer.

44. Letter from Augustin Hiriart to Robert Cecil, in Cecil Papers, August 1604, Calendar of the Cecil Papers in Hatfield House, vol. 16: 1604, holograph (undated), 1 p. (108.110). Hiriart left England for Italy and then travelled to Egypt, Arabia, Mesopotamia, Persia and finally India, where he died (before 1632). Whether Cecil acquired the stone is unknown.

45. GC, Court Minutes, O, fos. 588–590.

46. Probably Leonard Renatus, a French stone cutter in the parish of St Ann's, Blackfriars (see following chapter). Peter le Sage, a jeweller from Rouen, France, also a resident of St Anne's, was sworn to the Ordinances of the Goldsmiths' Company in 1605 (Court Book, O, fo. 416). Roger Flynt had a house in the parish of St Zachary, Aldersgate Ward (see LMA, will X019/014 fo. 178, December, 1626).

47. Unfortunately the name is illegible.

48. There are several recipes for making counterfeit balas rubies. See BL, MS. Sloane, 'Lucations way the famous Italian to make artificiall stones and more perfected by Sr Locan a famous artist', fos. 58–60ff.

49. GC, Court Minutes, R, Part II, fo. 472, 29 January 1633.

50. East Indies: February 1614, Calendar of State Papers Colonial, East Indies, China and Japan, vol. 2: 1513–1616 (1864) pp. 274–9.

51. Calendar of State Papers Domestic: James I, 1619–23, vol. 127: January 1622 (1858).

52. Calendar of State Papers Domestic: James I, 1623–25, vol. 163: April 1624 (1859).

53. Analytical index to the series of records known as the Remembrancia: 1579–1664, 'Trade and merchandise', pp. 517–30 (edited 1878).

54. GC, Court Minutes Q Part 2, fos. 309–13.

55. Ibid.

56. Pers. com., May 2010. The glass was analysed by Dr Andrew Shortland at the Centre for Archaeological and Forensic Analysis, Cranfield University, in May 2010. Dr Shortland did not give any reasons in his report for the lack of colouring elements.

57. Neri's text was translated into English in 1662. See *The Art of Glass … translated into English with some observations … by Christopher Merrett*, 1662, ed. Michael Cable, Society of Glass Technology, London, 2001, Book 1, p. 50.

58. *Calendar of State Papers Domestic: Charles I, 1625–49*, ed. John Bruce, London, 1864, vol. 8, p. 534 (October 1634).

59. *Calendar of State Papers Domestic: Charles I, 1635–6*, ed. John Bruce, London, 1866, vol. 10, p. 317 (March 1636).

60. R.H. Tawney and E. Power, eds, *Tudor Economic Documents*, 3 vols, London, 1924, vol. I, pp. 356–7.

61. GC, 'The Gouldesmythes Storehowse', 1604, MS. CII. 2, fo. 31v.

62. GC, Court Minutes, O, Part 3 – 4 November 1607.

63. Hudlay, no. 1481 (Spitalfields), in Irene Scouldoudi, *Returns of Strangers in the Metropolis 1593, 1627, 1635, 1639. A Study of an Active Minority*, Quarto Series of the Huguenot Society of London, vol. LVII, London, 1985, 15 October 1635.

64. 'Appendix: Extracts from the Foreign Charge, 1563–71', *Chamber Accounts of the Sixteenth Century: London Record Society*, 20, 1984, pp. 123–31 no. 320. 1570–71 [fo. 36]: 'First paid to John Wright goldsmith for silver to the new collar 13 oz and to the 7 new scutcheons with the city arms 7½ oz 2 dwt and to the amendment of the old SS and little scutcheons 2 oz 5 dwt, whereof abated … ¾ (fn. 32) oz unto him delivered in the old scutcheons … rest of new silver 18¾ oz which at 3s.10d. the [oz] amounts unto £4.12s.2d.; for making the new collar which had great workmanship 20s., for mending the 6 old collars and ameling of them anew 20s., for making of the 7 new great scutcheons and gilding of them being very fair and well wrought 25s., whereof abated 6½d.; summa as by a bill appears, £7. 16s. 8d.'

65. I. Scouldoudi, *Returns of Strangers in the Metropolis 1593, 1627, 1635, 1639. A Study of an Active Minority*, Quarto Series of the Huguenot Society of London, vol. LVII, London, 1985, p 297 no. 1481, 18 July 1635; Goldsmiths' Company Court Minutes, S, Part 1, 240, 270; S Part 2, 441; T, 83, 39, 55, 56, 173, 187; W, 33 and V, 30.

66. Cited in Sándo Mihalk, *Old Hungarian Enamels*, Budapest, 1961, pp. 31–32; I am grateful to Erika Speel for this reference.

67. Cornelius Johnson (born in Brussels), in *Returns of Strangers in the Metropolis*, 1593, no. 611; and Sophia Antine, 15 October 1635, no. 70.

68. R.E.G. and E.F. Kirk, *Returns of Aliens Living in the City and Suburbs of London from the Reign of Henry VIII to that of James I*, Lymington, Huguenot Society Publications, 1900, Part III, pp 177 and 207. Herman Michielssen from Brabant in the Netherlands, and a resident of Coleman Street is also listed as a pearl piercer in 1617.

69. GC, Apprentice Book, AB1 fo. 295. William Goble was apprenticed to Edward Vaughan and was free on 20 November 1629. Goble had moved to the parish of St Anne & Agnes within Aldersgate by 1650.

70. Leicestershire Record Office, Herrick Papers, Inventory DG2415.

71. GC, 'The Gouldesmythes Storehowse', 1604, MS. CII. 2. Apart from the manuscript in the Goldsmiths' Company, four other versions of this work are known: two in the British Library; one in the National Archives and, one in the Folger Shakespeare Library in Washington DC. The title page in the Goldsmiths' manuscript is: 'The Gouldesmythes Storehowse, wherearin is layde up manye hidden secretes of that Ingenious Misterie. Compiled, made, & Drawen into this Methode by H.G. Citezen And Gouldesmythe of London. Anno Saludis 1604'. The book was presented to the Company on 20 June, 1606 by Hannibal Gamon the Younger.

72. I am grateful to the Jewellery Industry Innovation Centre at Birmingham City University for discussing this piece. The description of the production process is my own.

73. D. Mitchell, *Then hey for Goldsmiths' Hall, God and St George: The Goldsmiths' Trade in Elizabethan and Stuart London,* forthcoming 2014.

74. V. Tourner, 'Steven van Herwijck', *The Numismatic Chronicle*, 5th series, vol. II, 1922, p. 102.

75. The words 'alien' and 'stranger' were strictly limited to immigrants, and the word 'foreigner' to non-freeman, though in practice the distinctions were often blurred.

76. Until the Dissolution of the Monasteries, the 'liberties' were attached to monastic precincts and were administered by the Church. The lands were transferred to the Crown in 1540. Although the City tried to purchase the lands to extend their municipal authority, the precincts were retained by the Crown or sold to private buyers.

77. NA, State Papers, SP/12/137, no. 74, April 1580, the parish of St Anne's Blackfriars.

78. The making of modern London. Ser. 1: The repertories of the Court of Aldermen, 1495–1835, Part 1: the repertories, 1495–1599 [microform] / from the Corporation of London Record Office, 31 August, 1574, Rep. 18, fo. 256.

79. Ibid., 15 April, 1606, fo. 34.

80. GC, Court Minutes, L, Part 2, fo. 213.

81. Lien Bich Luu, 'Aliens and Their impact on the Goldsmiths' Craft in London in the Sixteenth Century', in D. Mitchell, ed., *Goldsmiths Silversmiths and Bankers Innovations and the Transfer of Skill 1550–1750*, Centre for Metropolitan History Working Papers Series, No. 2, London, 1995, pp. 43–52.

82. Scouloudi, *Returns of Strangers in the Metropolis*, vol. LVII, p. 12.

83. NA, PROB11/174, will proved 18 July 1637. Abraham and Nathaneil Hardrett were appointed 'jewellers for life to the King'. Whether the Nathaniel who drafted the will in 1613 is one and the same as the Nathaniel who was appointed jeweller to the king or a namesake is unclear.

84. *Thomas Rymer, Foedera, conventiones, literae, et cujuscumque generis acta publica inter Reges Angliae…*, London, 1741, vol. XV Mabbe schedule, 1576 p. 756.

A WORLD ENCOMPASSED

1. Thomas Platter, *Travels in England* (1599), trans. Clare Williams, London, 1937.

2. Philip Stubbes, *The Anatomie of Abuses: Containing a discourse, or brief summarie of such notable vices corruptions as nowe raigne in many Christian Countreys of the worlde*, London, 1583.

3. Cited in F. M. O'Donoghue, *A Descriptive and Classified Catalogue of Portraits of Queen Elizabeth*, London, 1894.

4. Richard Hakluyt, *A Discourse of Western Planting*, London, 1584, p. 317.

5. John Smith, *A True Relation by Captain John Smith*, London, 1608.

6. John Saris to the East India Company, 4 December 1608, from *Letters received by the East India Company and from its Servants in the East, transcribed from the 'Original correspondence' series of The India Office Records*, Volume 1: *1602–1613*, ed. F.C. Danvers, London, 1896.

7. R. Barbour, 'The East India Company Journal of Anthony Marlowe, 1607–1608', *Huntington Library Quarterly*, vol. 71, no. 2, June 2008, pp. 255–301.

8. East Indies, March 1614, *Calendar of State Papers Colonial, East Indies, China and Japan*, vol. 2: 1513–1616, ed. W Noel Sainsbury, Oxford, 1864, pp. 279–89.

9. Robert Herrick, *Works of Robert Herrick*, vol. I, ed. Alfred Pollard, London, 1891, p. 196.

10. William Vaughan, *Approved directions for health, both naturall and artificiall…*, 2nd edition, London, 1612, p. 150.

11. Pierre de la Primaudaye, *The French academie Fully discoursed and finished in foure bookes…*, London, 1618, pp. 848–50.

12. Leslie G Matthews, *The Antiques of Perfume*, London, 1973, p. 42.

13. Society of Apothecaries, MS. Bill of Joiffe Lownes (his hignes Apothecary) for medicines supplied to the Court, July 1622–September 1622, fos 1–4.

14. British Museum, Sloane 5017, Bill of John Hemingwey, appointed apothecary to the Queen in 1558, January–June, 1564.

15. I am grateful to Derek Adlam for providing information about the Welbeck scent bottles (inv. nos 005747 and 005748), pers. com., 2008.

16. Juana Green, 'The Sempster's Wares: Merchandising and Marrying in the Fair

Maid of the Exchange (1607)', *Renaissance Quarterly*, vol. 53, no. 4 (Winter 2000), pp. 1084–1118.

17. Michèle Bimbenet-Privat, in T. Murdoch, ed., 'France Prior to the Revocation of the Edict of Nantes', in *Beyond the Border: Huguenot Goldsmiths in Northern Europe and North America*, Eastbourne, 2008, pp. 7–19; Hazel Forsyth in Isabelle Bardiès-Fronty, Philippe Walter and Michèle Bimbenet-Privat, *Le Bain et le Miroir: Soins du corps et cosmétiques de l'Antiquité à la Renaissance*, Paris, 2009, pp. 324–5.

18. East Indies, December 1615, *Calendar of State Papers Colonial, East Indies, China and Japan*, vol. 2: 1513–1616 (1864), pp. 446–53.

19. East Indies, June 1625, *Calendar of State Papers Colonial, East Indies, China and Japan*, vol. 6: 1625–1629 (1884), pp. 73–9.

20. The interrogatory covering three and half pages in Latin is included in Ethel Bruce Sainsbury, ed., *A Calendar of The Court Minutes East India Company, 1635–1639*, Oxford, 1907, pp. 261–2, no. 103, [Dom.Chas.I vol. Cccliv, no. 103]. With one or two exceptions the name Polman was anglicized to Pulman, with variant spellings Pullman, Pollman and Poleman. Likewise the name Heigenius is often rendered Higenius.

21. 'A Journal kept by me John Vian from England to Endie and Persia and from thence backe again … in the good ship Discoverie Capt. John Bickell Commander in the years – Anno 1629–1631', BL, India Office, L/MAR/ALII . Note: Captain Bickell (Bickley) died on the voyage and John Vian was dead by August 1632.

22. BL, L/MAR/ALII, fo. 53, Port Swally, spelt 'Sualie' in the logbook. The precise position of this port, which was used by English East India ships, is not entirely clear, though it was 10–12 miles north of Surat.

23. BL, L/MAR/ALII, fo. 57; and letter in the East India Company papers, *Calendar of State Papers Colonial, East Indies and Persia*, vol. 8: 1630–1634, pp. 125–41. The fleet lay in 5½ fathoms at low ebb.

24. Thomas Herbert, *Some Travels into Divers parts of Asia and Afrique: describing especially the two famous Empires, the Persian, and great Mogull: weaved with the History of these later Times*, London, 1638.

25. BL, L/MAR/ALII, fo. 57.

26. Parliamentary Archives, HL/PO/JO/10/1/1999, Depositions (hereafter referred to as Dep.), 21 January 1645–46, Dep. 42, Edward Castleton and Dep. 44, Christopher Addams, shipwright.

27. Dep. 44, Christopher Addams.

28. East Indies, March 1631, *Calendar of State Papers Colonial, East Indies and Persia*, vol. 8: 1630–1634 (1892) pp. 125–41.

29. Dep. 55, Richard Butler, Justice of the Peace; Dep. 42, Edward Castleton, ship's trumpeter.

30. From James Harvey Robinson, ed., *Readings in European History*, 2 vols, Boston MA, 1904–06, Volume II: *From the opening of the Protestant Revolt to the Present Day*, pp. 333–5. Scanned by Jerome S. Arkenberg, California State University, Fullerton. The text has been modernized by Prof. Arkenberg.

31. East Indies, October 1630, *Calendar of State Papers Colonial, East Indies and Persia*, vol. 8: 1630–1634, pp. 54–70.

32. Dep. 63, Trustrum Hughson, lamplighter on the *Discovery*.

33. Dep. 57, Frauncis Connisbye, Esq., Tower of London; Dep. 47, James Johnson, fishmonger.

34. BL, L/MAR/ALII, fo. 58. The fleet left Gombroon on 18 March 1631.

35. Dep. 56, Thomas Parker; Dep. 45, Hubbard; and Dep. 33, Davye Boysvill, prisoner in the Gatehouse, Westminster; he testified that he heard conversations of sailor's imprisoned there at the suit of the Earl of Lindsey.

36. Dep. 44, Christopher Addams.

37. Dep. 1, Elizabeth Addams, Christopher Addam's wife.

38. Dep. 44, Christopher Addams.

39. BL, L/MAR/ALII, fo. 66. Turtle Bay, 'three miles short of the new harbour', had a 'fyn sandy ground'. The ships arrived at 10 a.m. on 24 May 1631.

40. Dep. 54 item 3, Robert Pennycoat, merchant taylor. He overheard a conversation in an alehouse between Addams and Abraham Porter.

41. Dep. 44, Christopher Addams.

42. Dep. 58, Jeremy Sambrooke, Gent., reference to entry in the Purser's book 'for the shippe called the Discoverye belonging to the Company that one Gerrard Pulman dyed … on the 30 June 1631'. See also Dep. 41, Castleton: 'four months after ship set sail, upon the southern coast of Africa, Polman dyed'.

43. Dep. 42, Edward Castleton.

44. Dep. 44, Christopher Addams.

45. Captain Bickell (also spelt Bickley) seems to have been the fleet commander. The master of the Discovery was John Vian (d. 1632), and so it is possible that some of Pulman's jewels and chests were removed to the Reformation.

46. Dep. 42, Edward Castleton.

47. Calendar of State Papers Colonial, East Indies, China and Persia, vol. 6: 1625–1629, W. Noel Sainsbury, ed., 1884, p. 186, 13 October 1625. This reference actually relates to Company servants in Batavia.

48. Dep. 44, Christopher Addams.

49. Dep. 56, Thomas Parker, lapidary.

50. Dep. 56, Thomas Parker.

51. Dep. 60, Andrew Trumball, master's mate.

52. Dep. 44, Christopher Addams.

53. Dep. 44, Christopher Addams.

54. BL L/MAR/ALII, fo. 85.

55. The last stage in the voyage was particularly hazardous. As one contemporary put it: 'the danger in case of foul weather was not greater between England and India than between Gravesend and the Downs.' From East Indies, February 1631, State Papers Colonial, East Indies and Persia, vol. 8: 1630–1634 (1892) pp. 116–25. The Discovery was a merchant ship of 500 tons burthen, so her cargoes needed to be lightened to carry her over the shoals and sandbars of the Thames estuary.

56. Dep. 44, Christopher Addams.

57. Dep. 44, Christopher Addams. Addams wore the mariner's Monmouth cap.

58. Dep. 5, James Symth, carman.

59. Dep. 4, Susan Bradaye, widow, related to Christopher Addams.

60. Dep. 5, James Smith.

61. Dep. 9, James Sympson, jeweller, parish of St Botolph's Aldersgate, aged 57.

62. Dep. 9, James Sympson.

63. Dep. 9, James Sympson.

64. Dep. 57, Captain Connisbye, Tower of London.

65. Dep. 42 Edward Castleton.

66. Dep. 9, James Sympson.

67. Dep. 36, John Arson, jeweller, parish of St Martin-in-the-Fields, aged 48. He related a conversation that he had had with Nowell's widow.

68. Dep. 60, Andrew Trumball, mariner.

69. Dep. 55, Richard Buttler, Gent., City of Westminster.

70. Dep. 57, Frauncis Connisbye, Esq. Tower of London.

71. Dep. 55, Richard Buttler.

72. Dep. 58, Jeremy Sambrooke, Gent., Coleman Street, City of London.

73. Worshipful Company of Goldsmiths, 'The Gouldesmythes Storehowse', 1604, MS. CII. 2, ch. 55, fo. 54.

74. Dep. 44, Christopher Addams.

75. Dep. 29, John Critchlowe, goldsmith, parish of St Martin Wood Street, aged 38.

76. Dep. 45, James Hubbard, (?) mariner.

77. Dep. 45, James Hubbard.

78. Dep. 45, James Hubbard.

79. Dep. 48, Ralphe Whistler, occupation not recorded.

80. Dep. 44, Christopher Addams – gave a woman at Snow Hill a 'handful of pearles'.

81. Dep. 10, Roger Veiminge, goldsmith, Winchester, aged 50. Assessed the value at a least a £1,000, which he heard Addams say had been sold to a jeweller in London.

82. Dep. 45, James Hubbard.

83. Dep. 33, Davye Boysvill, occupation not recorded; sometime prisoner in the Gatehouse, Westminster. In his testimony Boysvill said that Addams had told him that he and James Hubbard had visited two gem dealers by the name of Cloeberryes (probably Nicholas Cloeberryes in Lombard Street) with a large store of jewels. But whether they sold anything the deponent did not know.

84. Dep. 26, Herman Marshall, jeweller, St Giles Cripplegate, aged 50.

85. Dep. 37, Balentine Ffyge, apothecary.

86. Dep. 32, Thomas Crosse, goldsmith, parish of St Martin's Ludgate, aged 50.

87. Possibly Giles Bishoppe of St Matthew Friday Street, or Peter Bishop. Both jewellers were known to use pearls in their jewellery.

88. Dep. 53, Adrian Henrickes, parish of All Hallows Barking, London, merchant, aged 53; Dep. 39, Frauncis Hall, goldsmith, Foster Lane, aged 50 years.

89. Dep. 44, Christopher Addams.

90. GC, 'The Gouldesmythes Storehowse', 1604, MS. CII. 2, fo. 40.

91. GC, 'The Gouldesmythes Storehowse', 1604, MS. CII. 2, ch. 63, fos. 56–7.

92. I am grateful to Beatriz Chadour-Sampson for drawing this to my attention.

93. Dep. 9, James Sympson, jeweller; Dep. 10, Roger Veiminge.

94. Dep. 44, Christopher Addams.

95. Dep. 45, James Hubbard.

96. GC, 'The Gouldesmythes Storehowse', 1604, MS. CII. 2, ch. 72, fos. 60–62.

97. RS, RB/1/39/9, fos. 81–94 (1670–1680s); and RB/1/27/151 Robert Boyle papers: 'Observations about Divers obtained by Questions proposed to an inquisitive Travailer who was present at ye famous Pearle fishing at Maneu between ye Island of Ceylon & ye neighbouring Continent', RS, RB/1/39/9, fos. 81–94 (1670–1680s); and RB/1/27/151.

98. V&A, *Lulls Album*, D.6.20-96.

99. Dep. 44, Christopher Addams; Dep. 3, Thomas Carleton, Gent., Christchurch, Dorset.

100. Dep. 44, Christopher Addams.

101. Dep. 44, Christopher Addams.

102. Dep. 54, Robert Pennycoate.

103. Dep. 45, James Hubbard.

104. Dep. 43, John Parker, goldsmith, parish of Christchurch, London, aged 56.

105. Dep. 55 and Dep. 44, Richard Buttler and Christopher Addams.

106. Dep. 44, Christopher Addams. This stone was subsequently valued at £50 and upwards.

107. Dep. 9, James Sympson.

108. Dep. 44 item 28, Christopher Addams.

109. Dep. 44 item 32. Addams clearly believed that the agent, Pennycoate, had misappropriated some of the jewels.

110. Dep. 54 item 10, Andrews, goldsmith in the Strand (possibly Gervase Andrews).

111. GC, 'The Gouldesmythes Storehowse', 1604, MS. CII. 2 fos. 59–60.

112. GC, 'The Gouldesmythes Storehowse', 1604, MS. CII. 2 fo. 45.

113. East Indies, April 1630, *Calendar of State Papers Colonial, East Indies and Persia*, vol. 8: 1630–1634 (1892), 13 April 1630.

114. East Indies, December 1634, *Calendar of State Papers Colonial, East Indies and Persia*, vol. 8: 1630–1634 (1892), 29 December 1634.

115. Dep. 9, James Sympson. John Blunt had been a journeymen to Peter Tise.

116. Dep 9. This turquoise was subsequently appraised by the jeweller John Arson and the lapidary Nulleboyes in Rochford's house near the Playhouse, Blackfriars.

117. Dep. 66, Frauncis Sympson, Gent., goldsmith/jeweller, parish of St Matthews, Friday Street, aged 50.

118. Dep. 66, Frauncis Sympson.

119. Dep. 56, Thomas Parker, lapidary, parish of St Andrews Holborn, aged 39, and Dep. 40, Benjamin Griffith goldsmith, St Botolph's Aldersgate, apprenticed in 1631 to John Nowell, aged 33.

120. Dep. 26, Herman Marshall, jeweller, St Giles Crippegate, aged 50.

121. Dep. 34, Robert Russell, lapidary, parish of St Botolph's Aldersgate, aged 53.

122. Dep. 51, Robert Evetts, lapidary, parish of St Anne's Aldersgate, aged 29.

123. Dep. 34, Robert Russell.

124. Dep. 29, John Critchlowe, goldsmith, parish of St Michael Woodstreet, London, aged 38.

125. Dep. 26, Herman Marshall, jeweller, parish of St Giles Cripplegate, aged 50.

126. Dep. 55, Richard Butler.

127. NA, SP 78/128, fo. 195/214v, 3 January and 13 December 1669.

128. Dep. 56, Thomas Parker.

129. Dep. 44, Christopher Addams.

130. G. Giuliani, S.M.F. Sheppard, A. Cheilletz and C. Rodriguez, 'Contribution de l'étude des phases fluides et de la GI 18O/16O, 13C/12C à la genèse des gisements d'émeraude de la Cordillère orientale de la Colombie', *Comptes Rendus de l'Académie des Sciences*, série II, 314 (1992), pp. 269–74. Also, G. Giuliani, M. Chaussidon, H.-J. Schubnel et al., 'Oxygen Isotopes and Emerald Trade Routes since Antiquity', *Science*, NS, vol. 287, no. 5453 (2000), pp 631–3.

131. Similar terms were used in London, with large stones compared to a 'child's hand', French beans and nuts. I am grateful to Professor Kris Lane for much of the information on the Bogota emerald trade. See K. Lane, *Colour of Paradise: The Emerald in the Age of Gunpowder Empires*, New Haven CT, 2010.

132. I am grateful to Denis Bellesort for pointing out this feature.

133. For further information on the relative concentrations of solid and fluid-filled inclusions in emeralds, see G. Giuliani, A. Cheilletz, J. Dubessy and C.T. Rodriguez, 'Chemical Composition of Fluid Inclusions in Colombian Emerald Deposits', in *Proceedings of the Eighth Quadrennial IAGOD Symposium*, Stuttgart, 1993, pp. 159–68.

134. *John Highen van Linschoten, His discours of voyages into ye Easte & West Indies Devided into foure booke*s, 1598, printed for the Hakluyt Society, London, 1885, p. 134.

135. GC, 'The Gouldesmythes Storehowse', MS. CII. 2, ch. 64, fos. 57–9.

136. See octagonal gilt-brass watchcase with two lids of faceted amethyst (*c.*1610–20) from Hamburg, Germany or France, in the Munson–Williams–Proctor Arts Institute, New York, inv. no. PC.277; 317577. There is a tantalizing, though unsubstantiated, reference to an emerald watch in Agnes C.W. Swinton and John L. Swinton, *Concerning Swinton Family Records and Portraits at Kimmerghame*, Edinburgh, 1908, p. 2, which is given here in full: 'There is at Kimmerghame a curious old watch, which is known as the "Emerald Watch". This was thought to be a complimentary name owing to the colour, but an expert in stones has pronounced the works to be sunk in a true emerald of a coarse type. The legend regarding it is that the watch was presented by Anne, Princess of Denmark, wife of James VI of Scotland, to George Keith, fifth Earl Marischal, who in 1589 was sent Ambassador Extraordinary to the Court of Denmark to arrange the marriage.' This is the only known reference to a watch in an emerald case and I am most grateful to Diane Gibbs for making the connection to Anne of Denmark and to Nigel Israel for finding this source.

137. NA, PROB 11/233, proved 11 May 1646.

138. Dep. 34, Robert Russell.

139. Dep. 41, Peter Handle, jeweller, parish of St Margaret's Lothbury, London, aged 68.
140. Dep. 29, John Critchlowe.
141. Dep. 52, Stephen Chapman, goldsmith, parish of St James Clerkenwell, aged 50.
142. Dep. 29, John Critchlowe.
143. Dep. 41, Peter Handale.
144. Dep. 36, John Arson, jeweller, parish of St Martin-in-the-Fields, aged 48. Humphrey Goddhard, jeweller of Saffron Hill, Field Lane, was born in France.
145. Robert Burton, *The Anatomy of Melancholy*, London, 1621.
146. GC, 'The Gouldesmythes Storehowse', 1604, MS. CII. 2, ch. 17, fos. 44–5; and ch. 36, fo. 49. There is a certain amount of ambiguity in the account and it is possible that the heat-treated 'carbuncles' were not garnets. Ballas rubies and spinels are described separately.
147. Dep. 46, Robert Opwick, merchant.
148. Dep. 12, James Donmeade, friend of Addam, and Dep. 14, Symon Badforke, occupation not recorded.
149. East India Company Court Minutes, 'Statement in the form of articles or interrogatories' put forth by Dr John Heigenius, 28 April 1637 [Latin], in *A Calendar of the Court Minutes of the East India Company 1635–1639* pp. 261–2.
150. Dep. 45, James Hubbard.
151. Dep. 38, Nicasius Russell.

BURIED TREASURE

1. *A Discourse of the Felicity of Man, or, His Summum Bonum*, London, 1598.
2. Edward Topsell, 'Of the Squirrel', in *The Historie of Foure-footed Beasts*, London, 1607, pp. 657–9.
3. John Swan, 'Sciurus', in *Speculum mundi. Or A glasse representing the face of the world sheweing both that it did begin, and must also end. …*', London, 1635, p. 454.
4. Henry Peacham, *The gentlemans exercise. Or an exquisite practise, as well for drawing all manner of beasts in their true portraitures …*', London, 1612.
5. Ben Jonson, *B.Ion: his part of King James his royall and magnificent entertainment through his honorable cittie of London, Thurseday, the 15. March 1603…*, London, 1604.
6. Richard Braithwaite, 'The Squirrel', *A strange metamorphosis of man, transformed into a wildernesse. Deciphered in characters*, London, 1634, ch. 2.
7. Topsell, 'Of the Squirrel', p. 658.
8. Wolfgang Franzius, *Historium animalium Sacra in qua plerorumque animalium praecipauae proprietates in gratium studiosorum theologiae…*', Wittenberg, 1612, translated as *The History of Brutes, Or, a Description of Living Creatures Wherein the Nature and Properties of Four-Footed Beasts Are at Large Described / By … And Now Rendred Into English*, by N.W., London, 1670, p. 12.
9. George Wither, *A collection of emblemes, ancient and moderne…*, London, 1635; see Book 3 illustration II.
10. Daniel de la Feuille, *Devises et emblemes*, 1691.
11. T.F. Reddaway, 'Elizabethan London – Goldsmith's Row in Cheapside, 1558–1645', in *The Guildhall Miscellany*, vol. 11, no. 5, October 1963, p. 194 (Courtnall became a freeman of the Goldsmiths' Company in 1568).
12. Pieter Cornelisz Hooft, *Emblemata amatoria*, Utrecht, 1611.
13. Subspecies of *Sciurus vulgaris* with red pelts are also found on the European mainland.
14. Mayor's Court Original Bills, MC1/14.207 = Francis Mudd and William Wheeler, January 1601. MC1/23.106 August 1607 = Cornelius Fishe, Chamberlain of City of London pl. Gregory Barker citizen and goldsmith.
15. NA E407/4/3, 1600.

16. LMA, Mayor's Court Original Bills, MC1/30.81, April 1611, plantiff William Curten, merchant; defendant Gomes Davila, merchant stranger.

17. Parliamentary Archives, HL/PO/JO/10/1999, Dep. 29 and Dep. 34. Robert Russell 'did cutt one of the cerces that came oute of the said ringes' and Renatus 'cut into two a cerse that came out of said ring'.

18. MC1/26.11, 4 June 1610, William Rogers, pl. and Edmund Stonard def. – trespass.

19. My stress. LMA Mayor's Court Original Bills, MC1/1582. 244, April 1666.

20. Philip Stubbes, *The Anatomie of Abuses*, London, 1583, p. 59.

21. William Shakespeare, *The Comedy of Errors*, Act II, Scene i.

22. Thomas Tomkis, *Lingua or the Combat of the Tongues*, London, 1607.

23. LMA Mayor's Court Original Bills, MC1/23.106 August 1607, and MC1/54.B52 November 1623 (Scotch pearl); PROB4/25805, 1670/71.

24. From Cecil Papers, December 1592, Calendar of the Cecil Papers in Hatfield House, Volume 4: 1590–1594 (1892), pp. 249–77. Goldsmiths' Company, MS. CII.2, 'The Gouldesmythes Storehowse', 1604, MS. CII. 2, fo. 34r.

25. LMA, MC1/23.106 = 1607.

26. NA, WARD 2/26/241/66 draft copy of letters patent, *c.*1603–1619, discharging jewels to Charles Howard, Earl of Nottingham, and the removal of jewels deposited in Whitehall during the reign of Elizabeth I to the Jewel House.

27. NA, E/407/3, 1600.

28. NLS, Adv. MS 31.1.10, (1609) nos. 37, 360, 363, 384 and 386.

29. NA, WARD 2/62/241/66, copy of letters patent *c.*1603–1619, discharging jewels to Charles Howard, earl of Nottingham. LMA, MC1/23.106, dispute between Cornelius Fische and Gregory Barker, August 1607.

30. LMA, MC1/49A.46, February 1630. Margery Smith plantiff and Patrick Murrey, defendant.

31. NLS, Adv. MS 31.1.10 fo. 12, 116.

32. NA, State Papers 78/128, fo. 196/215r 'An Inventory of all the Goods Plate and Household Stuffe belonging too the late Queene the Kings Mother begun to bee taken att Colombe the last of October 1669 and finished the fifth of November 1669'.

33. NA, Calendar of State Papers Foreign, Elizabeth, vol. 3: 1560–1561, pp. 172–87. Letter from Gresham to Parry, 7 July 1560.

34. Attributed to Francis Beaumont (1584–1616), *Hermaphroditus Salmacida spolia sine sanguine & sudore*, London, 1602.

35. BL, MS Stowe 557, fo. 104 [29].

36. NLS, Adv. MS 31.1.10, fos. 37, 360, 363 , 384 and 386 (1609).

37. LMA MC1/37.73, February 1623, 'a gold ringe sett with a flat halfe rounde table diamonde…' Edward Bates, haberdasher pl. and William Offley def.

38. GC, 'The Gouldesmythes Storehowse', 1604, MS. CII. 2, fo. 37r.

39. GC, 'The Gouldesmythes Storehowse', 1604, MS. CII. 2, fos. 38 and 39.

40. From Cecil Papers, December 1592, Calendar of the Cecil Papers in Hatfield House, vol. 4: 1590–1594 (1892), pp. 249–77.

41. RS, RB/1/20/40, 'A Description of the Diamond Mines', 1660.

42. RS, RB/1/27/17 BP27/119/631, 1660–70.

43. GC, 'The Gouldesmythes Storehowse', 1604, MS. CII. 2, fo. 37r.

44. GC, 'The Gouldesmythes Storehowse', 1604, MS. CII. 2, fo. 36.

45. NA, PROB 11/331, 24 December 1669.

46. Frederick Devon, *Issues of the Exchequer: being payments made out of His Majesty's revenue during the reign of King James I: extracted from the original rolls…*, London, 1836, p. 147.

47. LMA MC1/91B.15, CLA/024/02/136.

48. NA, E407/4/3, 'Jewells praised by John Spillman and Lennerd Blush Jewellers'.

49. NLS, Adv. MS. 31.1.10, fo. 18, 180.

50. RS, RB/1/20/40 – C1.P/91/32', A Description of the Diamond Mines', presented to the Society in 1676.

51. GC, 'The Gouldesmythes Storehowse', 1604, MS. CII. 2, ch. 4, fo. 36–7.
52. Thomas Nichols, *A Lapidary, or, History of Pretious Stones; with Cautions for the undeceiving of all those that deal with Pretious Stones*, Cambridge, 1652, pp. 51, 52.
53. NA E/407/4/3, 1600.
54. The letters IHS are sometimes erroneously intrepreted as an acronym for the Latin phrases *Iesus hominum salvator*, Jesus the saviour of mankind; *In Hoc Signo* [*Vinces*], In this sign thou [shalt conquer]; or *In Hac Salus*, In this [cross] is salvation.
55. NA, SP/16/7/86l, fo. 121. NLS, Adv. MS 31.10, fo. 16, 164; and fo. 18, 182.
56. I am grateful to David Davies for pointing this out.
57. LMA MC1/25.40, November 1609.
58. NA, E407/4/3, Jewels solde to John de Granade by virtue of her hinges privy seale dated the 7th November 1600.
59. NA, PROB 11/213, 5 April 1650.
60. NA, PROB 11/233, fo. 325, and 325v, 11 April 1649 (proved 1654).
61. NA, PROB 11/233 fo. 327, 11 April 1649 (proved 1654).
62. William Harrison, *A Description of England…*, London, 1578.
63. Gervase Markham, *Honour in his Perfection…*, London, 1624.
64. John Gerard, *The herball or Generall historie of plantes…*, London, 1636, p. 998.
65. Thomas Cogan, 'Of Strawberrie', in *The haven of health Chiefly gathered for the comfort of words of Hippocrates…*, London, 1636, ch. 92.
66. Robert Boyle, *Essay about the Origin and Virtues of Gems*, London, 1672, pp. 177–8.
67. Gerard, *The herball or Generall historie of plantes…*, ch. 386, p. 999.
68. *The Heroicall Devises of M. Claudius Paradin… trans. out of Latin in English by P.S.*, London, 1591, fig. on p. 83 of a snake entwined around a strawberry stem with the accompanying inscription 'Latet anguis in herba / The adder lurketh privilie in the grasse.' This concept seems to have its origin in Vergil's pastoral poem *Eclogues*, III, 92–93: 'Qui legitis flores et humi nascentia fraga, frigidus, o pueri, fugite hinc, latet anguis in herba.' See also Geffrey Whitney, *A Choice of Emblemes and other Devises*, Leyden, 1586, p. 24.
69. BL, 'Poems written by the Right Honorable William earl of Pembroke', London, 1660, Thomason/E.1924[3].
70. George Frederick Kunz, *The Curious Lore of Precious Stones…*, p. 390 and n45.
71. Hieronymus Brunschwig, *The noble experence of the vertuous handy warke of surgeri, practysyd [and] compyled…*, London, 1525 ch. 2 'another experymental lernyng for to staunche the bloode'.
72. Jan Huygen van Lischoten, *Iohn Huighen van Linschoten, his discours of voyages into ye Easte & West Indies, Devided into foure bookes*, London, 1598, p. 134.
73. GC, 'The Gouldesmythes Storehowse', 1604, MS. CII. 2, fo. 54.
74. *The Works of Thomas Nashe*, ed. Ronald B McKerrow, London, 1910, vol. 1, p 183.
75. LMA, MC1/171.63 = November 1667.
76. NA, MS E/407/3. An inventory made between Thomas Buckhurst, Lord High Treasurer of England and Charles earl of Nottingham and others…, 1600.
77. Thomas Rymer, *Foedera, conventiones, literae, et cujuscumque generis acta publica inter Reges Angliae…*, London, 1741, vol. XV; Mabbe schedule, 1576, pp. 757–8.
78. BL, Stowe MS 559, fos. 58 and 96v.
79. Cecil Papers, Calendar of the Cecil Papers in Hatfield House, vol. 10: 1600, ed. R.A. Roberts (1904), pp. 353–71, relating to 'Old jewels "praised" by Hugh Kayle, goldsmith and Jan Spillman, jeweller, taken out of the Tower of London by her Majesty's commandment, 17 and 22 October 1600'.
80. LMA, MC1/23.106, August 1607.
81. LMA, MC1/1582.34 9 March 1607 and MC1/161.18, September 1661.
82. Dimitris Plantzos, 'Ptolemaic Cameos of the Second and First Centuries BC', *Oxford Journal of Archaeology*, vol. 15, no. 1, March 1996, pp. 39–61.
83. I would like to thank Irina Sterlivgova, Kremlin Museum, pers. com. 2009, for assessing these gems and for the expert opinion offered.

84. I am grateful to Martin Henig for dating the Roman gems. See also Martin Henig, 'Itaglios from Roman London', in J. Clark et al., eds, *Londinium and Beyond: Essays on Roman London and its Hinterland for Harvey Sheldon*, CBA Research Report 156, York, 2008, pp. 226–38.

85. Text accompanying engraving depicting the 'Five Senses' by Huijch Allert in *Afbeeldinghe der Vyf Siennen*, Amsterdam, 1690. Also illustrated in *Atlas van Stolk. Katalogus der Historie-, spot- en zinneprenten betrekkelijk de geschiedenis van Nederland eds. Abraham van Stolk, Gerrit van Rijn*, Amsterdam, 1895.

86. Edward Topsell, *The historie of foure-footed beastes: Describing the true and lively figure of every beast, with a discourse of their severall names, conditions, kindes, vertues (both naturall and medicinall) countries of their breed, their love and hate to mankinde…*', London, 1607, pp. 2–9.

87. NA, PROB 11/233 fos. 326v and 327.

88. Cited in *The Book of Days of Popular Antiques, Popular Antiquities in Connection with the Calendar, Including Anecdote, Biography, & History, Curiosities of Literature and Oddities of Human Life and Character*, vol. 2, ed. Robert Chambers, London, 1893, p. 523.

89. Philip Attwood, *Italian Medals c. 1530–1600*, London, 2003, vol. I, p. 460 cat. nos 1156 and 1157.

90. Maler worked in Nuremberg from 1568 until his death in 1603; he travelled extensively, spending time in Würzburg, Munich and Dresden, in Prague, and in various places in Poland. See Marjorie Trusted, *German Renaissance Medals: a catalogue of the collection in the Victoria & Albert Museum*, London, 1990, p 67.

91. I am grateful to Jeremy Warren for drawing this to my attention.

92. The analysis by CP-SEM was undertaken by Dr Andrew Shortland at the Centre for Archaeological and Forensic Analysis at Cranfield University. This summary is largely derived from his report; pers. com. 19 May 2010.

93. 'An Elegie of a poynted Diamond given by the Aucthor to his wife at the byrth of his eldest sonne', *Epigrams*, London, 1618, cited in Gerard Kilroy, *The Epigrams of Sir John Harrington*, Farnham, 2009, p. 96.

94. The painting is in the Rijksmuseum (SK-A-102). Cited by Jan Waldgrave, *Een Eeuw van Schittering diamantjuwelen uit de 17de eeuw*, Antwerp, 1993, p. 71. See also M.H. Gans, *Juwelen en mensen – De geschiedenis van het bijou van 1400 tot 1900*, ed. J.H. de Bussy, Amsterdam 1961, p. 98.

95. NLS, Adv. Ms 31.1.10, fo. 30 (1609).

96. LMA MC1/14.207 – January 1601, Francis Mudd goldsmith pl. and William Wheeler, goldsmith, def.; and MC1/23.106, August 1607.

97. Leicestershire Record Office, Herrick Papers, inventory DG2415.

98. NA, H.C.A. 13/31 fo. 121 b, deposition from William Herrick, 5 November 1594.

99. GC, MS. CII. 2, ch. 28.

100. *Journal of the House of Commons*, volume 1: *1547–1629*, London, 1802, pp. 235–6, Act of Usury, 1604.

101. Rymer, *Foedera*, vol. XV, Mabbe Schedule, 13 April 1576, pp. 756–9.

102. NA, E407/4/3, 1600.

103. LMA, MC1/49A.46 = February 1630.

104. From Cecil Papers, December 1594, 1–15, Calendar of the Cecil Papers in Hatfield House, Volume 5: 1594–1595 (1894), pp. 26–39.

105. K28 May, 1607. Holograph. Seal. 1 p. (121. 64.), from Cecil Papers, May 1607, 16–30, Calendar of the Cecil Papers in Hatfield House, Volume 19 (1965), pp. 131–45 (28 May, 1607).

106. NA, Exchequer records: King's Remembrancer, Depositions taken by Commission, E134/13 & 14 Charles I/ Hil 15, Date range: 1637–1639. A dispute between Richard Forster and Drew Lovett, goldsmith, concerning jewels pawned by the defendant with the plaintiff and the dishonesty and misconduct of Thomas Naudike, the defendant's apprentice in offering to the plaintiff, precious stones.

107. *Antonio Neri, trans. Into English by Christopher Merrett*, ed. Michael Cable, Society of Glass Technology, Sheffield, 2001, p. 203.

108. For more information on these techniques and other enamelling terms, see E. Speel, *Dictionary of Enamelling History and Techniques*, Aldershot, 1998.

109. Gerard, *The herball or Generall historie of plantes…*

110. In December 2009 five pieces of white and blue enamel from the Cheapside Hoard were sampled for semi-quantitative analysis by Dr Stefan Röhrs and Dr Heike Bronk at the Technical University of Berlin Institute for Inorganic and Analytical Chemistry. The compositions 'corresponded well [with] contemporary enamel compositions of the sixteenth and seventeenth centuries. I would like to acknowledge the help of Erika Speel in facilitating this work and for her helpful comments on enamelling processes.

111. Harrison, *A Description of England…*

112. Museum of London, MS A14984, dated 1555; includes a reference to Richard Child of Westminster, who was arrested on suspicion of fellony and was caught red-handed with pick-locks etc.

113. Middlesex Sessions Rolls, 1665, Middlesex County Records: Volume 3: 1625–67 (1888), pp. 363–81, 13 December, 1664, theft from George Agard's house in Covent Garden.

114. *The Chamberlain Letters, A Selection of the Letters of John Chamberlain Concerning Life in England from 1597 to 1626*, ed. E.M. Thomson, New York, 1966; and Sir Dudley Carleton, *Letters of Dudley Carleton to John Chamberlain, 1603–1624* ed. M. Lee, New Brunswick, 1972; also cited in G. Ungerer, 'Mary Frith, alias Moll Cutpurse, in Life and Literature', *Shakespeare Studies* 18, 2000, pp. 42–84; p 67.

115. Middlesex Sessions Rolls, Middlesex County Records, Volume 2: 1603–25 (1887), p. 185, G.S.P.R., Easter, 31 Elizabeth, 26 March 1589.

116. Middlesex Sessions Rolls, Middlesex County Records, NS, Volume 1: 1550–1603 (1886), pp. 182–9, G.S.P.R., 31 Elizabeth, 11 April 1589.

117. Middlesex Sessions Rolls, 1609, Middlesex County Records, NS, Volume 2: 1603–25 (1887). pp 47–58, 19 August 1610.

118. These ganoid fishes with armoured plates and rows of palatal teeth grew up to 2.5 metres in length. The fossils are found in Upper Jurassic, Lower Cretaceous (155.7 to 150.8 million-year-old) rocks. The hemispherical shape was suited to their diet of crustacea and molluscs. The teeth are discoloured by the soil conditions and the surrounding rock matrix in which they were found. Some of the Cheapside toadstones have prominent wear marks.

119. Topsell, *The historie of foure-footed beastes*, p. 727.

120. Sessions, 1614: 11 and 12 January, County of Middlesex. Calendar to the Sessions Records, new series, Volume 1: 1612–14 (1935) pp. 308–35; Middlesex Sessions Rolls, G.D.R.2, 527/61, 95, 171, 182, December, 1613.

121. Middlesex Sessions Rolls, Middlesex County Records, Volume 1: 1550–1603 (1886), pp. 191–202, 16 April and 20 March 1591.

122. GC, Court Books, R, 7 February 1640.

123. Old Bailey Proceedings, 11 December 1678, ref. no. 16920831.

124. Old Bailey Proceedings, 31 August 1692, ref. no. t16920831–37.

125. Middlesex Sessions Rolls, Middlesex County Records: Volume 2: 1603–25 (1887), pp. 78–84, 1 June 1612.

126. John Evelyn, *The Diary of John Evelyn*, 6 vols, ed. E.S. de Beer, Oxford, 1955, vol. III, pp. 69–71.

127. O. Boersma and A.L. Jelsma, eds, *Unity in Multiformity, The Minutes of the Coetus of London, 1575 and the Consistory Minutes of the Italian Church of London, 1570–1591*, vol. LIX, Huguenot Society, London, 1997, p. 227.

128. *La Fédération Horlogère Suisse* 31, 20 April 1921, p. 223. See also J.A. Galiffe et al., *Notices Généalogiques sur les Familles Genevoises*, vol. 2, Geneva, 1831, p. 620. I am grateful to Carmen Vida for her help with the translation.

129. I am grateful to David Thompson of the British Museum for his assessment of this watch.

130. College of Arms, MS. L81, p. 107.

131. I am grateful to the Chester Herald at the College of Arms for discussing this badge with me, and for helpful advice on heraldic matters.

132. Westminster Diocesan Archives, Stafford Papers, B69 [10].

133. M.F.S. Hervey, *The Life, Correspondence and Collections of Thomas Howard, Earl of Arundel*, London, 1921, pp. 338–9.

134. Westminster Diocesan Archives B29[6], Stafford MSS, 7 August 1642.

135. W.S. Prideaux, *Memorials of the Goldsmiths' Company: being gleanings from their records between the Years 1335 and 1815*, London, 1896, Vol. 1, p. 209 (18 January 1643).

136. Andrea Alciato, *Emblematum liber*, Augsberg, 1531, emblem no. 49.

137. Edward Topsell, *The historie of serpents. Or, The second booke of liuing creatures wherein is contained their diuine, naturall, and morall descriptions…*, London, 1607, pp. 209–11.

138. Ibid., pp. 210–11.

139. For Topsell's descriptions of classical authorites, see ibid., p. 218. For additional references to the folklore associated with the salamander, see H. Bächtold-Stäubli, *Das Handwörterbuch des deutschen Aberglaubens*, vol. 6, Berlin, 1934, p. 455 s.v.

140. A.M. Lecoq, 'La Salamandre royale dans les Entrées de Francois Ier', in *Les Fêtes de la Renaissance* vol. 3, Paris, 1976, pp. 93–104.

141. NA, PROB 11/75, 21 January 1590, Widow of Sir John Horsey, knight, bequeathed to 'unto her Lovinge Daughter Elizabeth Chidleigh … a Jewell with a Salamander nyne Diamondes and twoe Rubies in hym'.

142. BL, MS Stowe 557, fo. 98 [62]; NA, E/407/4/3, 1600; and WARD 2/62/241/66, c. 1603–1619 [44].

143. Inventory of the Conventual Church, ACM Misc. 151, fo. 252, 1687, 'una Lucerta d'oro presentata dalla Signora Leonora Garibo sotto li 26 Xbre 1623 adornata di sei perle, tre piccole attaccate alle due Catinette doye sta' appesa, e l'altre tre maggiore pesa un'oncia (valuata 23.4 scudi.' I am grateful to Francesca Balzan for this reference.

Further reading

Arnold, J., *Queen Elizabeth's Wardrobe Unlock'd*, London, 1988.

Claessens-Perém A.M., and J. Walgrave et. al., *A Sparkling Age: 17th-Century Diamond Jewellery,* Antwerp, 1993.

Evans, J., *English Jewellery from the Fifth Century* A.D. *to 1800*, London, 1921.

Evans, J., *A History of Jewellery 1100–1870*, London, 1970.

Lane, K., *Colour of Paradise: The Emerald in the Age of Gunpowder Empires*, New Haven, 2010.

Muller, P.E., *Jewels in Spain 1500–1800,* New York, 1972.

Scarisbrick, D., *Jewellery in Britain 1066–1837*, Norwich, 1994.

Scarisbrick, D., *Tudor and Jacobean Jewellery*, London, 1995.

Scarisbrick, D., *Rings, symbols of Wealth, Power and Affection*, London, 1993.

Speel, E., *Dictionary of Enamelling: History and Techniques*, Aldershot, 1998.

Victoria & Albert Museum, *Princely Magnificence, Court Jewels of the Renaissance, 1500–1630*, ed. A. Somers Cocks, London, 1981.

Image sources

The author and the publishers would like to express their sincere thanks to the following institutions, who have provided images and granted permission to reproduce them. All images not otherwise credited are the copyright of the Museum of London.

Index of jewels

References to images are in *italics*.

Index

References to images are in *italics*.